*		

A RotoVision Book Published and Distributed by RotoVision SA Route Suisse 9 CH-1295 Mies Switzerland

RotoVision SA Sales and Production Office Sheridan House 112–116a Western Road Hove. BN3 1DD, UK

Telephone: +44 (0) 1273 72 72 68 Facsimile: +44 (0) 1273 72 72 69 E-mail: sales@rotovision.com Website: www.rotovision.com

Copyright © RotoVision SA 2002 All rights reserved. No part of this publication may be reproduced, stored in a retrieval system or transmitted in any form or by any means, electronic, mechanical, photocopying, recording or otherwise, without permission of the copyright holder. ISBN 2-88046-707-1

Book designed by Struktur Design Photography by Roger Fawcett-Tang

Originated by Hong Kong Scanner Arts

Printed and Bound in China by Midas Printing

Compiled and edited by Roger Fawcett-Tang Essays by William Owen

Mapping

An illustrated guide to graphic navigational systems

EMMET O'NEAL LIBRARY 50 OAK STREET MOUNTAIN BROOK, AL 35213

001	Half title page
002	Imprint
003	Title page
004	Contents
005	Contents
006	Contents
007	Contents
008	Chapter divider
009	Chapter divider
010	Beyond the horizon _ William Owen
011	Beyond the horizon _ William Owen
012	Beyond the horizon _ William Owen
013	Beyond the horizon _ William Owen
014	Chapterdivider
015	Chapter divider
016 017	You are here William Owen
017	You are here William Owen
019	Willi Kunz Associates _ Information posters Willi Kunz Associates Information posters
020	Imagination _The Journey Zone
021	Imagination The Journey Zone
022	The Kitchen USR Records
023	The Kitchen USR Records
024	Base MoMA QNS identity
025	Base MoMA QNS identity
026	Simon Patterson J.P.233 in C.S.O. Blue
027	Simon Patterson The Great Bear
028	Simon Patterson Untitled: 24hrs
029	Simon Patterson Rhodes Reason
030	Cartlidge Levene _ Christmas Cards 1995/1997
031	Cartlidge Levene _ Christmas Cards 1998/1999
032	Fibre_Cre@teOnline
033	Fibre_Cre@teOnline
034	John Crawford _ Parc de la Villette
035	John Crawford Parc de la Villette
036	Cartlidge Levene _ Eye advertising
037	Cartlidge Levene _ Eye advertising
038	The Kitchen _ Studio floorplan
039	The Kitchen _ Studio floorplan
040 041	Jeremy Johnson _ A visual record of the entire contents of a typecase
042	Jeremy Johnson _ A visual record of the entire contents of a typecase John Crawford Open Week poster
042	John Crawford Open Week poster
044	Mark Diaper/Michael Landy _ Breakdown
045	Mark Diaper/Michael Landy Breakdown
046	sans+baum Facts of Life gallery guide
047	sans+baum _ Facts of Life gallery guide
048	Cartlidge Levene _ Selfridges Birmingham brochure
049	Cartlidge Levene Selfridges Birmingham brochure
050	Build TRVL.
051	Build TRVL.
052	NickThornton-Jones and Warren Du Preez_Human mapping
053	NickThornton-Jones and Warren Du Preez Human mapping
054	Sinutype_AM7/The Sun Years
055	Sinutype AM7/The Sun Years
056	Sinutype AM7/The Sun Years
057	Sinutype AM7/The Sun Years
058	Sinutype AM7/File Exchange
059	Sinutype _ AM7/File Exchange
060	Lust Lust Map
061	Lust_Lust Map
062	Browns/John Wildgoose _ 0°
063	Browns/John Wildgoose 0°

Mapping

00

00

01

Introduction

Representation and space

065 Chapter divider 066 The inhabitable map William Owen and Fenella Collingridge 067 The inhabitable map _ William Owen and Fenella Collingridge Projekttriangle_Krypthästhesie 068 069 Projekttriangle Krypthästhesie Lust_AtelierHSLweb site 070 Lust Atelier HSL web site 072 Cartlidge Levene _ Process type movie 073 Cartlidge Levene _ Process type movie 074 Tomato Interactive _ Sony Vaio interface 075 Tomato Interactive Sony Vaio interface Fibre_Diesel StyleLab 076 077 Fibre Diesel StyleLab 078 Fibre_cc2000 079 Fibre_cc2000 080 Spin_Tourist 081 Spin_Tourist sans+baum_Future Map exhibition 082 083 sans+baum_Future Map exhibition Lust Open Ateliers 2000 084 085 Lust_Open Ateliers 2000 086 Frost Design_Give & Take 087 Frost Design_Give & Take 088 Lust_Risk Perceptions carpet 089 Lust_Risk Perceptions carpet Peter Anderson _ Cayenne interior 090 Peter Anderson _ Cayenne interior 091 092 Intégral Ruedi Baur et Associés _ Kalkriese Intégral Ruedi Baur et Associés _ Kalkriese 093 094 Intégral Ruedi Baur et Associés Centre Pompidou 095 Intégral Ruedi Baur et Associés _ Centre Pompidou 096 Peter Anderson Poles of Influence Peter Anderson Poles of Influence 097 098 The Kitchen Ocean 099 The Kitchen Ocean MetaDesign London _ Bristol City signage 100 101 MetaDesign London _ Bristol City signage North Selfridges interior signage 102 $North_Selfridges\,interior\,signage$ 103 Pentagram_Canary Wharf signage Pentagram_Canary Wharf signage 104 105 Pentagram _ Croydon signage 106 107 Pentagram _ Croydon signage 108 $Pentagram_Stansted\,Airport\,signage$ 109 Pentagram_Stansted Airport signage Base_PASS 110 $\mathsf{Base}_\mathsf{PASS}$ 111

Farrow Design _ Making the Modern World

Farrow Design _ Making the Modern World

Chapter divider

064

112 113

02 Inhabitable space

03

Information and space

114	Chapter divider
115	Chapter divider
116	Measunng the dataspace _ William Owen
117	Measunng the dataspace _ William Owen
118	Lust_Stad in Vorm
119	Lust_Stad in Vorm
120	Lust_Fietstocht doorVinex-locaties Den Haag
121	Lust_Fietstocht doorVinex-locaties Den Haag
122	Lust_Fietstocht doorVinex-locaties Den Haag
123	Lust_Fietstocht doorVinex-locaties Den Haag
124	Sandra Niedersberg _ London Connections
125	Sandra Niedersberg _ London Connections
126 .	Sandra Niedersberg _ London Connections
127	Sandra Niedersberg _ London Connections
128	Lust_l ³ Map
129	Lust_I ³ Map
130	UNA (London) designers _ Lost and Found exhibit
131	UNA (London) designers _ Lost and Found exhibit
132	Lust_HotelOscarEchoKiloVictorAlphaNovember
133	Lust_HotelOscarEchoKiloVictorAlphaNovember
134	Lust_HotelOscarEchoKiloVictorAlphaNovember
135	Lust_HotelOscarEchoKiloVictorAlphaNovember
136	Damian Jaques _ The MetaMap
137	Damian Jaques _ The MetaMap
138	Lust_kem DH Map
139	Lust_kern DH Map
140	Lust_kern DH Map
141	Lust_kern DH Map
142	Sinutype _ AM7/Die Deutsche Flugsicherung Frankfurst/Langen
143	Sinutype _ AM7/Die Deutsche Flugsicherung Frankfurst/Langen
144	Jeremy Johnson _ Colours
145	Jeremy Johnson _ Colours
146	Hochschule für Gestaltung Schwäbisch Gmünd _ Arbeitssuche im netz
147	Hochschule für Gestaltung Schwäbisch Gmünd _ Arbeitssuche im netz
148	Hochschule für Gestaltung Schwäbisch Gmünd_f.i.n.d.x.
149	Hochschule für Gestaltung Schwäbisch Gmünd_f.i.n.d.x.
150	The Attik_Ford 24.7
151	The Attik_Ford 24.7

Chapter divider 153 Chapter divider 154 I saw a man he wasn't there William Owen I saw a man he wasn't there _ William Owen 156 UNA (Amsterdam/London) designers _ 1999/2000 Diary UNA (Amsterdam/London) designers _ 1999/2000 Diary 157 158 UNA (Amsterdam) designers _ 2001 Diary UNA (Amsterdam) designers _ 2001 Diary 160 UNA (Amsterdam) designers _ 2002 Diary UNA (Amsterdam) designers _ 2002 Diary 162 A.G. Fronzoni _ 365 diary A.G. Fronzoni _ 365 diary 164 Tonne_Calendar52 Tonne Calendar52 Irwin Glusker_Phases of the Moon 2000 166 167 Irwin Glusker_ Phases of the Moon 2000 168 Büro für Gestaltung _ Calendars 1998-2001 Büro für Gestaltung _ Calendars 1998-2001 170 Secondary Modern _ Rokeby Venus 171 Secondary Modern Rokeby Venus 172 NB: Studio _ Knoll Twenty-First Century Classics 173 NB: Studio _ Knoll Twenty-First Century Classics 174 Proctor and Stevenson_Calendar 2001 175 Proctor and Stevenson Calendar 2001 176 Struktur Design _ 1998 Kalendar 177 Struktur Design _ Seven Days 1999 178 Struktur Design _ Perpetual Kalendar 179 Struktur Design _ Twentyfour Hour Clock 180 Attik_NoiseFourscreen saver 181 Attik_NoiseFourscreen saver Spin_Twenty-four Hours 182 183 Spin_Twenty-four Hours 184 Foundation 33 Numerical Time Based Sound Composition 185 Foundation 33 _ Numerical Time Based Sound Composition 186 Cartlidge Levene _ Canal Building 187 Cartlidge Levene _ Canal Building 188 Sagmeister Inc. _Timeline 189 Sagmeister Inc. _Timeline 190 Mark Diaper/Tony Oursler_The Influence Machine 191 Mark Diaper/Tony Oursler_The Influence Machine Damien Jaques/Quim Gil Ceci n'est pas un magazine 192 193 Damien Jaques/Quim Gil_Ceci n'est pas un magazine 194 Nina Naegal and A. Kanna_Time/Emotions Nina Naegal and A. Kanna_Time/Emotions 195 196 Jem Finer_Longplayer 197 Jem Finer_Longplayer 198 Imagination _The Talk Zone 199 Imagination_TheTalkZone 200 Studio Myerscough _ Coexistence exhibition 201 Studio Myerscough Coexistence exhibition MetaUnion _ Deutschbritischamerikanische Freundschaft 202 MetaUnion _ Deutschbritischamerikanische Freundschaft 204 Studio Myerscough _ Web Wizards exhibition graphics 205 Studio Myerscough _ Web Wizards exhibition graphics 206 Chapter divider

Chapter divider

Acknowledgments/credits

207

208

04 Time and space

05 Acknowledgments

00_Introduction

Mapping – An illustrated guide to graphic navigational systems $008/009\,$

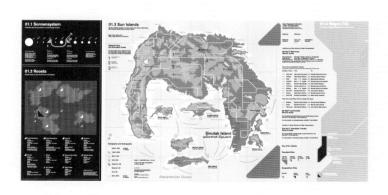

Beyond the horizon

Essay by William Owen 010/011

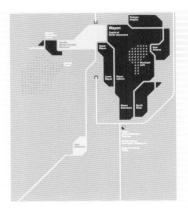

Sinutype AM7/The Sun Years 054/055

What is a map?

Maps inhabit the realm of fact, although not exclusively. They are figurative representations of dimensions, attributes and relations of things in the physical or logical world, reproduced at a scale smaller than life-size (usually, but not exclusively – sometimes their scale is 1:1 or, when mapping the microcosm, larger).

What can be mapped?

Anything can be mapped, and most things are: places, businesses, galaxies, histories, bodies, philosophies, devices and databases. The subject-matter of a map is measured, named and ordered (captured!) by the mapmaker who, armed with carefully verified data and a language of pictorial description, puts everything in its proper place with its proper name as he or she sees it.

Why make maps?

Maps give their makers the power to define the territory in their terms and write a singular vision onto the landscape. Princes, popes and governments have used maps to exert their rights, extend their trade, tax their subjects and know their enemies. Oil magnates use maps to locate and claim the earth. Newspapers use maps to tell stories of war and peace. Social scientists use maps to publicise social problems. A city resident sketches a map to bring a friend from the station by the shortest or most interesting route – the mapmaker decides.

Anything can be mapped, and most things are: places, businesses, galaxies, histories, bodies, philosophies, devices and databases.

Tomato Interactive Sony Vaio interface 074/075

Pentagram Stansted Airport signage 108/109

Why use maps?

Maps give their readers the simple and magical ability to see beyond the horizon. The enlightening and revelatory characteristic of a good map derives from its encompassing vision, contained within a single consistent pictorial model. The map provides a view that slides instantaneously between panorama and detail. A map embodies the work, knowledge and intelligence of others. We obtain a vision of a place that we may never have seen, or divine a previously unseen pattern in things we thought we knew intimately. So, we 'consult' a map as we would an adviser in order to locate, identify and decide, or to be enlightened. As a result we suffer, sometimes, a grand illusion of omnipotence by believing that the map contains everything necessary for understanding or controlling a domain. We forget that the mapmaker has an implicit or explicit agenda of his own, not necessarily aligned w th ours. Maps are imperfect. They have missing layers and gaps within the layers ("London", said its 'biographer' Peter Ackroyd, "is so large, and so diverse, that a thousand different maps or topographies have been drawn up in order to describe it"). Paradoxically, much information can be gathered from the gaps left in maps, not least about the mapmaker's intentions. This is one of the beauties of maps.

Are maps true?

Maps are man-made things and so are neither arbitrary nor pure. They purport to be 'natural' and objective visual representations arising out of scientific observation, and yet the observations are selective and they must be translated and communicated through some graphic form: the scientist (or surveyor) relies on the cartographer's art to illustrate his findings.

What gives maps their power?

Maps are seen by their readers as neutral carriers of information, and thus have the power to persuade without appearing to do so "because the myths they contain are naturalised within a system of "facts'." ¹

This naturalness inhabits the language and conventions of maps, which comprises a value-laden semiological system. Maps contain clear hierarchies that influence how we see the world. For example, Ptolemy chose to orient north at the top of the map, and mapmakers have followed his precedent ever since. There is no good reason for this other than convention, but the effect is to create a hierarchy of the earth and the idea that a particular view is 'correct'. This is just one of a system of signs and therefore of values that constitute cartography. The language of cartography is so ingrained that it has become invisible. We do not question the connection between the blue line on the map and the idea of a 'river', or that roads should be anything other than two black parallel lines (of a width apart that almost never conforms to the actual scale of the map). We see the signifier and signified as equivalents, one deriving naturally out of the other. It is quite natural to us that north should always be at the top, a round world transformed into a flat plane, a particular thematic selection made, a certain scale chosen. The cartographer, therefore, has a heavy responsibility to be frank about his choices and their effect on the use and value of the map.

The language of cartography is so ingrained that it has become invisible. We do not question the cor nection between the blue line on the map and the idea of a 'river', or that roads should be anything other than two black parallel lines.

¹ Denis Wood, 'The Power of Maps', The Guilford Press, New York, 1992.

Beyond the horizon

A MAN SOLD THE SOLD T

UNA (London) designers Lost and Found exhibit 130/131

Essay by William Owen 012/013

How do maps work?

Cartography has an arsenal of iconographic, geometric, linguistic and formal conventions with which to mediate source data into pictorial representation. Maps require geometric translations (of a 3D world onto a 2D plane) or transformations (scaling from 1:1 to 1: n), editorial selections (what is shown, what is ignored), and iconographic representation.

Two systems of signs are used predominantly to define attributes and dimensions: firstly icons, which normally define a general attribute or dimensional range (what order of object is this? a city, of between 50-100,000 inhabitants); and secondly text, to describe specific attributes (what name, who are the owners, how old is it, how big?).

There are four further sign systems – metapatterns that occur repeatedly in maps and which define spatial relations and dimensions: the matrix (also known as the chloropleth), which marks boundaries and divisions, where one area becomes another and what lies next to what; the network, which shows systems of flow, such as drainage, communication, navigation; the point, which marks the position of discrete objects within a space, such as settlements, landmarks or buildings; the nested layer, which reveals continuums of equality, as in contour lines marking equal height or isobars marking equal air pressure. Each of these sign systems exists within the context of a fifth, the axes or coordinates of the map, which frame the absolute relations of one point to another and define the limit of the map (and in extremes the edge of the known world).

How far can we stretch the meaning of 'map'?

The metapatterns – matrix, network, point and nest – are adaptable to an infinite range of non-geographic narratives. Activities that have a relation to physical space, such as social or commercial systems, usually adopt a geographical metaphor and are clearly accepted as maps by Western convention, mechanical, electronic or biological systems, such as the human body or electronic circuits, can be represented topologically or topographically. Mapping can be applied to ideas and information, to logical¹ systems of philosophy, religion, science and taxonomy, and even to allegorical or fictional accounts of social and political relations - Jonathan Swift's map of Gulliver's Travels is surely no less 'real' than Ortelius' atlas of the world, although one is merely mimicking the scientific language of the other. We tend, in Western culture, to restrict our definition of maps to faithfully scaled reproductions of linear spatial relations. Islamic and South Indian art pushes metapatterns much further, to create intuitive topological representations of human or physical relations independent of spatial dimensions. Such constructs are, potentially, a richly-layered, non-linear, multi-perspective communication model for the networked digital society, and they are no less maps.

> 1 Logic in the Hegelian sense, as the fundamental science of thought and its categories including metaphysics or ontology.

Cartography has an arsenal of iconographic, geometric, linguistic and formal conventions with which to mediate source data into pictorial representation.

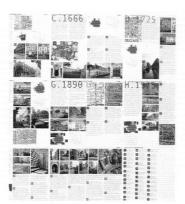

Kern DH map 138/139/140/141

Nina Naegal and A. Kanna Time/Emotions 194/195

Where and when are maps?

Maps and fragments of maps are everywhere at any time. Maps now have no beginning or end, merging with networked devices within other traditionally discrete objects: the map, the key, the guidebook, the wallet, the phone, the camera – all one thing. In-car navigation systems speak your route. Global positioning systems plot your coordinates and altitude. Head-up displays throw the map onto your personal vision of the landscape. Third generation mobile phones know who you are, where you are, what's nearyou, who is near you, even what you want. The phone becomes the map. Digital maps have multiple scales for zooming to capture details, with multiple digital layers for different themes. You choose: transport? drainage? buildings? heritage? Geographical Information Systems define millions of objects as discrete data points each with their own logical address, to which any amount of data can be attached, and so the map merges with the database table and the table is interrogated through the map. Changing the database changes the map so that at last the map keeps pace with the landscape, released from the inertia and inefficiencies of print. The future of maps is to vanish into all of these things, and reappear in everything.

Maps now have no beginning or end, merging with networked devices within other traditionally discrete objects: the map, the key, the guidebook, the wallet, the phone, the camera – all one thing.

01 _ Representation and space

The language of maps 014/015

You are here . . .

Imagination
The Journey Zone
020/021

Essay by William Owen

Inuit hunters carve three-dimensional charts of the coastlines around Greenland and Eastern Canada out of driftwood (and have done for over 300 years). These maps are highly functional and abstracted. The critical datum line provided by the land-sea boundary is represented by the flat edge of the carved wood – the chart is meant to be fingered on a dark night in a kayak out at sea – but the topography of islands and the features around coastal inlets are clearly represented in three dimensions in the curve and bulk of the wood. These maps fit easily in the hand and they are weatherproof and fumbleproof (if they are dropped overboard, they float). They also have no up or down, so orientation or hierarchy is not an issue, and neither are the problems of transformation from the real three-dimensional world to the flat land of maps¹. These carved pieces are masterpieces of design.

Light-aircraft pilots – not a world away from the Inuit in their navigational preoccupations – use two-dimensional aviation charts that represent a bewilderingly complex three-dimensional land, sea and airscape. The design of these charts is in vivid contrast with the Inuit driftwood objects. Like most Western maps, aviation charts are, of course, printed on paper, with three dimensions flattened into two by projection. Linear thematic layers are stratified one atop another and read (not fingered, smelled or tasted) by the eye and the mind of a rational observer who is familiar with a myriad of signs. The family of signs – symbols, icons and indices – that comprise the language of maps, here signifies the perilous reality of civil aviation routes, airport exclusion zones, military airspace, microwave towers, radio navigation beacons and high ground on the landscape.

The aviation chart is an extreme example of the tortuous transformation from three dimensions to two because, in addition to the ground features that provide

relational information, there are many different kinds of volumes of airspace to be negotiated, each with their own permissions, rules and other characteristics. The pilot flies through these or around them: not just over them, but also above, under and between them. In a busy and feature-laden airspace like that around southern England, the problem of spatial orientation and interpretation is acute; a highly refined sign-reading is critical to survival or the retention of one's flying licence. How a pilot must, sometimes, envy the intuitive instrument available to his kayaking counterpart.

The degree to which this chart is abstracted out of the reality of physical land, air and water is astounding - although in part this is merely because the abstraction is so evident. Many of the features indicated on the aviation chart, for example, have no physical reality. An airport exclusion zone is a man-made abstraction designed to control movement where there are no natural physical points of orientation (no traffic lights or curbstones in the sky!) although its existence is no less real in the pilot's mind. The zone is represented on the map by a combination of icons (signing airport and its position), index (boundary lines and coloured hatching indicating the extent and type of the exclusion zone) and symbols (text showing the name and altitude of the zone). This signification of abstract and physical entities applies to all maps to a greater or lesser degree and we have assimilated the language thoroughly into our consciousness. Having seen the name of a city represented on a map at scale, would we expect to see the same name printed in mile-wide text across the ground of the real world? Of course not, but why not? The language of maps that we have grown up with and that seems so natural and realistic has, nonetheless, a coded grammar and vocabulary that would be quite meaningless to an Inuit kayaker of 300 years ago.

The mediation that takes place during the transformation from the most objective survey data to readable map occurs at numerous levels and its result is an entirely subjective narrative.

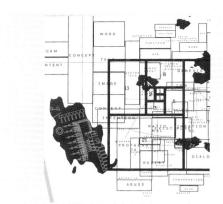

Lust Map 060/061

The mediation that takes place during the transformation from the most objective scientific survey data to readable map occurs at numerous levels and its result is an entirely subjective narrative. The most fundamental of these and the least visible are projection, orientation and scale. Projection gives a point of view, orientation creates a hierarchy, and scale provides an understanding of time and horizon - how far do we need to see and how far are we going. We don't need to be told that a 1:25,000 map is for walkers - anyone travelling faster needs a wider focus and less detail. It is telling that most single sheet maps contain within one view the distance a person can travel in half a day. 1:25,000 is 20-30 km across, being three to four hours walking at 6kph; 1: 50,000 is 40-60 km across, being three hours cycling at 20kph; 1: 300,000 is 150 km across, being three hours motoring at 50kph. A glance at the scale tells us the audience and purpose for the map.

Cartlidge Levene

Christmas card

030/031

The narrative is told by numerous factors that are extrinsic to the map itself. These are things that are not in the picture plane but inform it and establish context: the legend establishes a rhetorical style ('Classical Rome', 'Water: precious resource', 'pathfinder', 'streetwise'); unspoken but implicit themes are revealed by gaps in the mapped layers. (Think of the map of a seaside town that shows beaches but not sewage outfalls – the narrative is one of unsullied leisure without duty of care or acknowledging unpleasant reality.) There is also the utility of the map – why was it made and by whom, which might be revealed by some historical legacy such as the name Ordnance Survey (this map first served a military purpose) or the residue from a bygone age of travelling in the special signs for rural inns and public houses but none for contemporary urban coffee bars.

Other signs are intrinsic to the map itself – its icons and their correspondence to the objects they represent; its language, and how it elaborates on other signs; its tectonic codes and how they shape the space through projection, scale or indices; its temporal codes which are critical to the narrative form (most maps include only those classes of objects which are expected to remain static for a certain period of time – which could be a minute but is more likely to be a decade); its overall presentation, the style and tone of the imagery, which may be soft or loud, high or low contrast, luxurious or functional, whimsical or idealistic.

Browns

062/063

00

An example of the use of style and symbolic presentation in the subtle service of rhetoric is the GeoSphere project cited by Denis Wood2. Described by its publishers, National Geographic, as a 'global portrait' (i.e. photograph) this was a popular image of the earth created from satellite data by artist Tom Van Sant. The map presents itself as a photograph, a true image of the earth. It is nonetheless a map, comprised of indexical signs and therefore no more 'real' or 'natural' than any other map. In his deconstruction of the image, Wood notes that the 'Portrait' is first of all a flat picture of a round planet, with the world stretched and distorted to fit into a rectangle using the Robinson projection. The image is reproduced at scale, and its resolution is no greater than one pixel per square kilometre. The image caters to our perceptions of 'naturalness', its colours are false; there are no clouds visible whatsoever (the image is captioned 'a clear day' - one miraculously so), and – this is the clincher – there is no night: the entire surface of the globe is bathed in sunlight, and this last point is the least obvious to the casual observer when one asks what exactly is 'wrong' with this image.

¹ Victor Papanek, 'The Green Imperative: natural design for the real world', Thames and Hudson, 1995 (cited by George H. Brett, www.deadmedia.org),

²'The Power of Maps', ibid.

Design Project Client Willi Kunz Associates Programme information posters Columbia University

> Columbia University Graduate School of Architecture Planning and Preservation

Master of Science in

and

Architecture

Urban Design

gram

States.
to definition also en York the stituent central

The curriculum is greated toward the emerging ubtains in the United States, with a periodical resignation on the plateation in New York City. Its to define parameters and problems which will carry into the next century, also embracees's special relationship between the design studio and New York. It though collaboration with city agentices and other public interests to attacencies. Comparative study with other world orders is also considered central to the pedagogic critical to Decision of sentential and case studies.

The days a strineded in a sprine traspectory profession transpers and Sector for those which was further increasing the enjoys of appets of tratament. When Design is a general on activity, so could all more than a simgalar regimentation of a physical scale. In their modernia, a common and disposure and all is also so design activity. In this sense, the immore studied or Common above the TeX Cost to Section 4 substance, which we copied a strinedession of the applied of a ministed or patients within and copied as anotherous or the applied of a ministed or patient substance, which were the common and the sense of the sense of the applied of a copied as anotherous or the applied of a ministed or patients which was called a components of correctwork below to comparative to take would do see and estudies. The design studies in the periman stalky for the controllable, contended an alphyl individuality, service applied.

The Clinical University (I shake School of Architecture, Phoning and Presentation is a university and colored from which to our instead using (Idean Despie). The disorgainted, mindescypterary servicy vinuties a way change ground a presence with the estimate of university to surpose. As service and studies leading in restricted by extensive letters and adviscration soon and thind leading to the colored and and adviscration soon ground. The Area Architecture and the Architecture of the Architecture of Inchestory resources in the service site of the Architecture of the Architecture of the Architecture of the New York Chip, as a design are office as in the Architecture of the Archi

ernard Tschumi, Dean

Archard Plunz, Directo

Further information, and applicable Columbia University. Office of Architecture Admission 400 Avery Half. New York, NY 10027 223 864 2814.

Two posters produced for Columbia University. The first poster announces a programme in architecture and urban design at the university. It incorporates a series of black and white images arranged in a stepped formation to suggest the gradual expansion from city to industrial environment. The strong grid lines in the aerial photography have a close relation to the cityscape photograph in the bottom left corner, helping to form a fluid link through the various images. The staggered layout of images is echoed in the thick irregular frame that contains the poster.

The second poster was designed to announce an undergraduate programme in architecture, urban planning, and historic preservation held in New York and Paris. The poster shows simplified maps of the two cities, placing the map of New York's Manhattan within a square which echoes the nature of the street plan, and placing Paris within a circle, again illustrating the more organic nature of that city's street plan. The overlapping of the two maps helps to create a dynamic tension between the two cities.

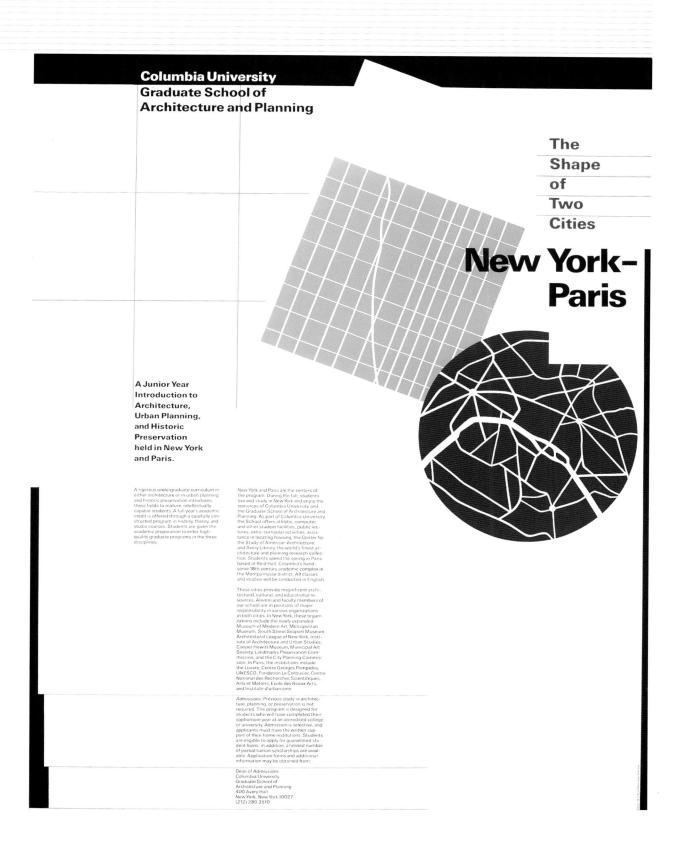

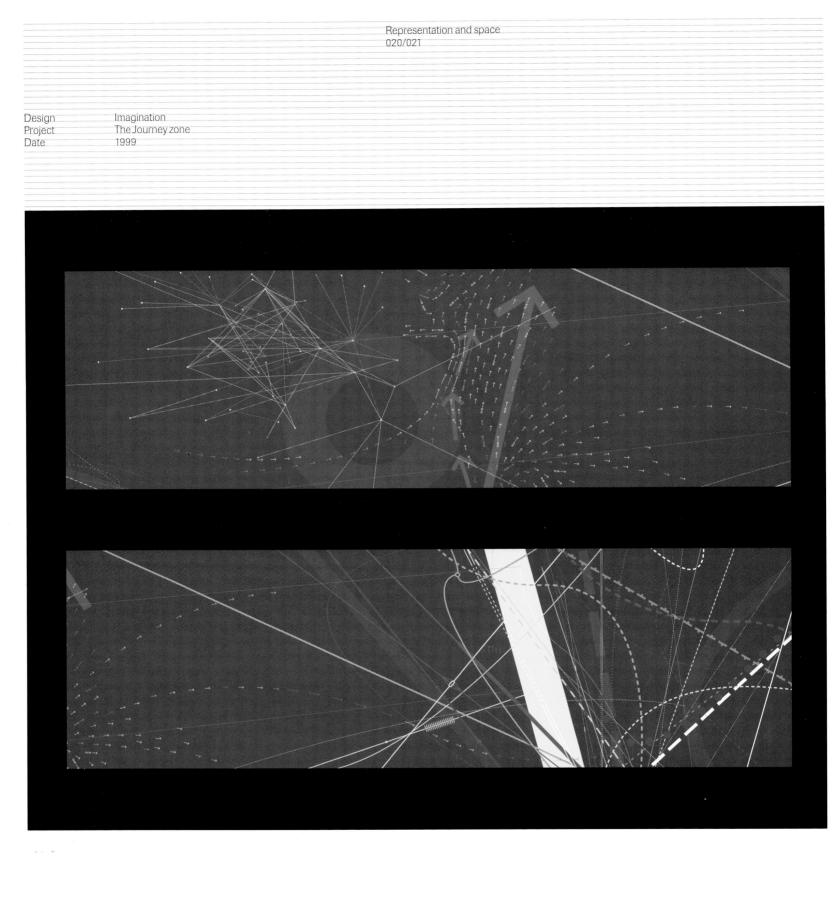

The Journey zone was the exhibition dealing with the subject of transportation at the UK's Millennium Dome, a network of exhibition pavilions designed to mark the new millennium. As the work of the multi-disciplinary design company Imagination, the building's architecture and the exhibition graphic were considered together, and the graphic design works to lead visitors around the exhibition, to create coherence throughout the building and to describe the nature of transportation and movement.

In the sample shown here, each panel graphically represents a different mode of travel/transport. By using and adapting the existing graphic language for each one, the viewer, with a little vision, can recognise the mode of transport being illustrated: motorways, flight

paths, rail routes, footpaths and bridleways, and so on. Individually these graphic elements do not convey any precise information – they are purely stylistic illustrations derived from the language of mapping which, if nothing else, illustrate to the viewer the myriad ways that movement can be expressed using simple lines and arrows – but together they provide an innovative form of signage leading the visitor around a complex walk-though exhibition.

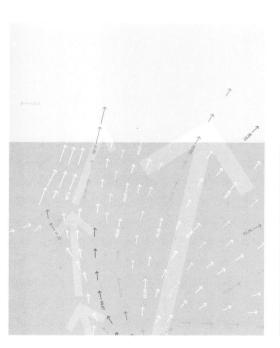

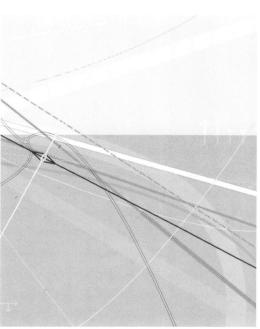

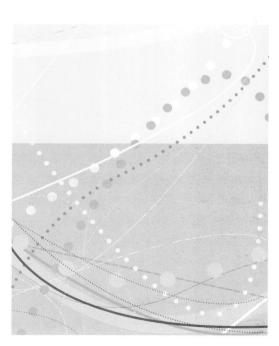

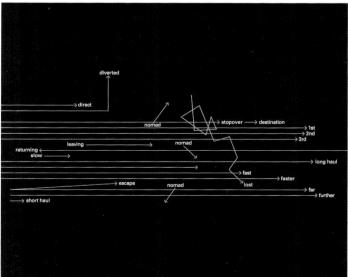

Representation and space 022/023 Design Project Date The Kitchen USR Records' house bags 2001

The language of mapping is appropriated for the sake of consistency in the output of record label USR, designed by The Kitchen. The design uses the graphic language of the underground/subway map, enlarging a small section of overlaying, interconnecting coloured lines. The backs of each sleeve form part of a larger map which has the potential to continue growing as more records are released. The fronts of the sleeves remain consistent to help consumer awareness and build instant recognition in the record store. The track listing, which appears on the back covers, again echoes the subway map, as each track appears like a stop on the line complete with a circular interchange point.

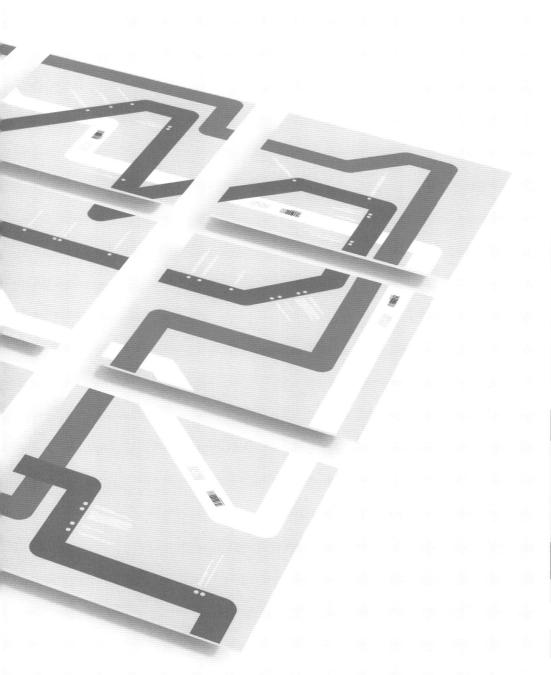

Representation and space 024/025

Design Project Date

Base MoMAQNS identity/signage 2000

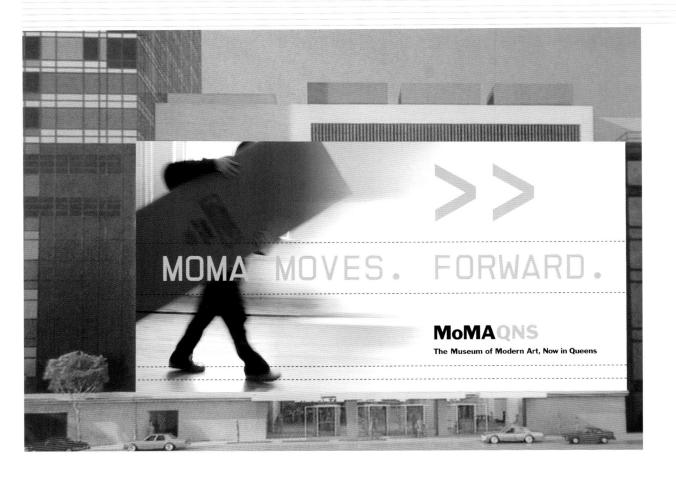

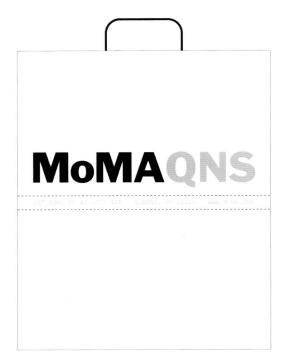

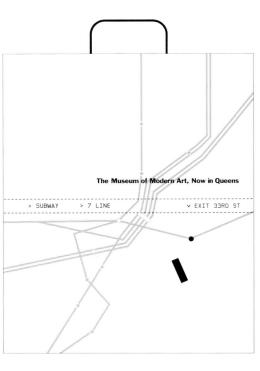

Designed by Base, an international design consultancy with offices in Belgium, New York and Barcelona, this visual identity for a new gallery of the Museum of Modern Art in New York used the New York subway map as an integral part of the identity. The gallery, which is located in Queens, off the standard gallery/museum circuit of Manhattan, represented a departure for MoMA, as its home is firmly fixed off 5th Avenue. The logo itself is in keeping with MoMA's existing identity, but with the addition of the letters QNS – an abbreviation of Queens in the style of airport name abbreviations (London Heathrow: LHR). Fragments of the New York subway map, stylised in accordance with identity guidelines, were then utilised in different applications ranging from carrier bags to vehicle

liveries, bringing home the message to New Yorkers that while the new Gallery is a part of MoMA, they will have to look in a new area to find it.

MoMAQNS

>> NOW >> N

>> MOMA MOVES. FORWARD. >> MOMA MOVES.

MANHATTAN >> QUEENS M

MANHATTAN >> QUEE

MOMA MOVES. FORWARD.

>> MOMA MOVES. FORWARD. >> MOMA MOVES. FORWARD. >>

MANHATTAN >> QUEENS MA

MANHATTAN >> QUEENS

MANHATTAN >> QUEENS

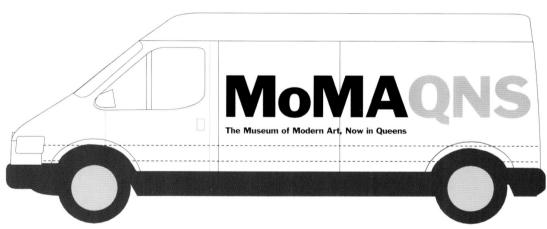

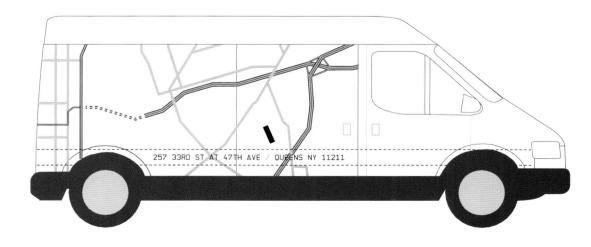

Representation and space 026/027

Artist Title Dimensions Date Simon Patterson 'J.P.233 in C.S.O. Blue' Variable 1992

Photography Image courtesy Matthias Hermann The Lisson Gallery, London Artist Title Dimensions

Simon Patterson 'The Great Bear' 1092 x 1346mm

Date
Copyright
Photography
Image courtesy 1992 Simon Patterson and London Regional Transport John Riddy The Lisson Gallery, London

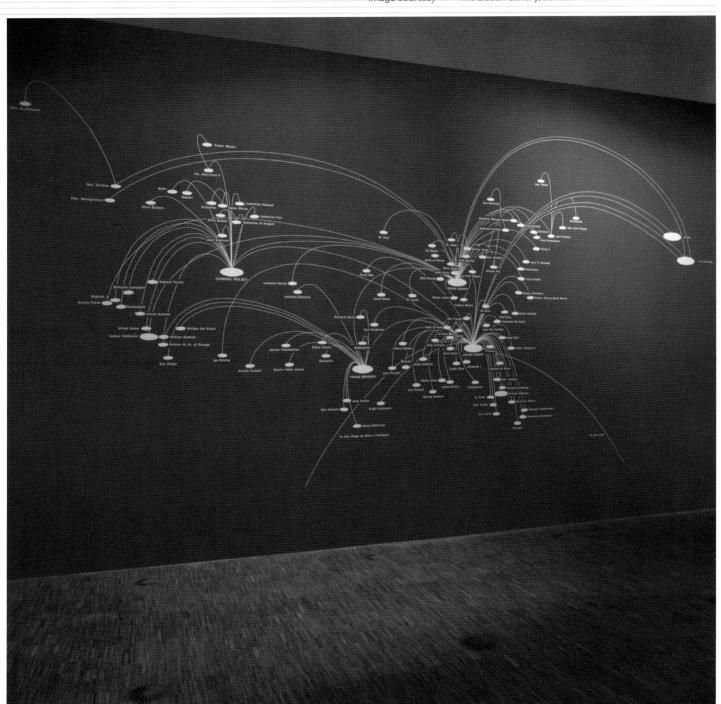

The artist Simon Patterson, a finalist for the Turner Prize, the UK's leading award for modern art, has worked extensively with the process of reinterpreting existing information systems. Shown here are two works by the artist which utilise maps and navigation/information systems.

'J.P.233 in C.S.O. Blue' is a large wall drawing which takes as its reference a global airline route map, using large sweeping arcs to represent the journeys between countries, which are implied by their relative positions rather than a delineation of boundaries. The destination names are replaced with seemingly unrelated famous people, from Julius Caesar, Elizabeth I, Pope John-Paul II and Mussolini to actors William Shatner, Helen Mirren, Leonard Nimoy and Peter Falk.

In 'The Great Bear', Patterson begins with a very famous reference point, the map of the London Underground, possibly the best-known and most copied subway map, which was itself first developed by Henry Beck in the 1930s. The London Underground map is most notable for the way it distorts and simplifies the physical spaces it represents, in order to provide the most effective presentation of the relationships between lines and stations, and aid the viewer with planning journeys on which there are few visible landmarks. In 'The Great Bear', Patterson remains faithful to the original London Underground map, but replaces all station names with a variety of famous names. Each line on the network plays host to a particular category of famous people – the Circle

line stations take on the names of philosophers, for example, while the Northern line becomes a list of film actors. This replacement of names disorients the viewer: at first glance the map looks familiar – until, that is, one tries to find a particular tube stop, then it becomes increasingly difficult, because all the points of reference have been changed.

The Great Bear

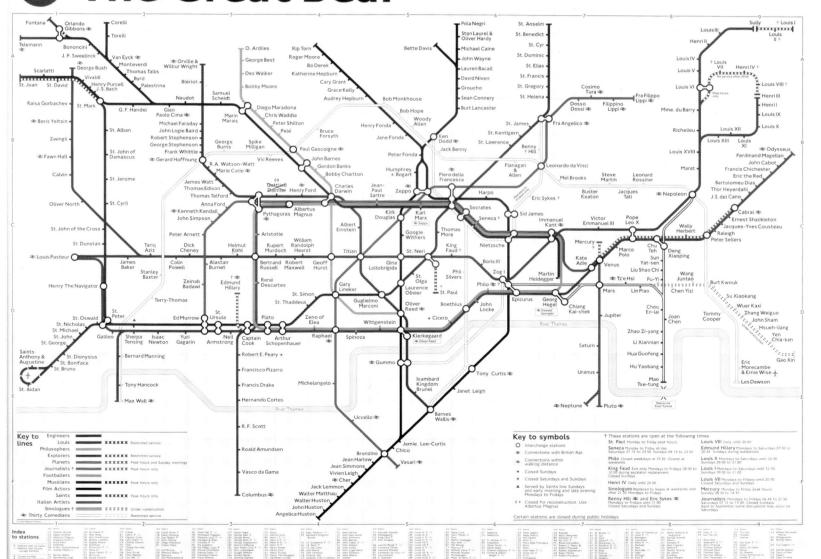

Representation and space 028/029

Artist Title Simon Patterson 'Untitled: 24 hrs'

Date 199

Image courtesy

1996 The Lisson Gallery, London Artist

Simon Patterson 'Rhodes Reason'

Title Date

Image courtesy

19

1995

The Lisson Gallery, London

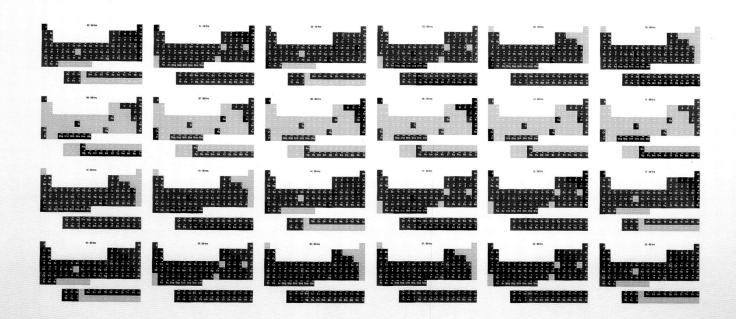

AP VI /X

Sina Part 1996

Two further works by the artist Simon Patterson both refer to the Periodic Table, pinned up on the wall of every school chemistry lab. This typographic work of beauty is frequently plagiarised by other graphic designers, but here it is taken to a higher level. 'Untitled: 24 hrs' reproduces the table 24 times. Each table is printed in four colours; the first row of tables are predominantly blue, the second row yellow, then red and finally black. The colours refer to a property of each substance: Black = Solid, Red = Gas, Blue = Liquid and Yellow = Synthetically Prepared. The same colour palette is also used in 'Rhodes Reason', which again features the odd film star, for example Kim Novak (Na 11) is Sodium, while Telly Savalas (As 33) is Arsenic. Rhodes Reason was also published as a book called Rex Reason.

Rhodes Reason

1 IA																	18
IA																	VIII
1							8 IIIA										7
Н	2						VIII G	roup Classification	ons 1			13	14	15	16	17	He
Hyperion	IIA IIA						26 A	tomic Number				IIIA	IVB	VB VA	VIB	VIIA	
3	4						Fe s	ymbol ²				5	6	7	8		Helios 1 (
Li	Ве					Fred Mac		ame				В	C	N	0	F	Ne
Sela Lugosi	Ingrid Bergman											Ingmar Bergman	Capucine	Niobe	Orpheus	Flore	Normus
11	12											13	14	15	16	17	18
Na Kim Novak	Mg	3 IIIA IIIB	4 IVA IVB	5 VA VB	6 VIA VIB	7 VIIA VIIB	8	9 VIIIA VIII	10	11 IB IB	12 IIB IIB	Al	Si	Р	S		Α
19	20	21	22	23	24	25	26	27	28	29	30	Alec McCowen	Stemone Signoret	Patrick MacNee	Steve McQueen	Cybele 35	Arladne 36
K	Ca	Sc	Ti	٧	Cr	Mn	Fe	Co	Ni	Cu	Zn	Ga	_				K
Brace Kelly	Claudia Cardinale	Sean Connery	Yoko Tani	Josef Von Sternberg	Conrad Veldt	F.W. Murnau	Fred MacMurray	Federico Fellini	Tatauya Nakadal	Tony Curtis	Fred Zinnemenn	Ghirlandaio	George Eastman	Telly Seveles	Poter Sellers	Bronzino	Kronos
37	38	39		41	42	43		45	46	47	48	49		51	52	53	54
Rb	Sr.	Y Lorette Young	Zr	Nb	Мо	To	Ru	Rh	Pd	Ag	Cd	In	Sn	Sb	Те		Xe
55	56	57	72	73	74	75		77	78	79	80	Rex Ingram 81	Susan Sarandon	Sarah Bernhardt	Tex Ritter 84	Kon Ichikawa 85	Xanthippe 86
Cs	Ва	La	Hf	Ta	W	Re	Os	Ir	Pt	Au	Hg	TI	Pb	Bi	Po	At	Rr
Cesare da Sesto	Bibl Andersson	Lens Turner	Henry Fonda	Elizabeth Taylor	Billy Wilder	Rex Resson	Rhodes Reason	Ub Iwerks	Rip Torn	Audrey Hepburn	Hugo van der Goes	Robert Taylor	Peter Bogdanovich	Juliette Binoche	Roman Polanski	Andrei Tarkovsky	Rhianus
87	88	89	104	105	106	107	108	109	1/	SMGP now reco	mmends the nume	rical classification	system given in t	the top	2/ Element sy	ymbol is colour-coo	ded as follows:
Fr	Ra	Ac	Unq	Unp	Unh	Uns	Uno	Une		row, however, some authorities prefer classification schemes that use A/D subgroup designations. Caution. A/B subgroup designations vary depending on the classification system used. ### Comparison of the classification system used.							
ra Filippo Lippi	Viulenno Romance	Anielles bivator	Unnilouadiam	Uncitpentium	Uanliberium	Unplisentlum	Unniloctium	Unnitenium		dehending on t	ne classification	system dsed.					

	58	59	60	61	62	63	64	65	66	67	68	69	70	71	
Lanthanide Series	Ce	Pr	Nd	Pm	Sm	Eu	Gd	Tb	Dy	Но	Er	Tm	Yb	Lu	
	Lon Chaney	Dita Parlo	David Niven	Promethium	Spanky McFarland	Edward Underdown	Paulette Goddard	Theda Bara	Walt Disney	John Huston	Emmanuele Rive	Toshiro Mifune	Yul Brynner	A & L Lumière	
	90	91	92	93	94	95	96	97	98	99	100	101	102	103	
Actinide Series =	Th	Pa	U	Np	Pu	Am	Cm	Bk	Cf	Es	Fm	Md	No	Lr	
	Terry-Thomas	Peggy Ashcroft	Peter Ustinov	Neptunium	Plutonium	Americium	Curium	Berkellum	Californium	Einsteinium	Fermlum	Mendelevium	Nobellum	Lawrencium	

Design Project Date Cartlidge Levene Christmas cards 1995/1997/1998/1999

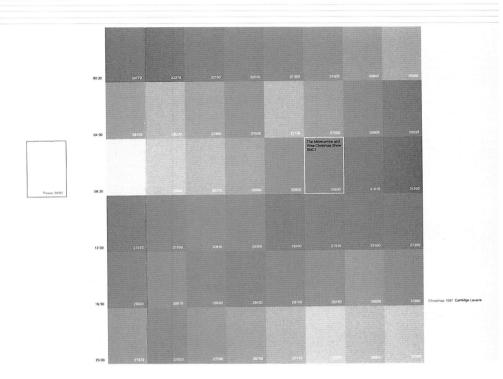

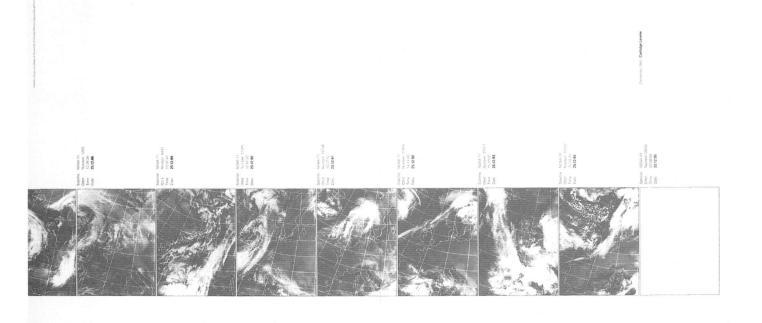

Each year the London-based graphic design consultancy Cartlidge Levene produces a Christmas card which pushes the connection to the festive period to its limits. As well as tidings of joy, the designers have often incorporated elements of mapping and location-finding in the cards. For Christmas 1995, the company used a collection of satellite images taken over its studio, one from each year since the company was founded, giving a snap-shot of the weather conditions on Christmas day throughout the period of the

company's existence. For Christmas 1998, the card listed every area post code to which it would be sent. The A6 card was concertina-folded with the list running down the left edge. Each card was personalised to the recipient by the addition of a small hole punched next to their post code. The card designed for Christmas 1999 featured the addresses at which each individual at Cartlidge Levene had spent Christmas since their birth, thereby mapping a geographical Christmas history for the company's staff.

Representation and space 032/033

Design

Fibre

Project Pages from Cre@teOnline

Date 2001

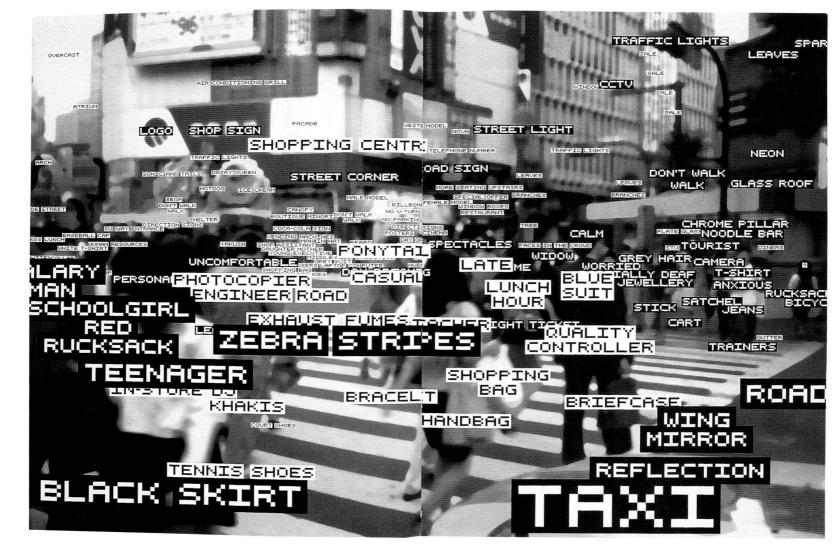

Commissioned by the digital media magazine Cre@teOnline to produce illustrations for a special issue about navigation, the London-based design consultancy Fibre produced two double-page spreads. The images taken in a busy street in Tokyo are blurred out, to the point where all details are lost. The images are then recoded with word byte captions printed in black and white in a bitmapped screen font. The captions identify every detail held on the page even down to a slightly buckled wheel on a sit-up-and-beg bicycle. The process of abstraction and re-translation turns a shot of reality into a computer game simulation, with multiple options.

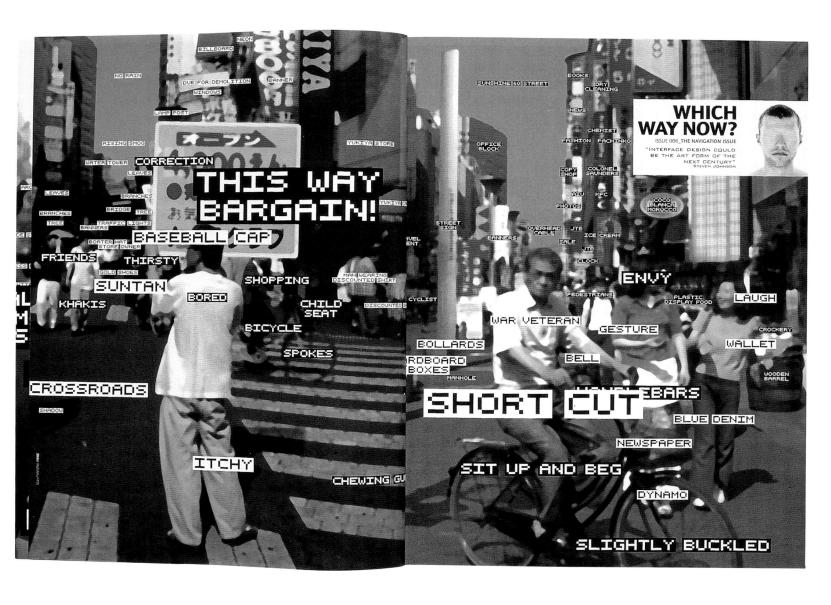

Representation and space 034/035

Design Project Date John Crawford Parc de la Villette, typographic project

Produced as a loose leaf book or album of pages, this project by graphic designer John Crawford deconstructs an architectural grid system used in Parc de la Villette, the group of Parisian follies designed by the architect Bernard Tschumi, who wrote: "La Villette moves towards interpretative infinity, for the effect of refusing fixity is not insignificance, but semantic plurality. The park's three autonomous and superimposed systems and the endless combinatory possibilities of the follies gives way to a multiplicity of impressions. Each observer will project his own interpretation, resulting in an account that will again be interpreted."

John Crawford began to create typographic fragments or follies and placed these within the framework of the abstracted grid of the park. Each page is pierced by a 47-mm square hole, so when the pages are stacked one-on-top of another, a third dimension is created, allowing an interplay between the surfaces, revealing further fragments of typography and grid work.

Representation and space 036/037

Design Project Date

Cartlidge Levene Eye magazine advertising

gepe 20 slide mounts barnett newman postcard layout layout layout layout c trace 90 ntn bearings telephone sony slv 474 operating instructions sony acv 3u operating instructions sony video cable morisawa type manual 3 graphic design in japan 90 magnets air france ticket wallet layout layout layout cassette selected poems charles bukowski hot water music charles bukowski m180 chisel point marker cheque book wallet mug vhs video black pilot razor point II vhs video black pilot razor point II petty cash vouchers design museum issue 5 keys receipt wallet receipt isle of wight rock telephone receipt paper clip 1989 2 pence piece paper clip receipt receipt black pilot razor point II rolodex paper black pilot razor point II taxi receipt clip rexel matador II stapler hotel du tribunal reciept post it pad 4h pencil receipt swann morton bs 2982 ner invoice copy ncr invoice copy receipt receipt ncr invoice copy guidex foolscap file 3ff11 ncr invoice copy guidex foolscap file 3ff11 ncr invoice copy settegiorni 1991rec guidex foolscap file 3ff11 ncr invoice copy 3 scalpel blades guidex foolscap file 3ff11 ncr invoice copy guidex foolscap file 3ff11 ncr invoice copy guidex foolscap file 3ff11 ncr invoice copy ncr invoice copy guidex foolscap file 3ff11 guidex foolscap file 3ff11 bromide bromide guidex foolscap file 3ff11 bromide estates gazette eye magazine no 1 bromide proof correspondence telephone dutch art + architecture today daler 3406 blue pilot razor point II touraine amboise 1989 japanese pan scrub calculator sl807 guidex foolscap file 3ff11 black pilot razor point II spectacles case tdk spectacles vhs video (lawrence of arabia) tacsimile facsimile facsimile unique adjustable triangle 20cb flip file facsimile settegiorni 1991 bromide ww39191

In the early days of Eye, the international review of graphic design, the London-based consultancy Cartlidge Levene designed self-promotional advertisements for issues two and four. Neither directly 'sells' the company, or even offers much direction as to what is being advertised. The 'red' ad forms a typographic map of Cartlidge Levene's studio at a given moment in time. The ad is composed of the contents of the desks of every designer in the company (who are identified only by their initials). The contents of the desks are given in words, which are repeated to signify multiples of the same object. The words are arranged on the sheet to

reflect the actual position of the objects on the desk. The result is a clear picture of the state of each designer's desk, ranging from busy clutter to the austere minimalism of a single Black Pilot Razor Point II pen. Interestingly there appears to be a total absence of any computer equipment, a reflection of the times perhaps.

The second ad was produced as a collaboration with 4th Floor, a firm of hairstylists, who work on the floor above the Cartlidge Levene studio. The design maps out aerial close-up photographs of the various hairdressers' heads, working them into a gridded matrix.

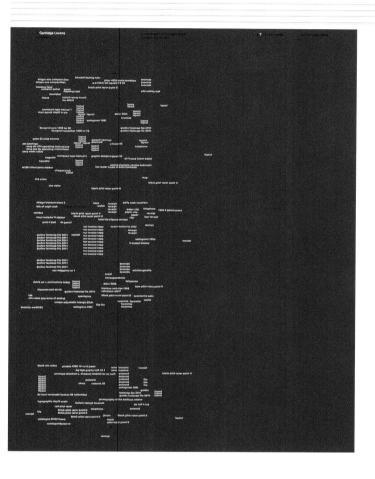

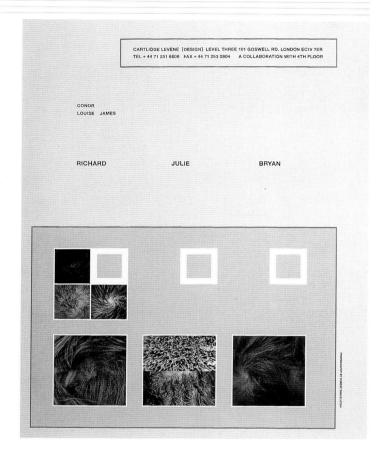

Representation and space
038/039

Design The Kitchen
Project Studio floorplan
Date 2000

This floorplan of the studio occupied by London-based design consultancy The Kitchen works as a graphic snapshot of the space at one moment in time. Each item within the space has been carefully itemised and catalogued, and the map visually represents their locations within the studio. While the shapes of the objects are abstracted, a complex coding system is used, where each item is assessed and allocated a unique colour which is derived from the colour used most prominently in the

object. The positions of the objects are further referenced – or cross-referenced – through a list of co-ordinates. The map of the studio contains none of the features one might expect to find in an interior plan – no suggestion of walls, windows, doors and so on – but the physical shape, business and working patterns of the studio are revealed by the relative densities and positions of the objects found in different parts of the map.

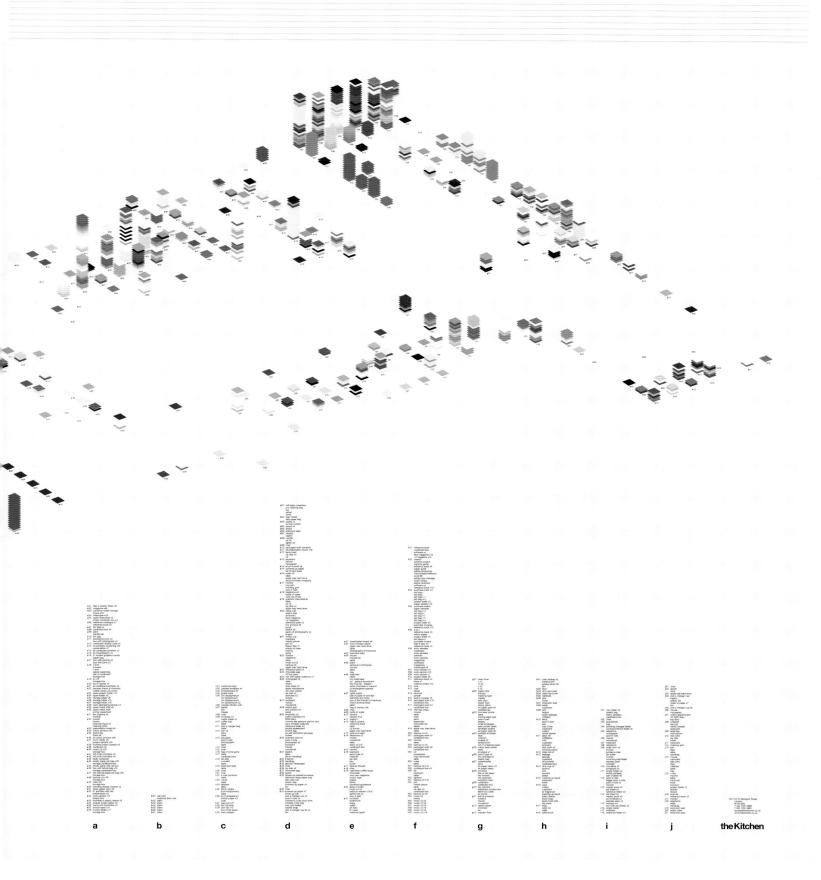

Representation and space 040/041

Design Project Date

Jeremy Johnson

A visual record of the entire contents of a typecase 2001

1411944544 Necastilipida provinciano programa.
141194454 Necessaria provinciano programa.
141194 Necessaria provinciano programa.
141194 Necessaria provinciano programa.
141194 Necessaria provinciano programa.
141194 Necessaria provinciano programa.
141194454 Necessaria programa.
14119445 Necessaria programa.
14119445 Necessaria programa.
14119445 Necessaria programa.
1411944 Necessaria programa.
141194 Neces

The Section of Contract of Con

| Administration | Proceedings | Proceedings

| Management | Man

Produced as a visual record of the entire contents of a type case at the Royal College of Art, London, over an 18-month period, this set of 12 425 x 1000-mm sheets was designed by Jeremy Johnson. The typographic inventories form clear maps showing the location of each character within the case and the quantity of each character. The work also highlights occasional mistakes on the part of those using the typecase, as the odd rogue letter crops up in the wrong location.

The first sheet acts as a 'road map' of the type case, showing all the streets, avenues and back alleys of the structure. The case is printed in silver, with

each character location denoted by a single black character. The following sheets show a variety of fonts from Helvetica Light 12pt to Grotesque No. 9 in 60pt. One sheet, which is dedicated to 'miscellaneous stock blocks', shows an eclectic mix of logos, illustrations and dingbats. Another page shows all six font sheets overprinted: Helvetica Light, Gill Sans Italic, Baskerville Roman, Fashion Script, Grotesque No. 9 and Joanna Roman are overlaid to create a dense cityscape of the collection. Finally, a set of three pages shows the reverse side of the three formes used on the job, which represent the complex infrastructure of the work.

sea of fife will be eccept 2, 2, 8, 5 B 111 222 333 44 555 60 7 **e**eee && blas ccccc dddp Hillilli sssss fif 888 699 1 00000 £ 6\$\$ ŒŒ Æ77 && 60 ddpdp AAA BARA GO, BDD Eccess FFF GGO Hillie gg weeke fikk kk ing man nang labih 000000 NY# pp# ;;;;; HH# III W KK LASH MM NN. GOO mmm nnnu h WZ 000 MM 00 nn 06 RRESSS TOOC VV 222 www nnuuu thitt aaara rerir go a9aaa. rrrr XX XXIII ZZZ Zaa UH# 4U3 a XXZ

Design Project Date John Crawford Open Week poster 1994

Briangl Temple Southampton

A16
ferry
A20
A259
A27
M22
M22
M22
Brugge =
Cales =
---Dover =
Londor Victoria >
Londor Waterlog =

Caen
A13
A15
A15
Caen >
Bowen =
Le Hoven >

Cambridge
411
M25
M3
M3
M27
Cambridge a
Lombor Exemptod St. a
Lombor Exemptod St. a

M4 M5 A36 M27 Turn Cardiff Central A Southampton

lisle

Coventry -Southerroton

Crosskeys

A467

M4

A46

A36

Don

Newport >
Cand/ff Central >

Darmstadt

Derby

A6

M1

A43

M40

A40

A34

M3

M27

Dewsbury

A644

A62

A644

A63

M10

M10

M40

A40

A40

A40

A40

Machaeser Picabing
Seuthampton

Donscary Munchesser Plaudily Southempton

Doncaster

Mis
ALI
Mis
ALI
ALI
ALI

AUI
M40
A40
A34
M3
M27
Sourcaster =
London Kings Cross =
London Kings Cross =
Southampton

Dover

peom > Southempton

A303 A36 A31 M27 Exeter > Salistoury > Southempton

Eastbourne
24 mari
A22
A259
A27
M27
M27
Eastbourne =
Brightourne =
Brightourne =
Southampton

Falmouth
A30
A38
A35
A31
M27
Is all
Eatmouth a
Civeter a

A35
A31
M27
Falmouth >
Eveter >
Southampton

A323 A31 A33 Famborough = Woking > Southampton

Farnham

Southampton

Folkestone
A299
A279
A27
M27
Folkestone = London Canon street > London Waterloo = Seuthampton

endurg a endurg a risk a Havre a

Harrogate

Harrogate

Aum
Aum
M1
Aum
M3
Aum
M4
Aum

Lancaster
symmi
M6
M5
A36
A37
Insurant
Lancaster
Southampton

AS3 M6 A36 A27 Southan

M6
M5
A36
Invariant
Lurgan a
Bediast Central a
Bediast York Road a
Larne a
Stranger aGlasiona Central a

Luton
M1
M25
M3
A33
M3
Luton > Luton > London Kings Cross >

A33
Luton =
Lundon Kings Cross >
London Kings Cross >
London Waterloo =
Southampton

Office Of

Maidstone

stone »
os Victoria »
on Waterloo »
hampton

A40 A34 M3 M27 Northampton > London Euston London Wabiris Southampton

Norwich

A11
A11
M11
M25
M3
M27
Is not
London Liverp

Noraich a London Liverpi London Waterl Southampton

Nottingha
b name
A52
M1
A43

Nottingha

Notal
A02
M1
A43
M40
A40
A31
M27
Notfingham a
Lundon Krerp
London Waterl
London Waterl

A6
A6
A1
14
15
5
5
6
Offenbach > Frankfurt Le Havre +
6
Southampton

Oldham

A227

M67

M66

M66

M66

M5

A36

A37

Subham ×

Manchester Pr

Southampton

Oxford
A34
M3
M2
Oxford >
Southampton

Paris

The intention behind this large format poster (1185 x 820mm), produced as a promotional mailer and private view invitation for a degree show at Southampton Institute of Higher Education, was to show how easy it is to get to the college from any location in the United Kingdom and Northern Europe. Each alphabetically listed location is accompanied by a set of different modes of transport; road, rail and ferry (where appropriate), and each subhead is followed by a basic list of motorways, A-roads and rail connections.

Aberdeen now All Ass ass ass ass ass Ass Ass	Belfest tree AA AA AV eve below belo	Braintree A181 A181 A181 A180 A180 M3 A30 M3 A31 Continue Companied St. a. Continue Companied St. a. Continue Companied St. a. Continue Companied St. a.	Colchester house A12 A05 A05 A08 A08 A08 A08 A08 A08 A08 A08 A09 A08	Epping more MYI MYR	The Hegue Vices A13 A15 A16 A1 S10 P1 15 15	Kendal Ma Ma Mb Mb AM Mb Mc	London to run to tendor therefore a feathermater Lonwestoft	Manuscript A company of the company	Activation of the control of the con	Stafford Note: 100 100 100 100 100 100 100 100 100 10	Wolcell to lead to
Aberystwyth	Switzer / Georges Cohen - Standarden - Stand	Brighton All Mill Brighton - Sombanguan	Cowntry Ang Medi ANI ANI Committee Committee	Episoni NS VI ANI NOT	First 14 Month of Text	Kettering Act Mal Add Add Add Add Add Add Add Add Add Ad	A 12 MgS Mg A 32 Mg Mg A 32 Mg Mg A 32 Mg Mg A 32 Mg	Morthampton Morthampton Asi Asi Asi	Religate 1979 193 193 194 194 194 194 194 194 194 194 194 194	Stoke In Test Stoke	Warnick Trea ASI Mg ASI Mg ASI Emergines has St + Emergines has St +
American American American American Anti-	A6 A8 A16 A15 A15 Beller p Felice Le Fierre Southangen	Bristal A JR AJR MJ / Service Energies Weeks a Sendengerien	Crosskeys Arr Ma AM AM	Exetor AND AN AN AN	Na Na Na Namburg e Persa - Le Physics - Ne Section of the Section	London River Cities on London Millerine on Southwestern Kilddermin star Assr No. Also	Carpan A3 A4 A6 A36 A36 A96 A96 A96 A98	M3 M27 No Thirthingson or Sendon Summ or Sendon Summor Send	Rochdele Mil Mil Mil Mil Mil Mil Mil	Steurbridge ** **** **** *** *** *** **	Watford In our Mys Wa In our Flushoot Sonder Control Sonder Contro
99 A32 A32 Amelian - Amelian - Sauthengton Amelianian	Bielefeld All All All All All All All All All	Brugge Ass Are Appl Appl Appl Appl Appl Appl Appl	Control of	Eastbourna 10-10 207 200 207 200 207	Harrogete Anti- Alian Mill Mill Anti- Anti	A221 ** ** *Cutaconisister / Landini Kruga Dises / Landini Kruga Dises / Euroten Warning - * ** ** ** ** ** ** ** ** ** ** ** **	Larger's Souther Country is Souther Country is Souther Country is Southern to Southern to Stranger in Stranger in Southern Country is Southern Sout	Add	Manhane Possily - Sechanges Rotherhers	Stratford A332 A301 A301 A301 A301	Wigan My An
AZY	Berefert - Franklit - Fail - La Hone - ins Southengelen	Briggs = Cares = No. Sec. Sec. Sec. Sec. Sec. Sec. Sec. Sec	14 19 10 10 10 10 10 10 10 10 10 10 10 10 10	(arbinated a throphic a touchare tun Falmout to	to require a garden service and	A No. Maria	Larters 401 AUS AUS AUS Lorters Lorder Norga Cross J Lorder W enforce s Sentence s	Nottingham All All All All All All All A	M42 A34 M21 M22 M34 M34 M44 M44 M44 M44 M44 M44 M44 M44	Countries Security Se	Wigger = Manchester Fraudity = Sanchester Sanchester Wilnehester 143 142
Arnham	An An An A	ASI	Derby A6 91 46 48 48 A8 A80 A90 007	AND	METT MCCS MCS MCS MCS MCS MCS MCS MCS MCS MC	Lancaster 586 695 A38 527 5 coupler - Southerspin	Lyon A4 A44 A45 Ans	Noticephan : Linchin (Junjaco Se : Linchin (Roven A15 A15 September (September) September (September) September(September)	And	Weston-S-Mare Apr Apr Apr
NUMBER AND	Sinte - Suntainantes Birmingham	Cambridge With W	Derits - Southwepton Dewastisory 444 547 644 547	Fernbarough A33 A3 A45 A45 A46 Fencough - World's Bootherepton	Piterow 505 60 A3 A34 Hansily a London Marylebone Seneta World no a Seneta galan	Leeh Ad Ad Ad Ad Ad	From A France A Franc	Ontology Ont	Rogby A327 697 445 6460 A396 643	London Warning Community C	Washing Share a Brown Sengre Wester a Beathampton
Ashington Ashington All All All All All	Everytee has to - Sectionalist Blacktown	Conterbury A2 A2 A3 A3 A3 A3	U.S. 141 140 140 144 151 1maximir -	Farnhows A31 V3 A32 A32 Farnham Southersten	Heartings A207 A207 A207 A207 Mag 2 Medicips - Socyaton -	Sandangdd Leads 51 45 46 40 A3	ART	Oldham Azz	Lestine Array Crise is promote Withouther is Sautheringsee Salford 66 69 405	Swanera Swanera Swanera	AGE
Maria	And State St	Certesburgs (certesburgs) (certesburgs) (certesburgs) (certesburgs) (certesburgs) (certesburgs)	Descassor One One Asi One Asi Asi Asi Asi Asi Asi	Follostone A270 A27 A27 A27 A27 A27 A28 A28 A28 A38 A38 A38 A38 A38 A38 A38 A38 A38 A3	Merufacel A19 A49 A55 A55 A55 A55 A55 A55 A55 A55 A55 A5	Laicester	Maida Lone 429 429 421 421 Mathematical States of Control of	US NATIONAL PROBLEM S SINGLE STATE OF S	627 Saferia - Saferia - Machinero Victoria - Machinero Victoria - Machinero Michilly - Sastietoury Satietoury	Mail Sources of Carlot	Waterford No. Aug
Ayleshury A413 A412 A424 A43 A43 A43 A43 A43 A43 A	Blackpowl MAI ANI ANI ANI Blackpowle s Full for the state of the	As A	Consistence of Landon Crise Consistence of Landon Schemen of Southernation	Frankfurt A5 A6 A6 14	Hereford - Hereford - Hereford - Hereford - Hereford - Hereford - A51	443 A49 A49 A43 A43 A43 A43 A43 A44 A44 A44 A44 A44	Medial	AN AN Mg Mg Columb Esustangum	Scarborough	A 300	to a Waterford - Resident Shrend - Riches Hallpoor a to Shallpoord a Carter Certific a Bauthampitos
Aprilatory v Marylatoma v Warshine v Shushampton	Berdeaux AN 19 19 19 19 19 19 20 AN	Op MS A35 A22 Carfely , Sauthergran	A2T A2T A2T Green v Landau Vertilar a Landau Vertilar a Landau Vertilar a Landau Vertilar a Sauthenglann	Facilities - Frank La Moure - La	A15 M3 A3 In or Medical a Common Graph Common Graph Common Graph Common Graph Common a Graph Com	La Havra	AS AS MANUA Fina La Hanne y Sawherenten	Forth Street Str	A1 A1m 614 49 A2 560 A5 A5 A5 A5 A5 A5 A5 A5 A5 A5 A5 A5 A5	Tolford 7014 M6 M6 M7 M7 M7 M7 M7 M7 M7 M7	Worcester A45 A65 A65 A66 A67 A67 A67 Worcester + Calcut > Section page on the calcut of the calcu
AS MS MS ASP MS	Section	Carmerthen Ass Ass Ass Ass Ass Ass Ass Ass Carmerhan Control Carmer Sommanden	Durblin Special Special MS MS MS Abi Special Spec	And	Huddersfield AC AC AC AN AN AN Man Machanists Machanists Machanists Machanists Machanists	Limerick NOT NOT AND AND AND AND AND AND Emerick a	Manchester Alle Alle Manchester Printly - Southwarpton	Perth to sell the sel	For a handre Kregs, Cross v Landers Kregs, Cross v Landers Markelin v September 1997 (1997) Sheffield MI AZ	Southerpus Sur St = Southerpus	Wolverhampton ses Apr Apr Ses Sundantarytins Saudantarytins
Animamban and animamban an	Residence Free Comments Free Comme	Services Carticles C	Creations	Familiarion Famil	Phofis Phofis	Nation Street 1 Nation Street 2 Nation Street	Monsfield		Mail All All All All All All All All All A	Francisco Services Francisco Services Francisco Fr	Westerd State of Stat
Barnaley UL AAI BAD UUI	Begner Regis 57 57 57 57 57 57 57 57 57 57 57 57 57	Choltenham AS AS MC Choltenham Brind Englis Mesh = Southenham Southenha	Dunstable After Age	Glosposter NY AN Line Glosposter British Fersille May \$4 a Sandragette	May Discourse of Contract Fund Contract Fund Contract Fund Contract Fundaments South-sensition Fundaments Fund	All Mary All	Manufacture of the control of the co	Paintenagh An	Substitute Substitute William Substitute Wi	Turin 10 1 1 1 1 1 1 1 1 1 1 1 1 1 1 1 1 1 1	A 423 A 5 V/4 V/5 A 32 N/2 N/2 Novabbry + Shoughty + Shoughty + Shoughty + Shoughty +
Section : Southwester Basel 3 arr Arr Arr Arr	1942 1942 1943 1944 1945 1945 1947 1948 1948 1948 1948 1948 1948 1948 1948	Chaster AND AND AND AND AND AND AND AND AND AN	Comban Kings Crean a Limitar Migramine a Southernglann Durtherng	Granthars 41 A18 A18 A19 A29 A20 A20 A34 A34	A423 A4 A22 A3 A3 A3 C S S S S S S S S S S S S S S S S S S S	Mit. Mit. Aug. Mit. Aug. Mit. Mit. Mit. Mit. Mit. Mit. Mit. Mit	ALS ALS ALS VET VET VET VET Defringtion - Landow Crys Cross - Londow Working - Sovyhampton	Fyrmolis Essens Shibony Shib	M27 Supplement is Supplement in London Exergence for a London Exergence for a London Exergence Supplement Supp	Part of the second of the seco	Yearell Is year A37 A36 A37 A37 A37 A37 Very Tend of Sendanges
Town - To	Bournamouth North A31 Mgr 15 Burnamouth Seuthampus	Chesserfield Chesserfield ANT ANT AND AND AND AND AND AND	ALL AND AND AND AND AND Sept Defends Complete Company Combine	A39 Common Common Common Students Angle Common Angle Common Students Stude	Invertors	Name Real A5 A5 A5 A5 A5 A5 A5 A7	Mercelle Ar Ac Ac Ac Ac Ac Ac Ac Ac Ac	Protton Protton See See See See See See See See See Se	ACTS MM MA	NE N	York 19 cm 464 441 442 469 471 471 471
A23 A33 A35 Templifie a Southenpus Beth	Bradford ARE MCZ MT MCS MSS MSS MSS MSS MSS MSS MSS MSS MSS	A34 V3 M37 Chrosofaid; Sortiampion Chippenham	Edinburgh AT AB AB AB AB AB AB AB AB AB	MED RES TO A STATE OF THE STATE OF T	Despite Const of Switzers of S	Loughborough	Munich No tas A6 A19 A66	Ma Add Add Add Add Add Add Add Add Add Ad	\$1. Albans In core M1 M2 M3 M3 M3 M3 To war London Kings Creas is London Kings Creas is	Ware Nore AN US M3 A3 A3	MUT York S. Lawster Kanga Crisis v Landon Warenes v Southerappes
AM V27 Nor a Southerupton	EMBY Southenplan	ASI ASI ASI In-Vi Cropunture a Brightmeter			Symple - Symple	ture Boughterrough's Covering a Bouthampson	A1) A1 A1 A15 A15 A15 A16 A17		Andrews	Water of Louisian Interception to a Louisian Millerton of Secretary Millerton of Secretary Associations of Secretary Associations (Secretary Association)	A

Representation and space 044/045

Design Artist Project Client Date Mark Diaper Michael Landy Breakdown Artangel 2001

BREAK DOWN

Over the course of two weeks in February 2001, the British artist Michael Landy took up residence in a former C&A clothing store in London's Oxford Street, and systematically destroyed all of his personal possessions, from his car to his passport and credit cards, in an industrial shredder. Prior to the event, the artist had made an inventory of his possessions – in effect, an inventory of his 37-year life. Over 5000 entries catalogued every piece of furniture, every record, every article of clothing, every letter from friends, every gadget, and every work of art – his own work and gifts from fellow artists such as Gary Hume – which were owned by the artist.

This inventory forms the basis of a book, designed by Mark Diaper, produced to document the project by Artangel, the agency which funded it. The possessions are categorised and given a prefix: A = Artworks, C = Clothing, E = Electrical, E = Furniture, E = Electrical, E

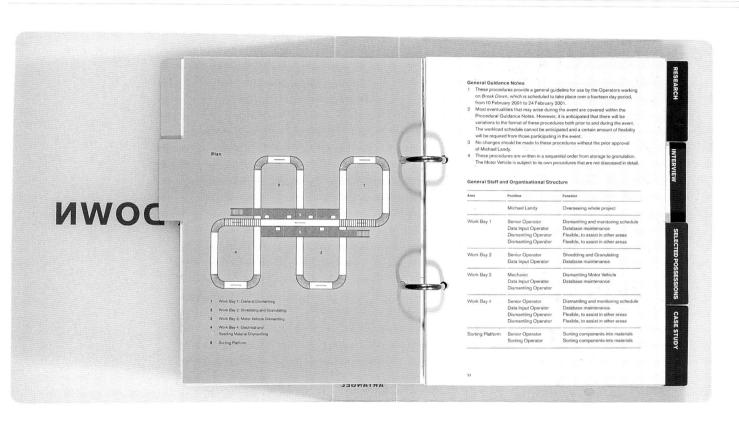

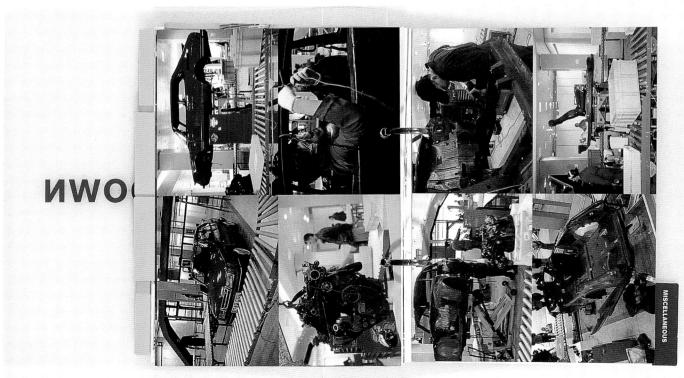

Design Map design Project sans+baum Russell Bell

Project Date Facts of Life gallery guide

2001

Hayward Gallery

Facts of Life Comtemporary Japanese art Hayward Gallery 4 October – 9 December 2001

Facts of Life presents painting, photography, video, installation, scuipture, sound pieces and performance work—in the order of the photography of

FACTS OF LIFE

for extended information on all the artists in Facts of Life log on to the special exhibition site at www.haywardgallery.org.uk

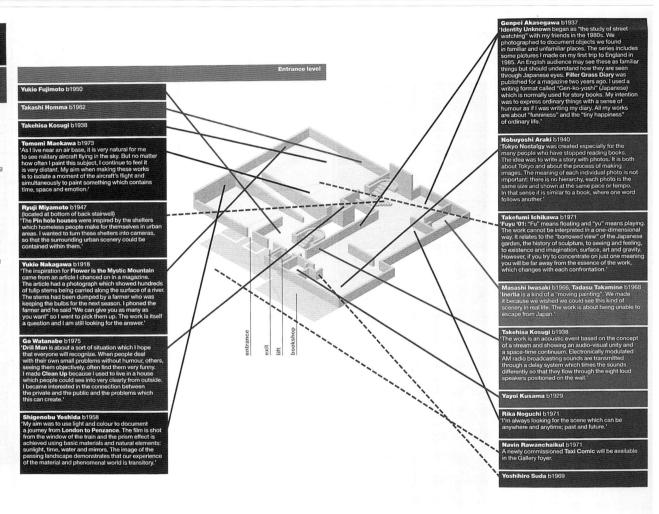

Produced as a concertina-folded sheet of paper, this gallery guide for the exhibition Facts of Life at the Hayward Gallery in London was designed to help visitors navigate easily around a fairly complex set of exhibits, while providing information about the artists whose works they encountered along the way. The primary intention was to design an accessible guide which made the different gallery levels and spaces immediately clear. A

colour-coding system was introduced to draw attention to the individuality of each exhibitor and their work. The isometric drawings of the two levels of the gallery are annotated by thick rules colour-coded to identify the presence of particular artists' works, while dotted lines are used to indicate a work which occupies a non-standard gallery space such as the basement area or the gallery's foyer, for example.

Public programmes

Public programmes
An extensive programme of
events gives adults, students and
families a range of opportunities
or engage with the issues and
ideas behind Facts of Life. Gallery
Guides are regularly on hand to
offer short, informal tours of the
exhibition and to answer your
questions. A series of informal
galiery talks by arrists and curators
is open to all, as well as our regular
student debates, this time with
Goldsmiths' College and Kingston
University. Two Hayward Forums,
and two seminars with the Institute
of the College and Kingston
University. Two Hayward Forums,
and two seminars with the Institute
of the College and Kingston
University. Two Hayward Forums,
and two seminars with the Institute
disciplinary discussions around
identity, transience, globalisation
and the myths of orientalism
and universalism.
Families are invited to make
prin-hole cameras, comic books
and much more over the opening
weekend with Takefurmi Ichikawa
and Ryuji Miyamoto, alongside
British arists Sally Barker and
Milika Murtu. In addition, arists
will be leading workshops over
the half-term holiday.
Full listings of Hayward Gallery
ovents are given in the exhibition
leafet available in the foyer,
or visit our website at
www.haywardgallery.org.uk
Facts of Life catalogue

www.haywardgallery.org.uk
Facts of Life catalogue
A fully illustrated catalogue
accompanies the exhibition.
The book includes texts by
Jonathan Walkins and Mami
Kataoka. The catalogue is
available from the Hayward
Shop at a special price during
the exhibition, and by mail order
from Cornerhouse Publications
telephone
+44 (0)161 200 1503

**Texts of the Control of the Control
**Texts of t

bisability access
For information on disability, please ask at the Information Point in the Hayward Gallery telephone +44 (0)20 7960 5226

Representation and space 048/049

Design Project Date Architects

Cartlidge Levene Selfridges Birmingham brochure 2001 Future Systems

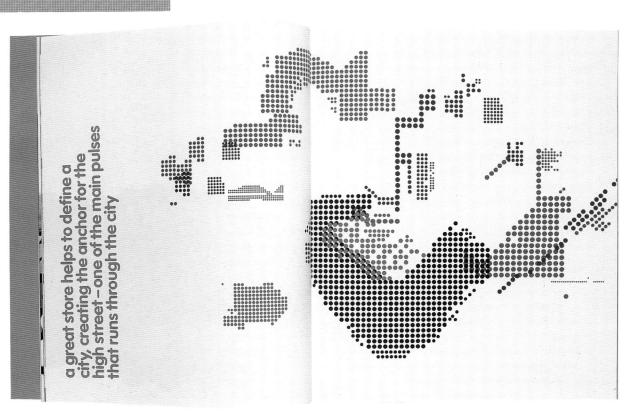

Selfridges department stores and the architectural firm Future Systems requested the help of the London-based design consultancy Cartlidge Levene to design a promotional brochure for a new Selfridges store to be opened in Birmingham. Targeted at fashion brand owners, who might open branded concessions in the store, the aim of the brochure was to generate interest in the as yet unbuilt Birmingham Selfridges. The brochure includes

models by Future Systems showing the proposed new building, whose organic form is covered with circular discs. The motif is used throughout the brochure as a graphic device. The publication includes a map showing the customer catchment area in and around the city of Birmingham, demonstrating the potential of the area to investors, and making a graphic feature of further abstractions of the map in different colours.

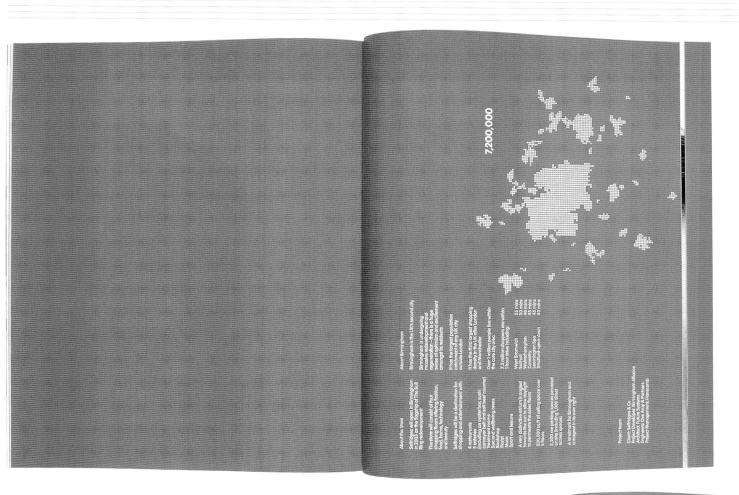

Design Project Date Build 'TRVL'. 2001

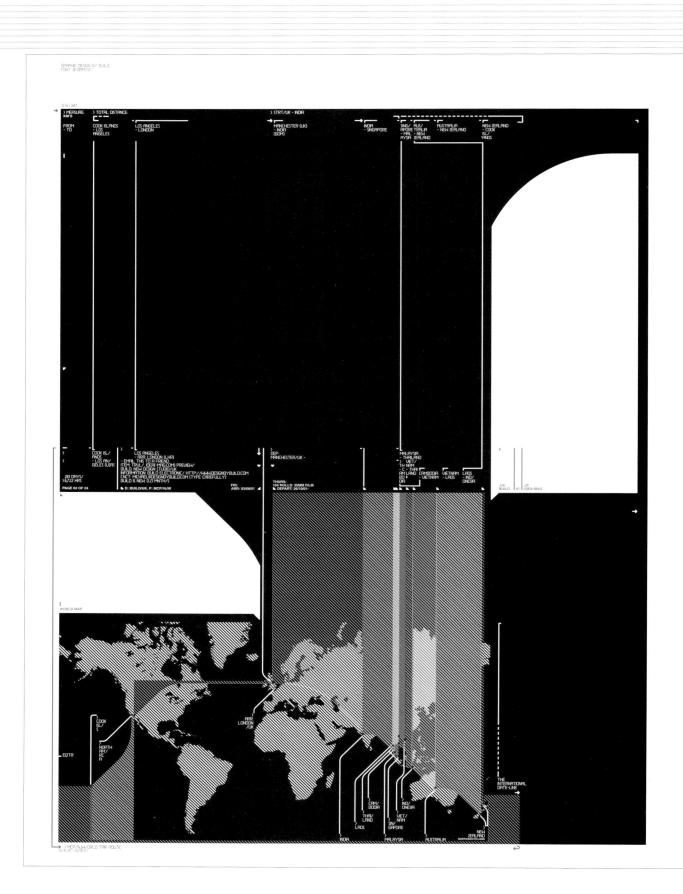

Build is a UK-based design consultancy established by MIchael Place, who was previously employed at The Designers Republic. When he was commissioned by the Japanese graphic design journal Idea to produce a piece of work, he chose to base it on the 281-day round-theworld trip he had taken between leaving The Designers Republic and founding Build. The resulting piece is a supplement/book which acts as a travelogue – a graphic depiction of the journey.

'TRVL'., as it was titled, is a 24-page French-folded publication featuring photographs taken during the trip, which are supported by and cross-referenced with location/map references and records of times and distances travelled. Each page represents a stage of the journey, identified by arrival and departure times and related data.

Design Project Date Nick Thornton-Jones/Warren Du Preez Human mapping research project 2001

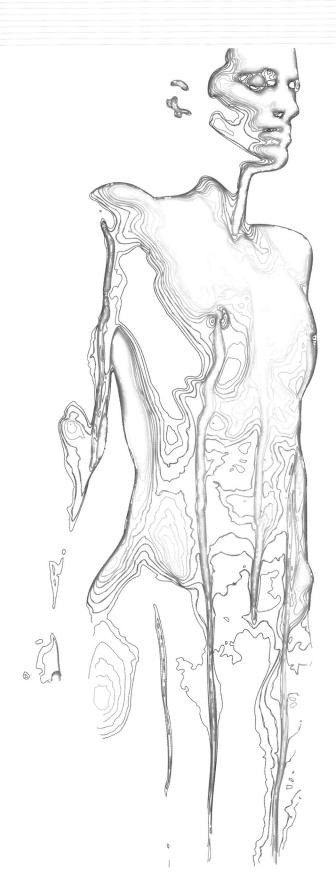

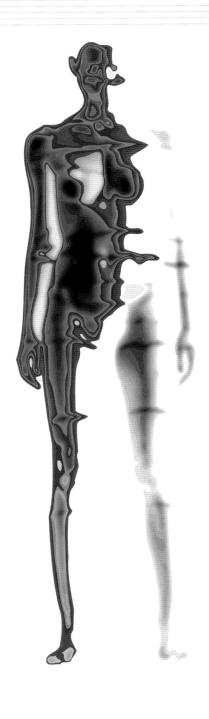

Nick Thornton-Jones and Warren Du Preez work together as image creators. With Du Preez coming from a fashion photography background and Thornton-Jones coming from graphic design and illustration, together they blur the boundaries between photography and digital illustration.

The work shown here is part of an ongoing research project into the abstraction and reduction of the human form into light and contours,

exploring surface, curvature, volume and perspective. They are interested in discovering a point at which a photograph becomes a graphic representation, and how far this representation can be pushed. By reducing images of the body to a series of tonal contour lines, the pair explore a level of information about shape and form that is not normally evident – or at least given prominence – in representations of the human figure.

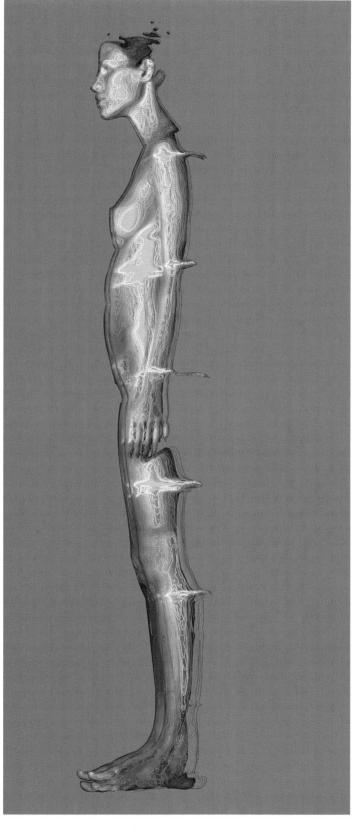

Studio Design Project Date Sinutype Maik Stapelberg and Daniel Fritz 'AM7/The Sun Years' 2001

AM7/The Sun Years AD 3527-3539

SUN/MU/SI The third heart - Stor Ministragewhile der Sun Mannach (Mannach SUR .3540-E) and the "Ministrage" of the Control Springer and State Office as storace, in the CFF must be on the mannaching friends betterning, upon and the production of the grant of the storace of the 2 min 4 4000 000 500 500

Sun - Entstehung, Erbe und Zukunft Professor Stai Aleeza Sun Memorial University, Tampa/SI

01.1-5

Karten

02.1-3

Corporate Tree A

03.1-3

Corporate Tree B

03.4-6

Corporate Tree C

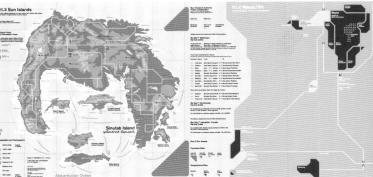

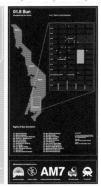

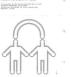

The 'Akademische Mitteilungen' (Academic Announcements) is a publication of the Academy of Arts and Design in Stuttgart, Germany. The magazine is published once a year by two graphic design students from the academy. The content of the magazine is always based around one main theme. The seventh issue of the magazine, designed by Daniel Fritz and Maik Stapelberg, was titled 'AM7'. The theme running throughout this issue was 'communication'.

The AM7 Sun Poster elaborates on an article written in the magazine called 'Sun Years', which is a fictional story about Elvis being kidnapped, after an alien race listened to his music which was on the golden record sent on a Voyager probe in 1977. The poster, which

measures 1185 x 835mm, shows a series of very elaborate and stylistic maps for the fictional world 'Planet Roosta' whose continents bear a striking resemblance to a portrait of the King himself.

The poster forms a total graphic manual for Planet Roosta, showing everything from corporate colour palette and typeface to pharmaceutical and food packaging, and maps the entire infrastructure of the civiliasation. It includes a revised map of the solar system, a world map, a map of Sun Islands focusing on their roads, waterways and cities, a map of Wayon, the capital of North Alacarecca, a map of Sun, the capital of Sun Islands with a zoom-in Sun Downtown (streetmap) and also a ferry map for Sun Island (shown below).

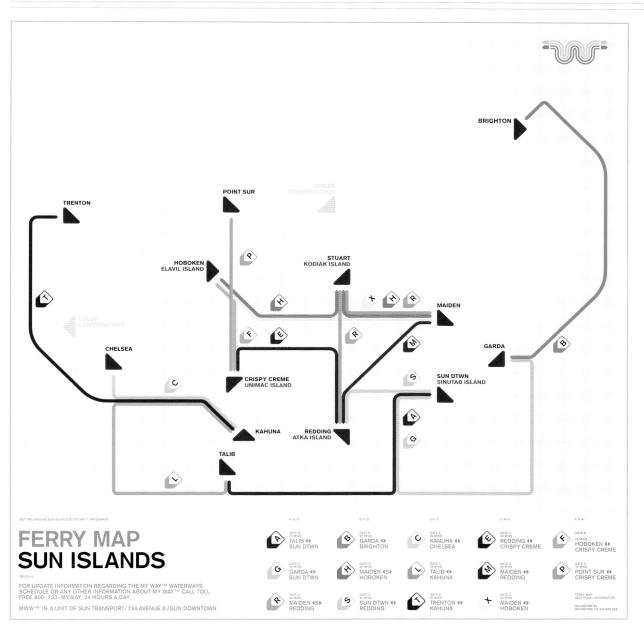

Studio Design Project Date

Sinutype Maik Stapelberg and Daniel Fritz 'AM7/The Sun Years'

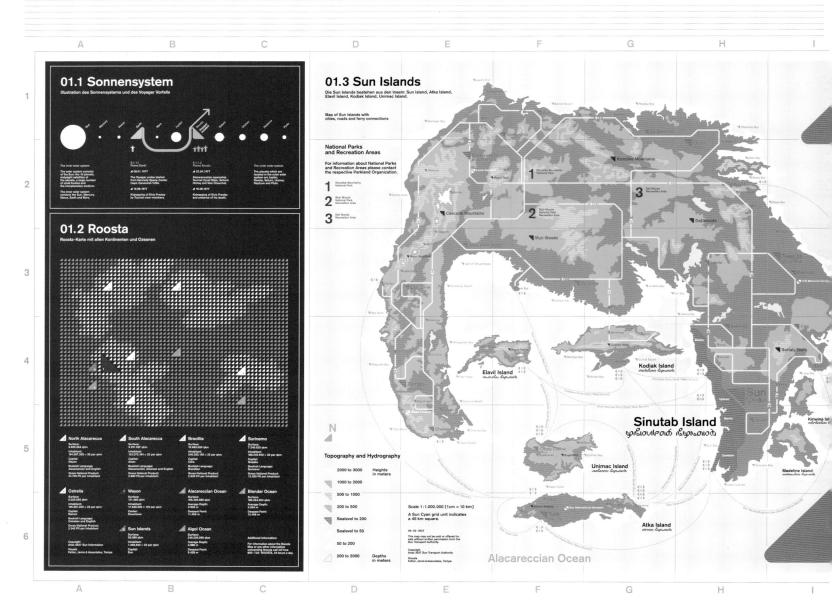

Shown here in more detail are: a revised map of the solar

Studio

Sinutype

AM7/File Exchange

Design

Maik Stapelberg and Daniel Fritz

Project Date

2001

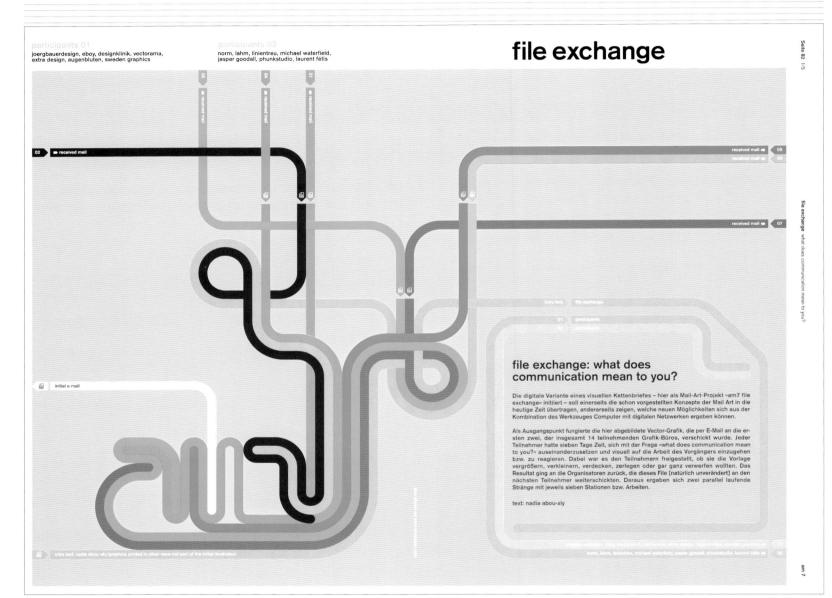

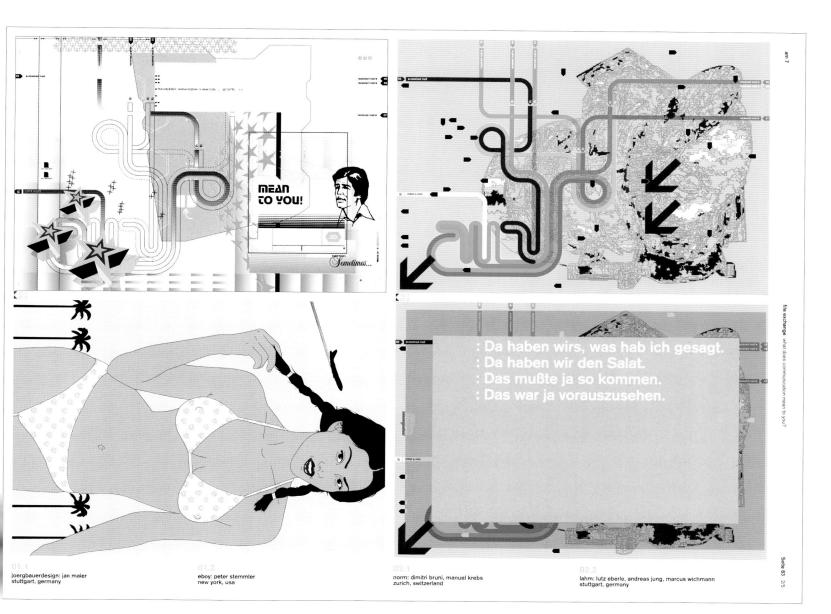

Representation and space 060/061

Lust

Design Project Date

Lust Map 1995

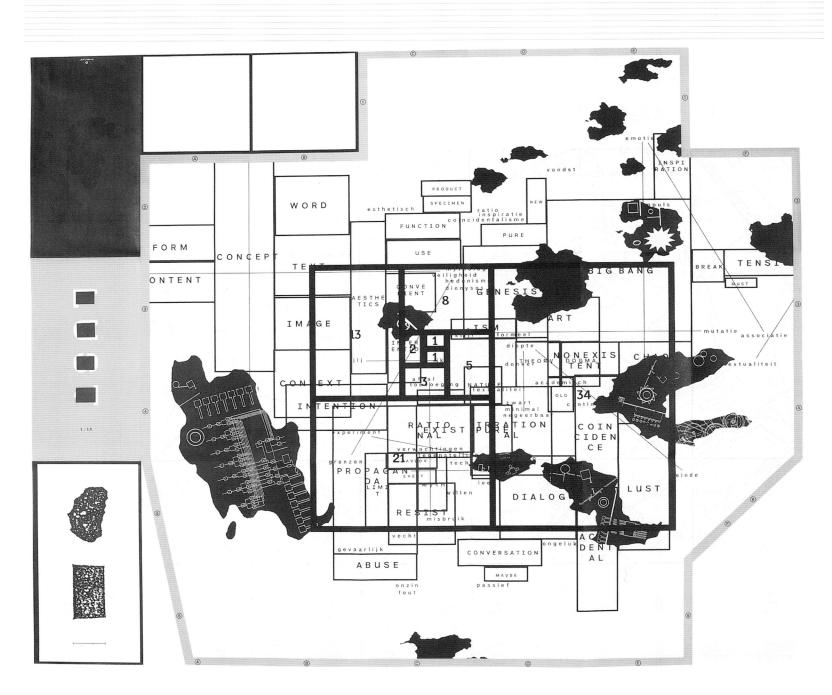

This map functions as a conceptual guide to the inner workings of the studio that designed it, Lust. It was created as a map to accompany two separate design projects, one being a study of the role of coincidence and association in graphic design, and the other being the implementation of these concepts in relation to architecture and urban structures. According to the designers, the key elements of the map which directly relate to the Lust design philosophy and methodology include an associative collection of words, a ratio of magnification, a virtual legend, a relative scale, an index of self-defined words and images, coincidental spaces, architectural and urban structures, the Golden Section, Fibonacci numbers, an intentionally broken piece of glass, a black square, and a pin-up girl.

I N D E X Wegwers 1. afeal 2. als het thousand

LUS

LUST WERELD

LUST STAD

COLOFON

Vasr meer inform Jercet Serender Sorpestreer 60 3733 NX SE BLLT L 835 211528

Design Project Date

Browns '0°'

Photography

1999 John Wildgoose

Produced in time for the Millennium celebrations at the end of 1999, "0°" is a beautifully produced book showing the work of the photographer John Wildgoose. The book follows the Greenwich Meridian as it passes through England, from Peacehaven in the south to Tunstall in the north. The line, which represents the Prime Meridian of the world – 0° longitude – dictates that every place on earth is measured in terms of its distance east orwest of it. From rolling chalk hills to flatlands, the images are held together by that invisible man-made thread which circles the world. Images were taken directly north or south along the 0° line. Nothing was chosen for its particular beauty or ugliness, and nothing was shot for political reasons. The only arbiter was the line.

The inhabitable map

Essay by William Owen + Fenella Collingridge 066/067

The dividing line between the map, the landscape and the narratives scored onto it by man can be very slim. Subject and object have a tendency to intersect and fuse, each influencing the other. Before humans made maps they incised them on the landscape – both small signs and megamaps marking out territory or homestead, naming places and objects and providing orientation. The handheld map, whether made of stone, papyrus or paper, comes much later.

Man-made marks on the landscape have large ambitions: they tell narratives of life and death and attempt to control and moderate nature. There are numerous examples of these megamappings at huge scale still in existence. The Egyptian necropolis plots the path to the underworld; the giant neolithic chalk figures in southern England proclaim fertility and virility; the intaglio geoglyphs (incised pictures) in Blythe, California, are barely visible from the ground but vast when seen from the air. Another example would be the extraordinary Nazca lines in Peru which are believed to be a model at a huge scale of the drainage from the Andes mountains into the Nazca desert, with ceremonial walkways travelled by the map's makers to encourage the water down.

We have our modern equivalents in art, architecture and engineering of people's attempts to feel as large as the landscape they inhabit. The artist Christo wrapped in fabric (and remade) whole coastlines and photographed them from the air. In the United States the National Survey and Land Acts have recreated the literal appearance of a map on the surface of the western states, marked out in the chequerboard landscape of 1-mile squares created by fields and roads that religiously follow the survey lines. This repetitious, hyper-rationalist grid deviates only to pass insurmountable natural obstacles such as rivers, canyons or mountain ranges. Here is a case of the mapmakers not merely

recording the landscape, but subjugating it, however imperfectly.

The modern city, too, is subtly and not so subtly marked in many hundreds of ways by objects, signs and symbols that exist only to map it and help us read the way. We insert small clues throughout the built environment to enable identification and orientation in cultural and geographical matters. Church spires and skyscrapers over-reach sight lines and provide orientation and locus; textured curbstones mark the boundary between road and walkway; signs identify buildings and their purpose or ownership; brass studs set into the pavement delineate property boundaries; viewpoints along major routes relate goal to starting point; and different districts are identified by their unique building types. These visual and textural cues are like a trail left by a pathfinder, clues to help us in our quest of navigation and exploration. We only register their importance where a city or suburb is visually homogenous, perhaps because - like Tokyo, for example there are only one or two discernible historical layers, or because we are unfamiliar with the cultural signs of difference. The result is disorientation.

Every city and every district contains key modes of outlet or entry, often subway stations or rail termini, portals at which orientation is a critical issue and which establish the city's rhythm. Rational signage systems are built around these points, providing the text and directional markers that complete the inhabitable map.

Signage is a complex subset of information design that combines architectural, graphic and industrial design skills with a cartographer's understanding of theme. One signage system cannot serve every user. Some users may be visitors, with little knowledge of the city; others may be residents, familiar with the overall pattern but not the detail of certain districts. Some users will want to stay; others only want to leave. Some users may be travelling rapidly by car or bicycle, others by foot. Some users will be interested only in tourist sites, others in utilities like hospitals or transport. There are, clearly, only a limited number of themes, modes of

Knowledge of a navigator's identity, location and intention is the holy grail of signage designers but something that in reality they can make only crude assumptions about.

Intégral Ruedi Baur et Associés Parc et Musée Archéologique de Kalkriese 192/193

Peter Anderson Poles of Influence 096/097

Lust Open Ateliers 2000 084/085

passage and user goals that can be served by a single signage system before it overloads and collapses under its own weight.

Knowledge of a navigator's identity, location and intention is the holy grail of signage designers but something that in reality they can make only crude assumptions about. If we were to make the ideal sign or map, we would know these things. And likewise, we would reintegrate the inhabitable three-dimensional landscape with the two-dimensional map so that they became one thing.

Digital technology brings us much nearer to the reintegration of sign, map and landscape, in the form of the mobile phone. Third generation mobile technology is not only capable of downloading video and cartographic data, but it is also location-sensitive, knows the identity of the user, and may through customisation or personalisation know or infer specific intentions at any one point in time.

Geographic Information Systems offer the potential to enable mobile phone users to interrogate objects, buildings – even people – or any selected thematic layer within the landscape (each will carry attribute data located at a specific logical address in the digital space that parallels its real address in the physical landscape), to push or pull information about events, services, times or offers at the user as well, of course, as acting as a traditional pictorial map.

Digital production, reproduction and distribution has exciting (and dreadful) implications for the way we make and use maps, and for the effect on the landscape maps survey.

First of all, we may no longer be using shared maps – as are the thousands of identical multiple-run printed maps – but ones that are unique to ourselves, with levels of access to information and control over the space of the city that varies according to all sorts of factors such as our personal selection, our credit card status, our phone company

or our technical ability. Individuals may develop radically different viewpoints on the same location.

Secondly, the digital map may also map its user (the map knows its own location) and so there is the obvious possibility that a map of map-readers can be created, shifting constantly in real time as the readers move about. Feedback effects can result, as the world that is mapped changes according to the action of individuals responding to the map. This happens in printed maps too, but more slowly (the guide book recommends a restaurant, which as a result becomes overcrowded and therefore undesirable).

These feedback effects might create interesting and bizarre situations in a world in which we can survey, reproduce and distribute maps of the landscape instantaneously (mapping in real time). The flocking effect of in-car navigation systems, whereby the more cars that use the system and take similar congestion avoidance action, the more quickly alternative centres of congestion are created, is a prototypical example.

Real time mapping (using the appropriate sensors) enables us to map many new classes of object including those (like map readers) that are impermanent and highly localised: goods for sale, in storage or transit, for example; vehicles on the road; events; discarded items; pollution; weather. Knowledge of these things will affect their properties and relationships with each other and us. One can envisage that the overall effect could be a massive acceleration of change and a huge concentration of power and therefore value in the map. It is worth remembering, then, that in the Renaissance a map cost the equivalent of many thousands of times what it does today. The real time, location-aware, identity-aware, intention-aware maps of tomorrow may be equally valuable to their users.

Man-made marks on the landscape have large ambitions: they attempt to control and moderate nature.

Design Project Date Projekttriangle Krypthästhesie 2000

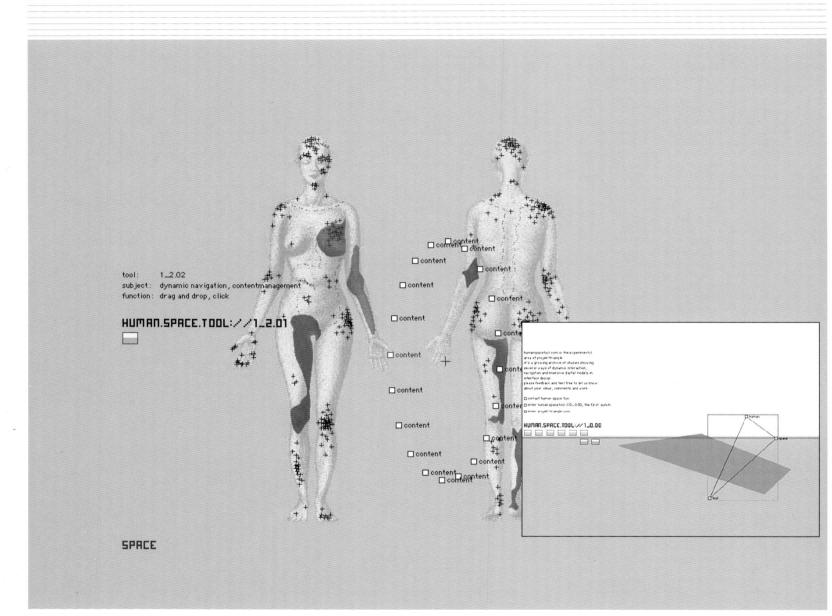

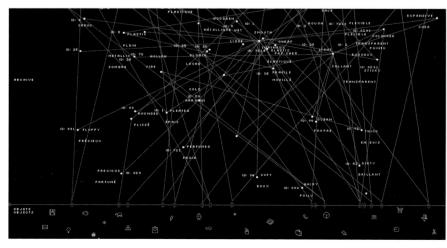

The mapping system Krypthästhesie was developed from German design company Projekttriangle's researches into a new and more effective way of finding and presenting information concealed in the multiplicity of data. "Our study is years ahead of the technology needed to implement it," says Martin Grothmaak of Projekttriangle. "We don't wait with our designs for the engineering to be available to put them into practice. What interests us is not the media themselves but intermedia relationships, in particular the inter-relationships between man and medium. Human beings are always at the centre of our interface design."

This research tool looks for information in big databases or on the Internet, evaluates it

and displays it geometrically. The dynamic model illustrates both the content-based relationships between search criteria and the generation of search results. The results appear not as a list but as data clouds in the form of points in a circle around the central search word. If you search for information about 'Japan', for example, all the available information on that country appears as points distributed in a circle. A dynamic data map is created on the surface which permits a geographical orientation. The points closest to the search word contain a lot of information about Japan and the more distant ones less. If a second word – 'museums' – is entered at the edge of the circle the points rearrange themselves dynamically. They move

towards the word to which they are most closely related. The user can now look at a point in more detail that is close to the word 'museums' but relatively far from 'Japan'. The information revealed when one clicks on the point turns out to be a museum of ethnology with Japanese exhibits.

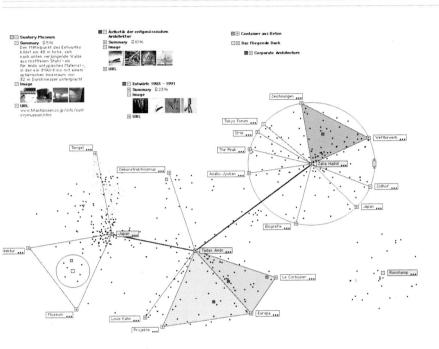

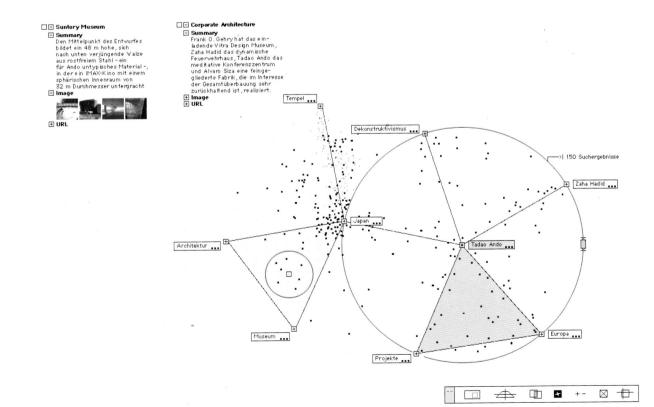

Inhabitable space 070/071

Design

Lust

Project Atelier HSL web site

Date 2001

Atelier HSL is an arts and cultural programme based
around the Dutch High Speed Rail Line. Its web site
functions as a medium where activities surrounding HSL
are presented on-line. The concept for the interface is a
matrix of points that symbolises points on a map and the
distance between them. Since the arrival of the HSL, time
and distance have become relative because of speed.
Cities are drawn closer together: to a traveller, Amsterdam
will be 'nearer' to Paris than to a southern Dutch city such
as Maastricht. By the expansion and contraction of the
points of the matrix, areas are created for the content of the
site. This expansion and contraction relates back to the
idea of the relativity of time and distance.

Inhabitable Space
072/073

Design Cartlidge Levene
Project Process type movie
Date 2001

With no brief, apart from that the design company wished to be represented by an on-screen piece of work in an exhibition organised by the International Society of Typographic Designers held in London, Cartlidge Levene created the design shown here. The content of the sevenminute on-screen loop was created directly from dialogue around the subject of what the piece may become – a representation of conversation, over time, using typography and sound. The animated typography highlights structures and links though the repetition of words. Letters are repeated, removed and distorted during the loop.

Inhabitable space 074/075

Design Project Date

Tomato Interactive Sony Vaio interface 2001

Developed as an interface for the Sony Valio system,

formato interactive produced this on-screen navigational world, in which the viewer can click on a morphic blob and set ransterred to another focation and cuture. Despite sontaining a huge wealth of information, the system is straightforward and simple to interact with.

"A monk visited eight sacred places for Buddhist, and writes up about the travel. Included here are topics about Buddha, Gandhi, and Taj Mahal."

Road to Buddha

Road to Buddha

WORLD HERITAGE

Fibre Diesel StyleLab 2001

DieselStyleLab

Diesel's cutting edge clothing range, StyleLab, commissioned London-based graphic design consultancy Fibre to produce a CD-Rom as a directional tool for the company's ethos. The interface is based loosely on a molecular structure, which moves and morphs shape as the mouse is moved around the area. By clicking on a blue circle a key word appears together with a close-up macro photographic detail of a garment. By using the plus and minus icons the viewer can travel deeper into the system.

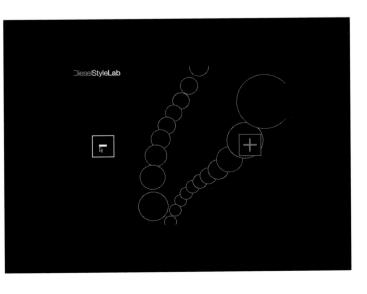

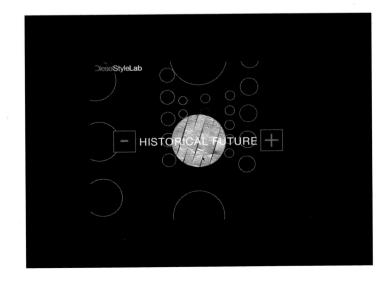

Design Fibre
Project cc2000
Date 2000

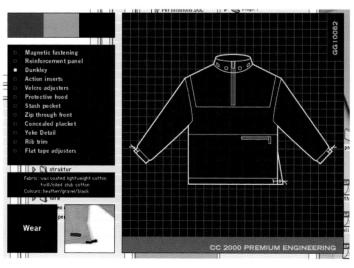

Produced to promote Cat's (Caterpillar Clothing) collection, Fibre produced a CD-Rom-based interface. The programme runs just in the central area of the screen, leaving all the other desktop windows visible, visually suggesting that the cc2000 interface floats over the 'urban' landscape of the user's computer. The interface is broken down into several sections such as Wear, Experience, Image, Signs and Watch, and the content of these modules varies widely, from narrated stories and an exhibition events guide, to showing the actual clothing. The navigational system works by using the mouse to scroll over a moving grid matrix; the section names pop up as you scroll, and the section is entered by clicking on the section name as it floats over the navigation box.

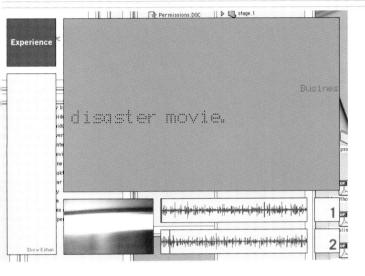

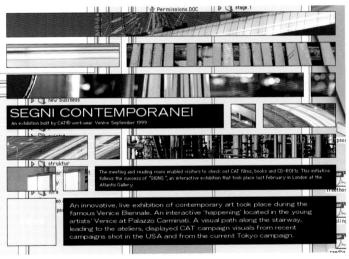

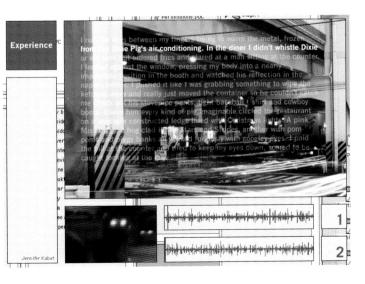

	Inhabitable space 080/081	
Spin Tourist		
2002		

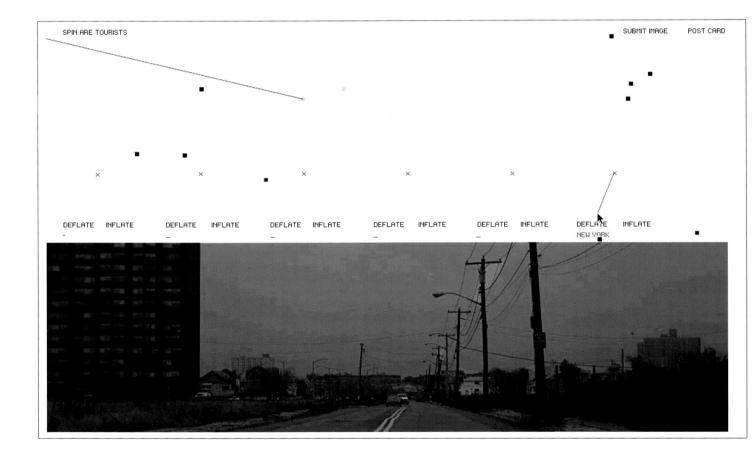

every year the design consultancy Spin sends its designers of unknown destinations to encourage them to develop heir own responses to what they find. Tourist is a self-initiated project inspired by this activity. Tourist is divided not five layers, consisting of ten items (black squares). The ayers are navigated by moving the mouse close to the black crosses. Linear connections can be formed using the mouse. These activities reveal various snapshots taken at different Spin holiday locations such as Blackpool, the Isle of Wight and New York.

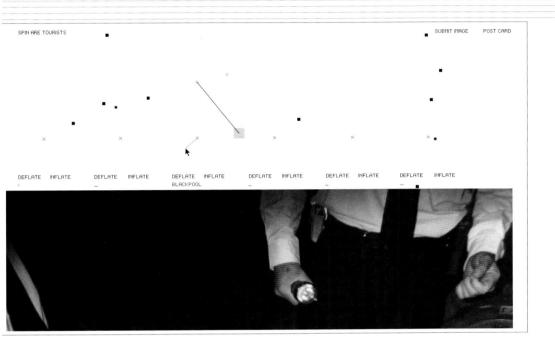

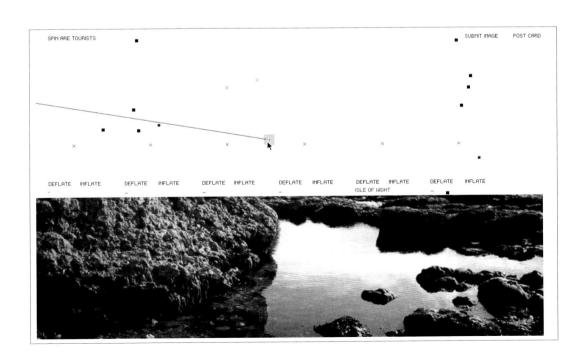

Inhabitable space 082/083

Design Project Date sans+baum

Future Map exhibition graphics

1999

Future Map celebrates the best work of graduates from the London Institute, the umbrella body containing many of shrink-wrapped, as private view invitations. A series of London's best-known art and design schools, and is held each year in the London Institute's gallery space near Bond Street. To emphasise the individual nature of the work, each student's contact details were printed on a series of 'jotter pads' throughout the exhibition. Sheets could be torn off and collected into a bag which was provided to

essays on larger pads were also available for collection. There was no need for any graphics on the walls or a catalogue. The jotter pad dimensions acted as a module on which all of the exhibition design was based so that graphics and build became totally integrated.

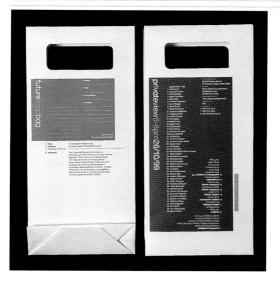

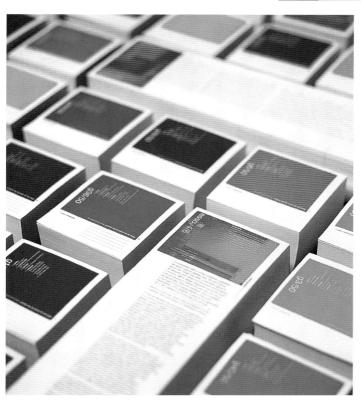

Inhabitable space 084/085

Design

Lust

Project Open Ateliers 2000

Date 2000

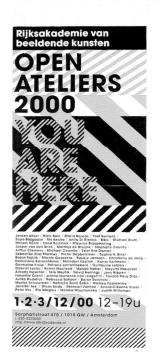

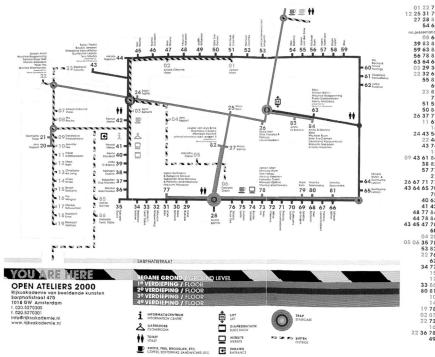

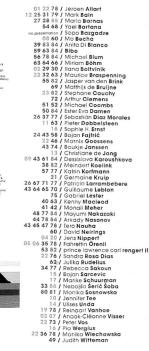

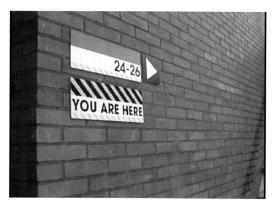

The Rijksakademie, Amsterdam, holds an event called Open Ateliers when the public can visit the studios of the artists attending the school. Because of the complex nature of the building, a major complaint in previous years was that no-one could find their way to all of the studios. The decision to use a metro-like map with floor markings, as used in institutions such as hospitals, led to the main graphic element of the print work – floor-tape. A map was therefore designed which led the public around the building directly to the studio of choice: no-one got lost.

Inhabitable space 086/087

Design Project Date

Frost Design Give & Take exhibition graphics 2001

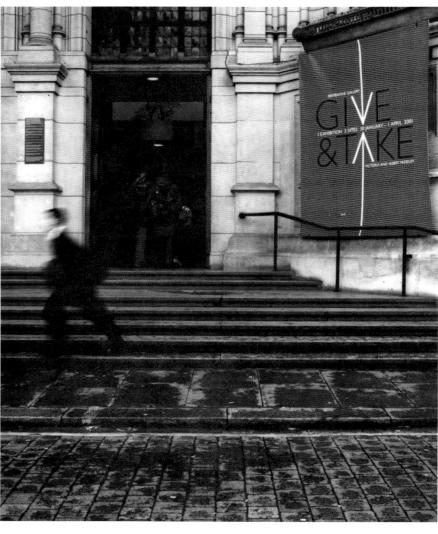

Faced with the task of producing graphics for an exhibition at the Victoria & Albert Museum (V&A) in London, Frost Design created a concept that rembodied both a logo and a navigational system that ran through the entire space.

The exhibition juxtaposed permanent display artefacts with contemporary art, and the works

were not confined to just one or two rooms, but ran throughout the entire museum. A strong navigational system to help guide the viewer through the labyrinth of exhibition rooms and corridors was therefore crucial. The designers' solution was to run a red stripe along the floors (a system frequently used in hospitals to guide patients to the appropriate ward). The red line also becomes a recurring motif, appearing in the exhibition logo and graphics, the 'V' of 'give' and the 'A' of 'take' becoming arrowheads.

Inhabitable space 088/089

Design Project

Lus

Risk Perception carpet for InfoArcadia

Date 2000

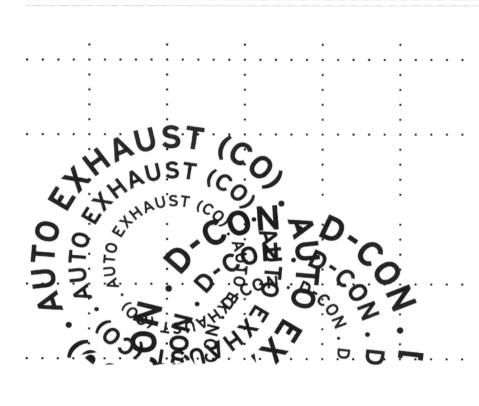

InfoArcadia is an exhibition about data, information and the manner in which they are visualised. Information graphics, instruction manuals, information landscapes, data clusters are included, but so too are more personal ideas – like mapping one's life by marking events on food tin lids. The Dutch design company Lust was asked to make a piece which interpreted the data Paul Slovic gathered through surveys on people's perception of risks in 1988. Lust selected 81 'risks' from Slovic's collection of more than 40,000 answers. A way was needed to visualise the 'x-y matrix' on which the 'risks' were mapped. The

commissioner wanted a visualisation of three results of the research: factors such as 'controllable vs. uncontrollable' and 'known risk vs. unknown risk'; the desire of people for strict regulation of certain risks; and the importance of certain risks as signals to society. Lust decided that the visitor would form the third axis (z). The carpet measures 3×3 metres.

UNKNOWN RISK. NEW. DELAYED EFFECT

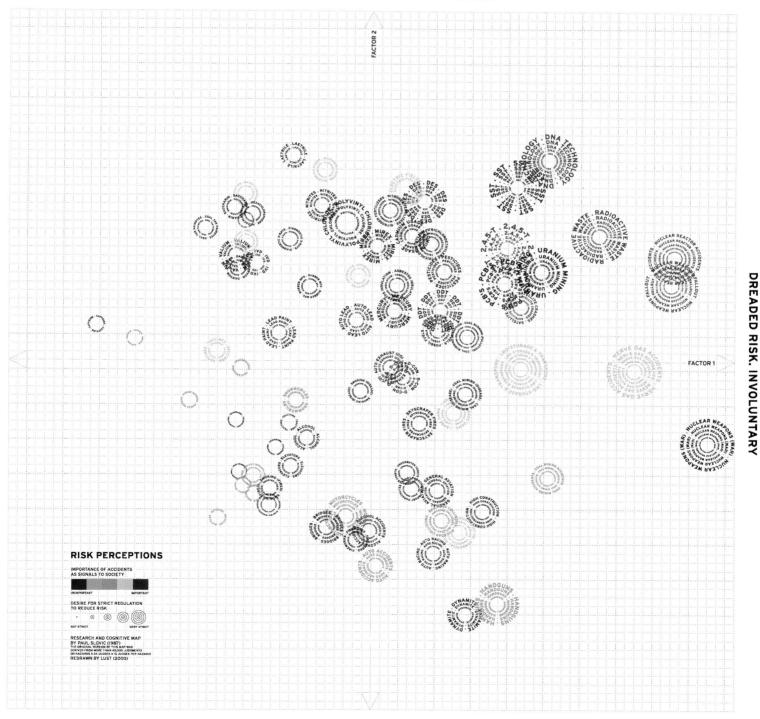

Inhabitable space 090/091

Design Project Date Peter Anderson Cayenne interior 2000

When Peter Anderson was commissioned to produce graphics for a stylish restaurant in Belfast, Northern Ireland called Cayenne, the resulting material became more art installation than just menu cover design. For a piece recessed into one wall of the restaurant (below), Anderson took as a starting point every surname in the Belfast telephone directory, then began to work this mass of typographic data into an abstraction of the Belfast street map. This random placement of names created some interesting instances of wordplay, and in a divided city where one can often tell the area where someone lives by

their surname, the appearance of some names next to others created a talking point – or thinking point – for some more observant diners. Other elements of Anderson's design included a lenticular wall piece, mounted above the bar, called 'Mountain People' (left). Made up of map reference points for high points in the mountains around Belfast as well as grid references for cities around the world, the piece asks the question 'are mountain people curious? Do they always want to see what is on the other side?'

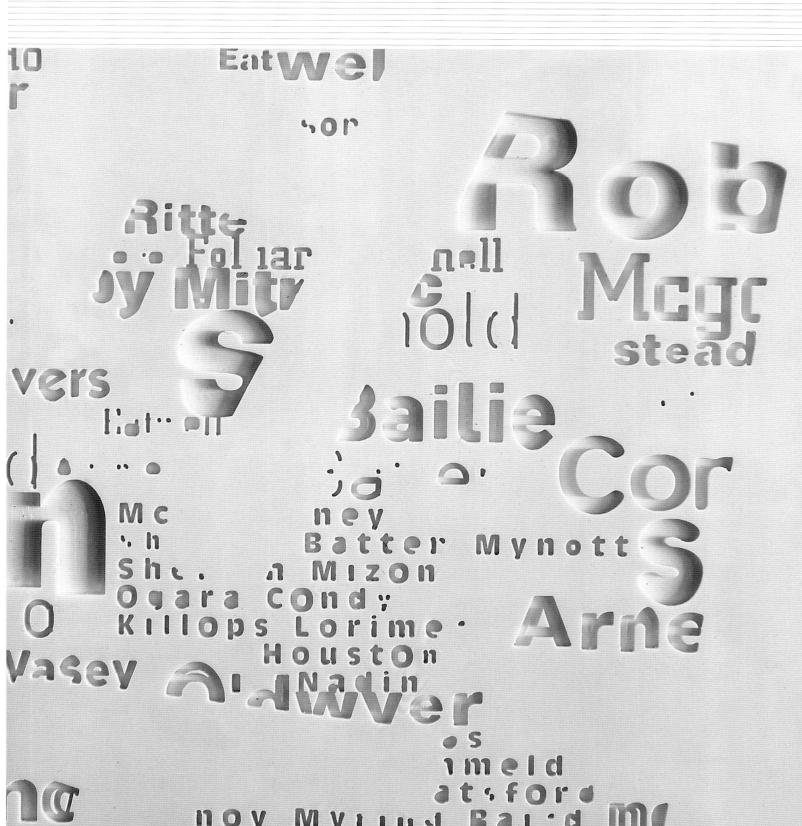

westwood

Shepar

Design Project

Intégral Ruedi Baur et Associés Parc et Musée Archéologique de Kalkriese 1999-2002

Date Photography

Eva Kubinyi

, SPRENGEN- DANN-ALLS, DIE-1 N. IN. DIE- QUERE- KOMMEN, AU Hander - Ond - Zertreten - Ot BODEN-LIEBENDEN, GEORNEI TACITUS. RÖNISCHER GEST TSSCHREIBER, BEBOREN-UM-HR.)

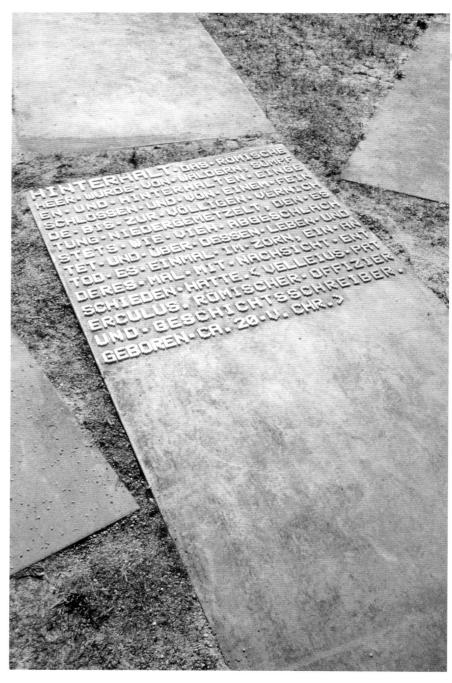

This archeological museum is located at a site where the 'Germans' beat the Romans. It tries to retrace the battle using large iron plates installed in the ground on which inscriptions in Latin and German explain the course of events. Three pavilions, constructed from corrugated iron, connect this event to the contemporary world through the expression of sensations such as seeing, hearing and understanding. The large iron slabs work as both a

pathway and a directional signage system, leading the visitor through the different parts of the museum. The typography on the slabs is raised and set in a bitmapped font, all in upper case, working as a counterbalance to the history of the museum. As the iron is untreated, the surface is gradually eroded by the elements, allowing the panels to work in harmony with the surrounding nature.

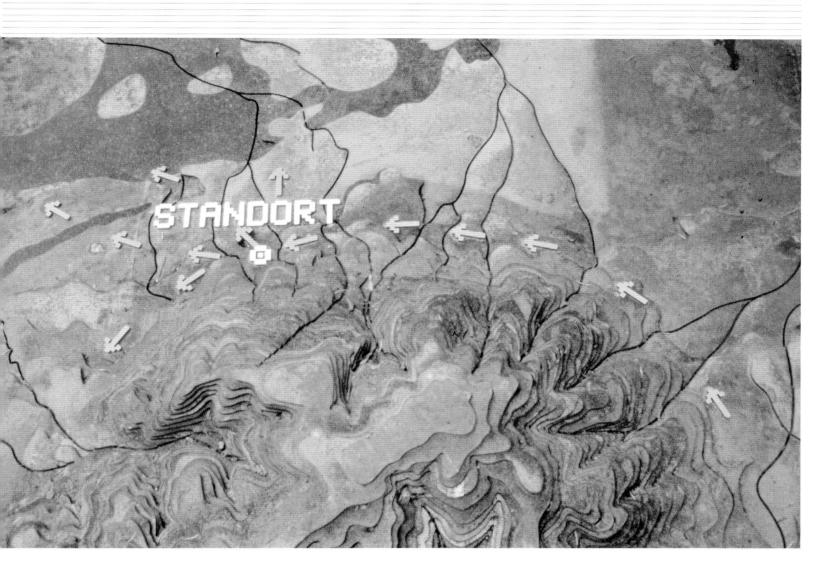

Inhabitable space 094/095

Intégral Ruedi Baur et Associés Centre Pompidou, Paris 1997–2001 Blaise Adilon

Design Project Date Photography

The signage system developed by Ruedi Bauer for the Centre Georges Pompidou, Paris, is based on the idea of 'spatial explosion' of information usually contained in a single signage panel. Signage, in this case, equals scenography. Concentrations of words appearing in different languages express the interdisciplinarity and multi-culturalism present at the Centre Pompidou.

The signage system works on various surfaces and non-surfaces, including freely suspended neon typographic elements, and large format banners overprinted in numerous colours with the same word in various languages. The overall effect of the system is one of energy and immediacy, The interaction between surfaces and the open spaces all helps to build on the graphic intensity.

Peter Anderson Poles of Influence 1998

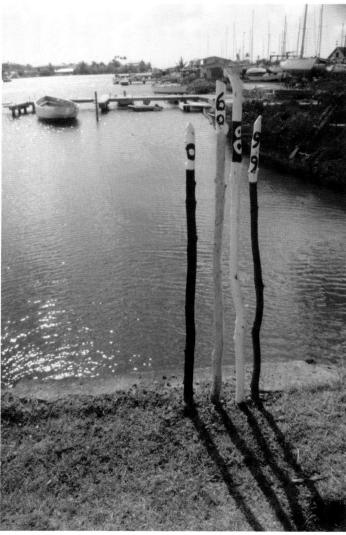

London-based graphic designer and artist Peter Anderson was commissioned to produce a work of art for the opening exhibition of the St. Lucia Museum of Contemporary Art, but on arriving on the Caribbean island, he discovered that the museum was not yet finished. This gave him some time to familiarise himself with the island and its culture. He discovered that tall, thin wooden poles were everywhere, their uses ranging from acting as props for banana trees and washing lines to building houses. As he was keen to produce a work of art that responded to its

environment, he decided to use these wooden poles as an art installation which would extend across the entire island. He painted the sticks using a colour coding system and gave each stick a specific number, which ranged from his carregistration number to an ex-girlfriend's phone number. These poles were then planted across the island in groups following a specific matrix, thereby creating a new set of co-ordinates for the island, and allowing islanders and tourists to weave their own stories around these strange interventions in the landscape.

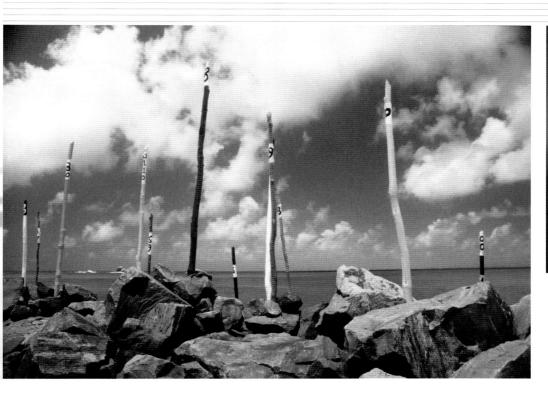

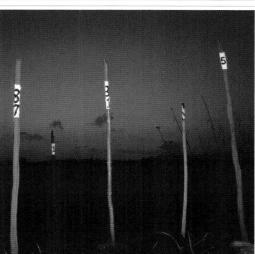

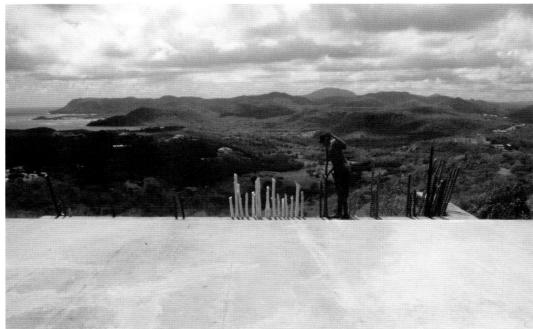

The Kitchen Ocean club signage system 2001

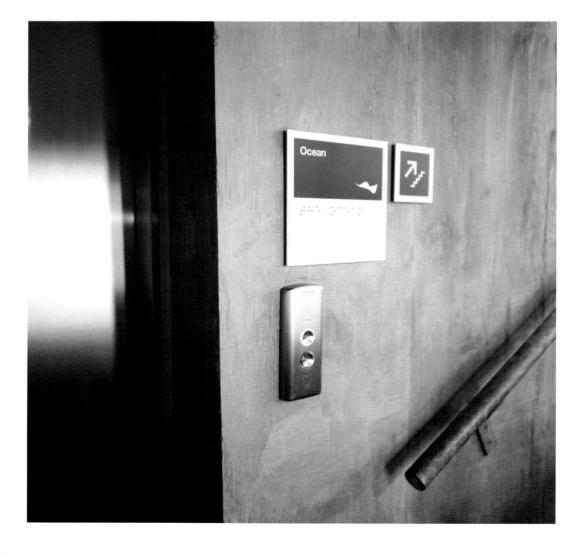

How do you create a navigation system for people who cannot see? That was the question facing graphic design consultancy The Kitchen when it was commissioned to create a signage system as part of its identity for Ocean. Ocean is one of the largest music venues in London with a capacity of 3000, and boasting three auditoriums over four levels.

The Kitchen attempted to devise a system that was as restrained as possible, working all the signs into a square format produced in enamelled metal panels. White backgrounds were applied to all the signs with a second colour chosen for each of the auditoriums.

All panels are split in half along a horizontal axis, with the text and icons shown in white out of the area colour at the top, braille text also reads across the foot of each panel. A further element of braille was applied to the sign, but this information was printed, not embossed, thereby becoming purely a surface effect, and adding a little humour to the otherwise austere signs (the text contains the titles of famous songs which are relevant to the area or information the sign depicts; the toilet sign reads 'Boys and Girls' by Blur, a sign showing the way upstairs reads 'Stairway to Heaven' by Led Zeppelin, and so on.) This aspect of the signage has proved to be

successful among the partially sighted, who are able to read printed text as well as braille.

The system has proved to be highly successful, with a number of the panels being 'liberated' in the weeks after the new venue opened.

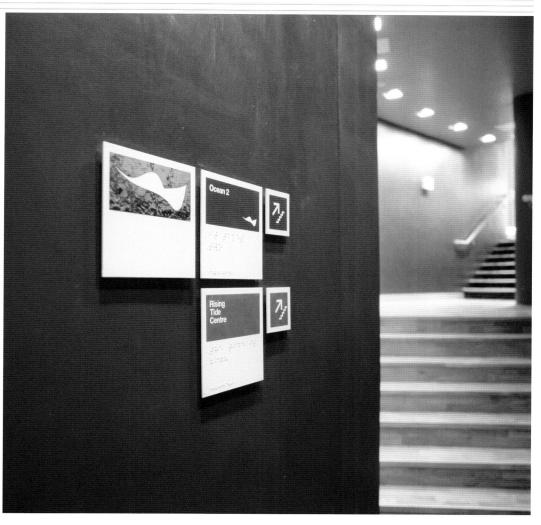

MetaDesign, London Bristol City street signage 2001

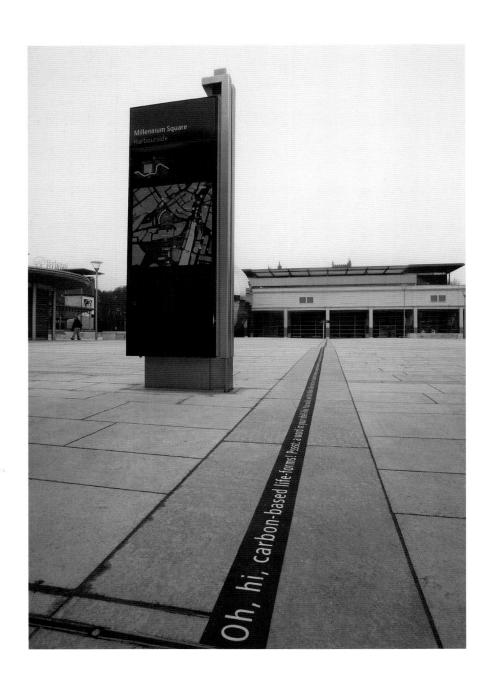

The UK city of Bristol has always proved to be a navigational nightmare for pedestrians and motorists alike. MetaDesign, London, was asked to solve the problem by introducing a complete signage and navigational system for the entire city centre. One of the most radical and yet obvious ideas behind the system was to angle the street information panels towards the desired destination from the viewer's perspective, making the orientation immediately clear.

Inhabitable space 102/103

Design Project Date

North Selfridges interior signage 2000

Department stores generate a very noisy visual environment to work in, with numerous in-store concessions shouting for attention with a multitude of different graphic styles and tactics. Graphic design consultancy North was asked to devise a navigational signage system for Selfridges on Oxford Street in London, one of the oldest and largest independent department stores in the city. North's approach was one of reduction. Instead of trying to shout louder than the others, the designers adopted a totem pole device, which measures a

mere 150×80 mm but extends upwards to three metres. The posts are predominantly white, which helps to make them more noticeable against the background colour and noise.

A strong hierarchical system was developed to allow certain poles to contain very minimal levels of information, with pictograms on one plane and the descriptive word on the following plane. The basic colour palette was used sparingly; the level the shopper is on is highlighted in yellow whilst the other levels remain white.

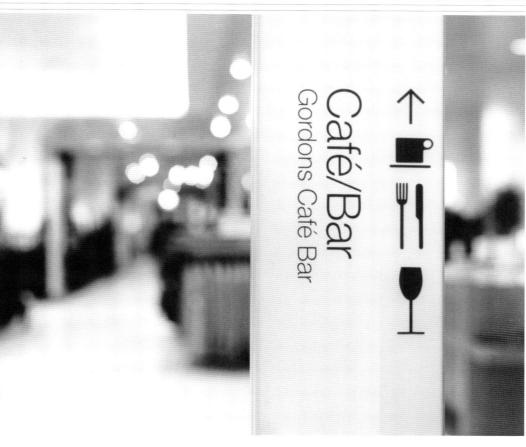

Pentagram Canary Wharf signage 1995

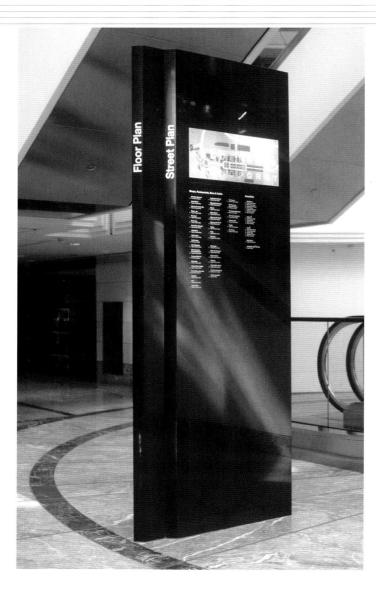

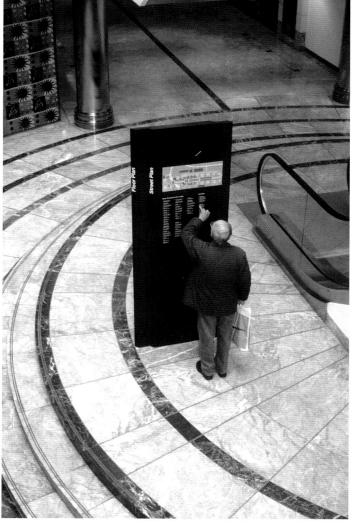

Design consultancy Pentagram was commissioned to undertake a review of the existing interior and exterior signage in use at the prestigious Canary Wharf development in London. The client's brief dictated a solution that would solve the problems of scale and flexibility. The exterior signage creates a natural arrow device by the intersection of two planes set at an angle to each other. This construction is both simple and striking.

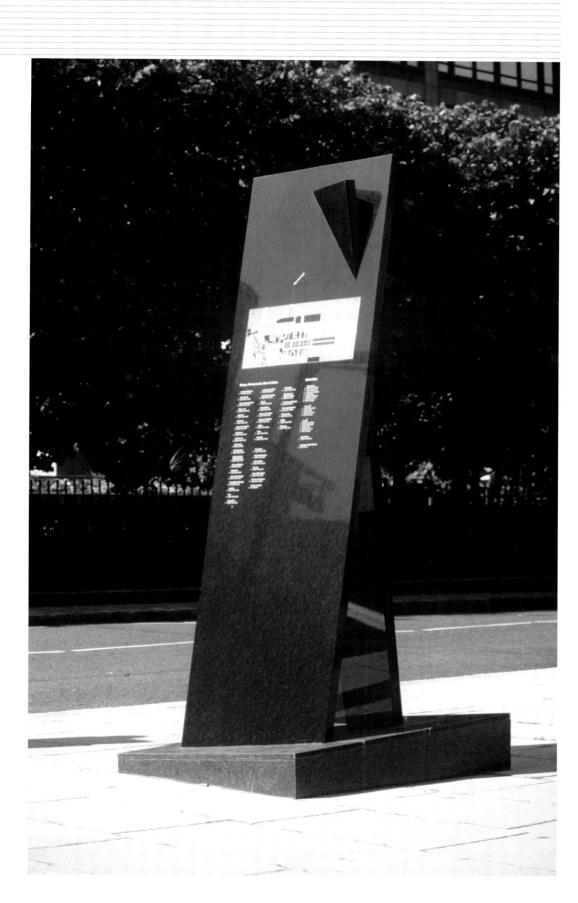

Pentagram Croydon signage 1992–1993

Croydon Council commissioned Pentagram to design signage for a new arts complex containing a museum, library, cinema and art gallery. The brief called for public, 'front of house' signs and non-public signage for staff 'behind the scenes'. Attached to the Town Hall, the complex was in the process of being built by architects Tibols, Karsky, Williams and Monroe.

The behind the scenes signage was deliberately discreet and low key. By contrast the public signs were large and high profile. Giant arrows gave

directions, while monolithic numerals indicated floor levels. Signs with boldly applied graphics were used to identify particular locations within the complex, such as the David Lean Cinema, the Riesco Gallery and the shops.

Secondary signage, designed as easily understood pictograms, indicated amenities and facilities such as cloakrooms, reception and toilets.

Pentagram Stansted Airport signage 1990–1991

Stansted, London's third international airport, was designed by the architect Sir Norman Foster, who commissioned the design consultancy Pentagram to produce a signage system which would complement the distinctive architecture. The solution includes large-scale graphic symbols which can be seen at a distance across the open space of the interior. These guide and reassure the traveller by pinpointing toilets, food services, the currency exchange and other essential facilities.

The location and information signs are back-lit letters set in the monochromatic walls and dividing panels of offices, the check-in counters, customs barriers and so on. The directional signs, largely confined to the

huge tree-like columns that support the building and make natural information points, are modified versions of the yellow British Airport Authority sign system.

Unfortunately the rot has set in: visitors to Stansted today will find this beautiful system still in place, but the visual noise and pollution of shops and advertising has destroyed the original purity. The world of cut-price, budget airlines has graphically bombarded the space, while the original elegance of the Pentagramdesigned BAA signage system, set in a clean sans serif, has been replaced by a clumsy bold serif, which has no relationship to the purity of the supergraphics.

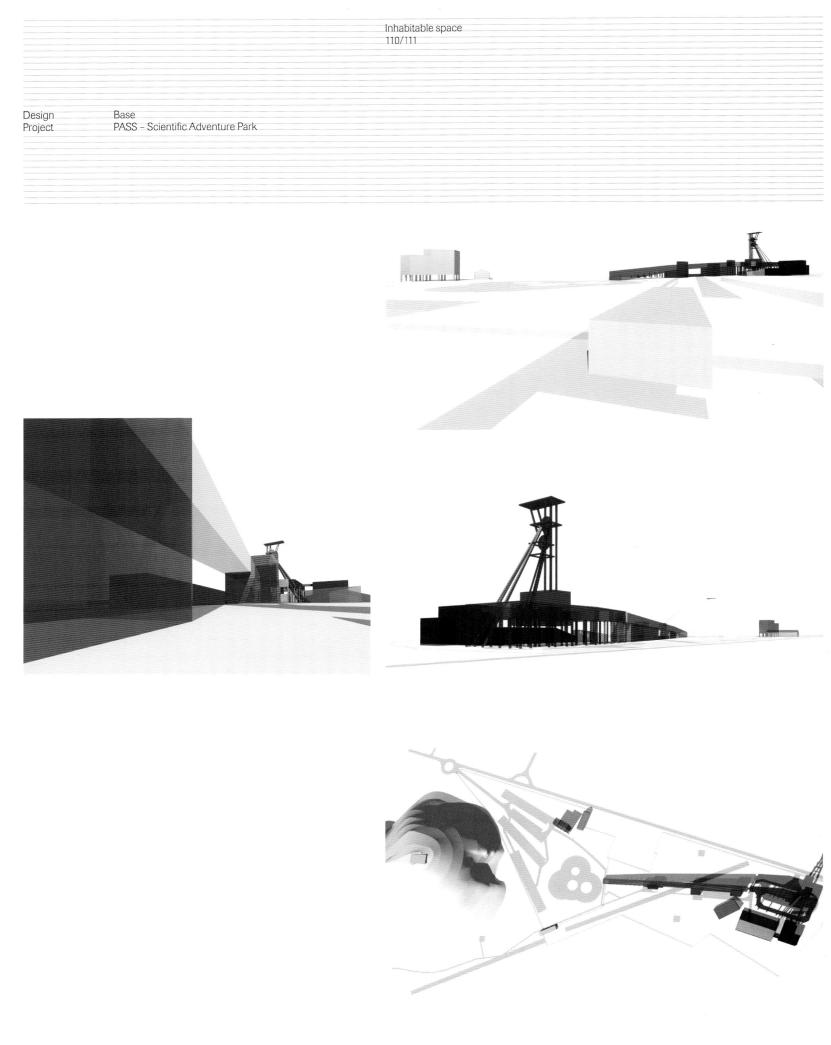

The graphic identity for this Scientific Adventure Park in Belgium was designed by Base, who were involved in every aspect of the graphic project from web site to building graphics. The interiors have the quality of a raw industrial plant, space station or bunker, and untreated structural materials such as concrete and steel are visible throughout the building. The signage and navigational system works with these raw materials: large panels are painted in bright colours, which relate to an on-screen virtual navigation map of the park. Large typography, applied directly to the surface, indicates zones or levels, while huge icons are applied to walls and floors marking lift shafts and ticket halls.

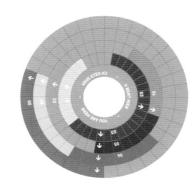

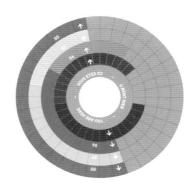

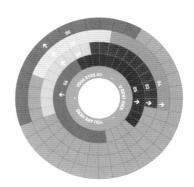

Farrow Design Making the Modern World 2001

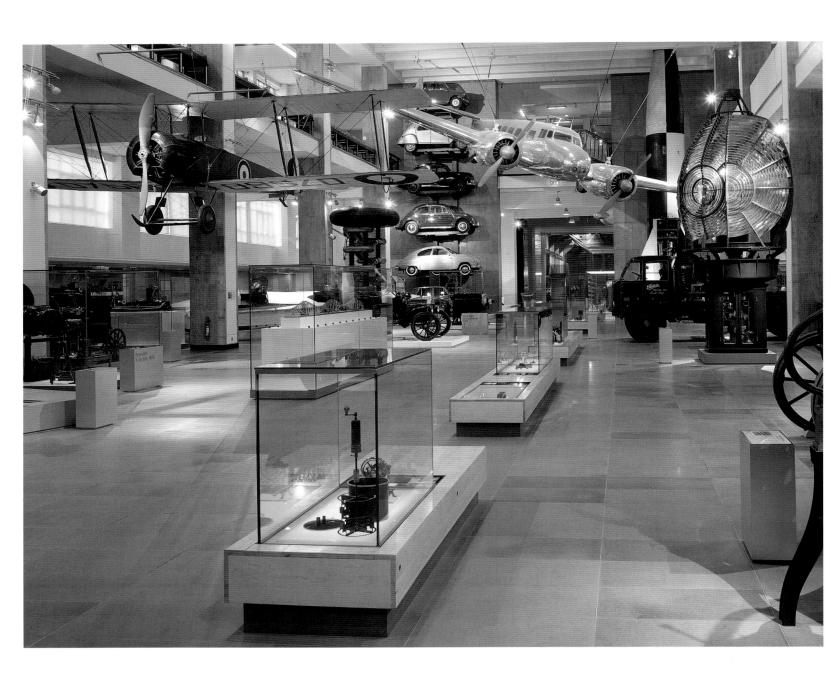

Farrow Design was asked to design the permanent exhibition 'Making the Modern World' at the Science Museum in London.

At the entrance to the gallery is a large black stone obelisk which contains a lightbox with orientation graphics of the gallery. One of the most striking features of the gallery is 'Carhenge', a stack of six cars which extends right up to the roof. The plinth at the base of this tower contains a flush-mounted graphic panel housing information on each car. Smaller items are housed in floor-standing boxes with back-lit panels on the top plane showing information about the object and an LCD monitor which shows footage of the object in action.

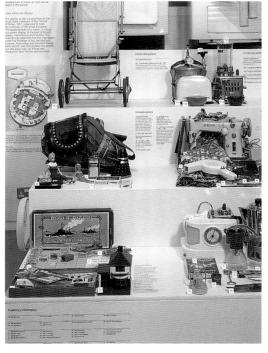

03 _ Information and space Mapping intangibles 114/115 [ab 800 m] 038 17 Sichtflughöhe BAW1896 078 28 DLH: 126 033 5 FRANKFURT 018 8

Measuring the dataspace

Essay by William Owen 116/117

By teaching the simple facts of the shape, size and position of a country relative to all the others, the political map of the world has become intrinsic to our sense of national identity. When I was growing up, in Britain in the mid-1960s, our school maps portrayed the British Isles (we just called it 'England') sitting comfortably and naturally at the exact longitudinal centre of a flat world, north at the top and south at the bottom, the country subtly and significantly exaggerated in size by the Mercator projection and coloured prettily in pink. We learnt from the beginning that this was the natural way of things.

A lot of the rest of the world was pink, too: these were the twilight years of the British Empire. The map was probably 20 years old by then and its representation of demi-global dominion in superabundant pinkness had already been made obsolete by national liberation movements across Africa, the Mediterranean, Arabia, India, East Asia and the Caribbean. But it wasn't easy for a school geography department to keep up with the winds of change and so we clung to the fiction of empire.

The real use of this map, like most maps, was "to possess and to claim, to legitimate and to name" 1, in this case the assertion by the British state of sovereignty over itself and a large portion of the world, and the expression of the singular point of view that England lay at the centre of everything.

In the 35 years since I was at junior school ideas about possession and sovereignty have altered, possibly faster than maps have. The political map of the world has been redrawn, of course, with the creation within the former Soviet and Yugoslav Republics of nineteen new nation states and the destruction of one (the GDR). These are the kinds of absolute changes that conventional maps excel at: the transformation of political boundaries – lines on the ground – or of names, or of regimes. Rights were being reasserted in eastern Europe and Russia, but elsewhere national boundaries were becoming confused. The more interesting and subtle changes – for society and for cartography – have been those arising out of the integration of world trade, communications, politics, culture and population, and the diminishing importance of national political boundaries.

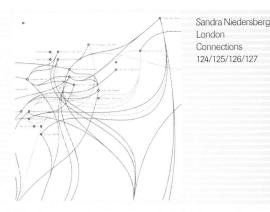

The inexorable progress of globalisation is a challenge to mapmakers. How do we define, in cartographic terms, contemporary political relations, or ideas about nearness and remoteness, relative size and wealth in a world where political alignment is multi-layered and distance is measured in air miles and bits per second. Harder still, how do we represent within a figurative geographical construct what it is to be British, Japanese, Nigerian or Turkish and how each nation fits within the world, when we each live, either in a literal or metaphorical sense, everywhere?

The inadequacy of the one-dimensional identity and the singular point of view described by a national boundary (and national colour, flag, anthem, bird...) should be self-evident, although like a school geography department we cling to old truths. Western topographical conventions are fixated on physical space, not just for the needs of navigation but also because they are rooted in asserting property relations - rights of ownership - and therefore the accurate description and allocation of territories (private or state) is paramount. Space, however, is increasingly distorted by the wealth or continuity of communications or by cultural influence and integration (who needs to be in California when Starbucks is round every corner?). Also, the assertion of absolute rights of ownership has relatively less meaning than access to goods and services (or to certain rights and privileges that in the modern world supersede citizenship: those accruing from educational qualifications, wealth or trading block membership). The possession of physical space and the representation of 'real' physical distance (and even navigation across it) has relatively less meaning than newer, more complex equations of proximity or privilege.

How do we define, in cartographaphic terms, ideas about nearness and remoteness, relative size and wealth in a world where distance is measured in air miles and bits per second?

Lust Fietstocht door Vinex-locaties Den Haag 120/121/122/123

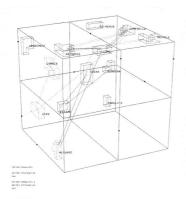

Lust |3 map |130/131

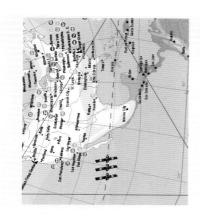

Damian Jaques The MetaMap 136/137

Take Britain as an example of a vague, ambiguous and unresolved political state. There is a ghostly fragment of Empire in the Commonwealth and in dominion over Northern Ireland and diminutive offshore redoubts like the Turks and Caicos islands. There is a degree of internal fragmentation expressed in its one 'parliament' - British and three 'assemblies' - Scottish, Welsh and Northern Irish. Britain's principal legal and economic policies are subject to those of the European Union, of which it is a leading member. However Britain remains outside the common currency Eurozone, and is semi-detached from the Schengen Agreement that defines border controls and police cooperation within the EU, dictating the all-important policy of who to let in and who to shut out. Other aspects of national sovereignty are influenced by membership of bodies such as Nato (defence policy) and the World Trade Organisation, (which defines tight parameters within which the economic and trade policies of its member states can flex).

Now take into account Britain's eclectic ethnic, cultural or linguistic traditions, or its central position within the global networked sub-economy in which a substantial minority of its citizens participate, in highly mobile supranational industries such as finance, media, software, oil and professional consulting. In the light of these multiple layers (and multiple maps?) what constitutes 'Britain' and 'Britishness' evidently still matters but has lost its old crispness.

Remapping a world in which global and national space/time co-exist requires a radical new approach, that allows topographical and topological representations to co-exist. Showing the 'true' proximity of one place to another in a jet-turbined, video-conferenced and Internet-enabled world requires a similarly multi-dimensional understanding of space and time, logical and physical. For example, if we measured distance by the duration, availability and price of air travel between two locations, rather than miles or kilometres, London would be very much 'nearer' to New York than to, say, Athens; or we could measure connectivity not by roads, railways or shipping lanes – as my mid-1960s atlas did – but by the number of Internet users and ISPs, or the price of voice telephony, the number of mobile users per population, the connection speed and miles of optical fibre, the number of television stations.

Such a map of proximity and connectivity would reveal a chain of massively connected global cities girdling the earth: in Europe – London, Paris and Frankfurt; in the Middle East – Dubai; in the Far East – Kuala Lumpur, Singapore, Hong Kong, Shanghai, Tokyo, Sydney; in the Americas – Sao Paolo, San Francisco, New York. Huge swathes of the world – predominantly but not exclusively in Africa and Asia – would be seen to be almost entirely disconnected from this hyper-concentration of activities and resources.

"The new networked sub-economy of the global city occupies a strategic geography that is partly deterritorialised, cuts across borders, and connects a variety of points on the globe. It occupies only a fraction of its local setting, its boundaries are not those of the city where it is partly located, nor those of the 'neighbourhood'."²

Where are the boundaries located, in a world in which the power of a non-government organisation (say Greenpeace), a media network (CNN) and a global corporation (Shell) are as significant in shaping environmental policy as a national government?

The boundaries lie in multiple dimensions, and not merely along national borders. They cross the routes of cross-border migration and encircle linguistic concentrations; they plot the activities of global corporations and their influence on our food, entertainment and health; they pinpoint the hotspots of international crime; they lie around trade zones and regions (or philosophies) of political alignment; they follow the contour lines of equal wealth, education, skills or connectivity; they are intersected and overlaid by specialised human activities (such as finance or media) or key nodal points of physical or digital exchange (Heathrow Airport, Wall Street, Dubai Internet City, the golf course at Palm Springs).

Our sense of place and position, and our understanding of the relations between things, their dimensions and attributes (true or false), is forged and reinforced by their representation on the map. By making these new facts visible, and revealing the coincidence of logical and physical objects or the rapid oscillation and contradiction between global and local points of view, then we should have a better map.

¹'The Power of Maps',

2 'Obbis Terrarum, Ways of Worldmaking, cartography and Contemporary Art', ed. King and Brayer, Ludion Press, Ghent/Amsterdam

Lust 'Stad in Vorm' 2001

INHOUDSOPGAVE

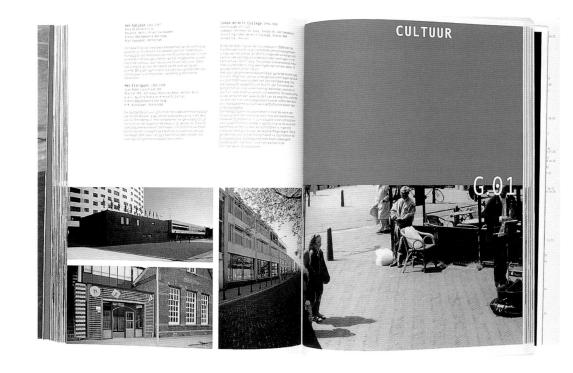

This book documenting the architectural projects of the last 15 years in The Hague was designed by Dutch design consultancy Lust. The photography, by Guus Rijven, is careful to show not only the facades and spaces of the buildings, but also the architecture in context – peopled by those who live and work in the buildings.

The design of the book is based on a classification system which helps to guide the reader through several layers of information throughout the book. The ten chapters, each covering a different genre of

architectural planning, are represented by specific colours. These colours are combined with an alphabetic 'numbering' system, which runs from A to J. Therefore, each building is given a distinctive 'serial number' comprised of the section letter and colour. On the inside of the dust jacket, several maps of The Hague are presented, showing only the areas mentioned in the text. Thus a cluster of green numbers on the map reveals, in an intuitive way, that that part of the city is mainly residential.

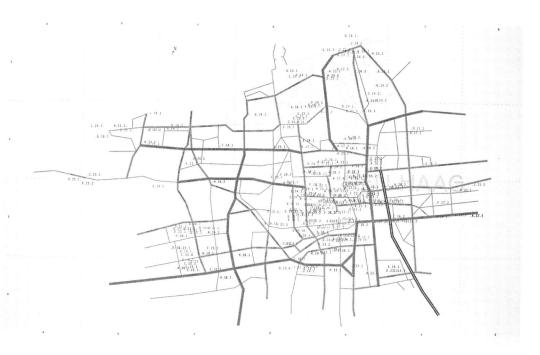

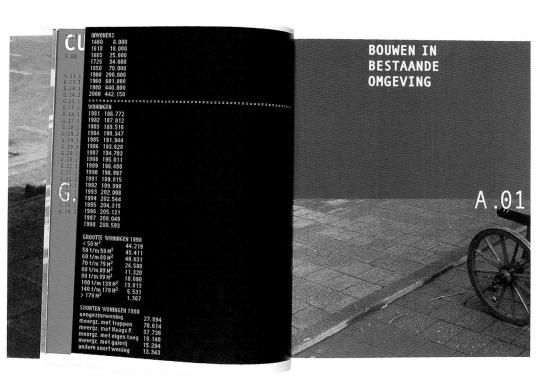

ust

Fietstocht doorVinex-locaties Den Haag 2001

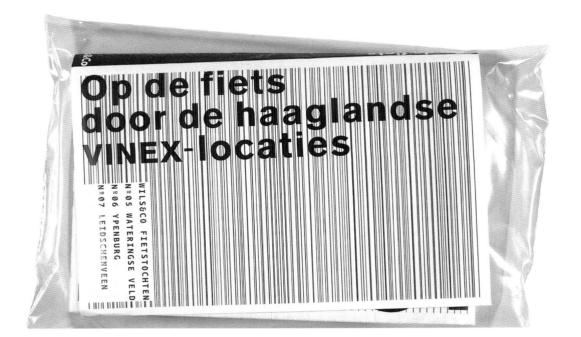

In celebration of Architecture Day in Holland, a set of maps were published to describe cycling tours of the special architectural projects built in the 'vinex' communities of The Hague (public lands set aside by the government of the Netherlands for suburban growth). A matrix was designed as an index to help users quickly find either the streets where projects are located, or the architects who built them. The street names form the y-axis and the architects' names form the x-axis. Each architect is given a colour, thereby making it simple to spot an architect and their projects on the map. The colour scheme of the matrix is

defined by the alphabetical order of the street names, which gives the matrix of each map a unique 'colour fingerprint'. The 'fingerprint' of each matrix is then used as the cover panel for its respective map. All three fingerprints stacked on top of each other then form the cover for the whole piece.

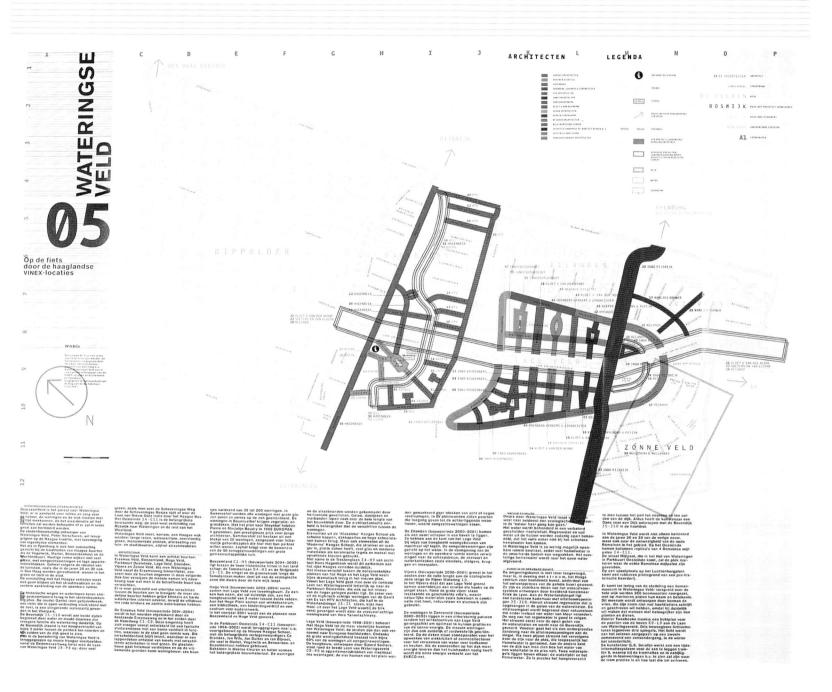

Fietstocht doorVinex-locaties Den Haag

2001

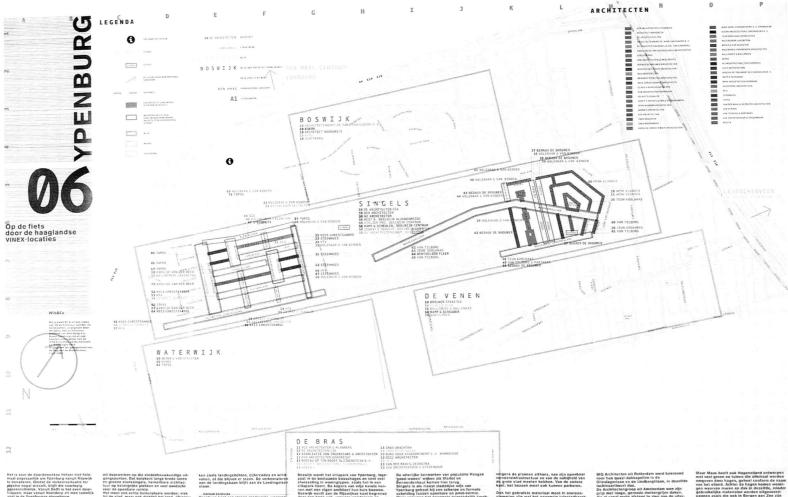

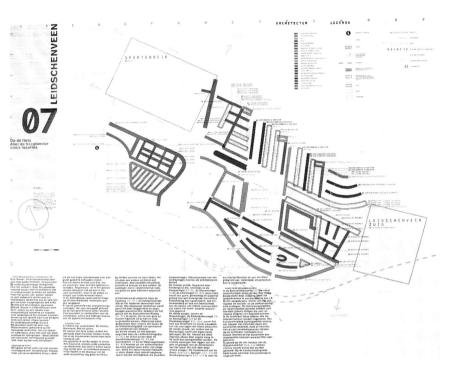

H 14) S (SHAMA)	O Hiller of Reports		## #UDFEE COMPAGNIS (#V12E PA1134)		
18101				The second secon	#E AND PARTIES
IP+++				00 DOCTEDETO STREET	VICE PLANT STATES
	Annual Coloniana and Coloniana Coloniana and			TR ROUTE STEERS	
		13 (accessors) escentific	14 MUTTE CONFACTORS (NTTE PATEER)	1) tredte	ARCHITECTER
			15 corrie (oursteams (artes ratios)	14 ASSELLATION STREET	
					Pe conces decices
		29 1445(15) 4	NAM DES MEES	years a resemble of the consequence of the same	2) 130(20 5011(45
		33 contact (CAN DER MEER		
34 14135 15511864C5		15 (ess 61)56136		26 ortifetti Steess	W
				25 TAX SARREES & YAR	YEEN 29 530ERS SOLTERS
	PE CLASS S KAAR	KINCHA L RODEDA		NA ANCIENCE CLASS	
				33 SPECEVELO STREES	34 5 100 mb 500 71 m5
	PE CLASS & CAMP		34 KOLPER (DOPAGNIOS (ATTEC PARLIN)		
			43 COLFEE CONFACTORS (EVILL PATEIN)		1111
44 NC 45C411CC1004510004			d surris conracanas (avril ratios)		
And the second s					46 ART SHAIRE
	_ 27 Tribut St Hopets			49 POECEVELO STREES	SO VERNESSEN VERERNEN D. DE HAAN
			DO COM P NAM STIC	1	52 ANT ZEALTHE
				SA VAN SAMPLEK & V	
	14 CLUSS & CLUS				
9111					4 turn setter
	42 CLOSS & CARE				44 SPOCKED SOCTIONS 41 VERNOTTER VERNORER & OF HARR
			40 van 1	MEN DEVEN CANTILES & ROOMBEEN	44 175882 5017181
					44 130583 5051685 47 130586 5051685
	49 HISAUT DE BROYNER	44 1949 413[8]]6	Na entrela reservission (artist tallin)		
19111			31 sylpte (besacens (errit sattin)		P\$ 520(80 \$0(100)
		M sasting a	SA DIS VICE BE LOOF & WAN STELL	,	73 SOCIO SOCIO
	and the same of th	99 5345154 2	VAN DEL MEN		NA VIENCED IN VERSOUR & DE HARM
	29 (LBOS : RASK		AMPPPERS SECULTUCIES		A HOLDS HAME OF THE STATE OF TH
n sta			82 1807 5 VAN 5110	!	
	44 64 (1934)	, compa o modera	85 CHIPCE COMPAGNONS (MYTEC PATEIN)		
	AN AUTHOR M. MANAGE.		## ROIPER CORPAGNONS (NYTZE PATEZN)		
				DO VAN SAMBLEK & VAN	11(A
	45 BIDANE BE RADUELS				
			Tile assectatii		
	97 DOSSELANE, DE COOR			18 VAN SAMBLER & VAN	vitta
	Del CORP E COR	** 1989 W132913K			100 COCKNO SACTERS
	141 CLAPS & CALA		142 414	A DEN OCACE SYNINGS P WOODSELF -	
	B111	A COUNT OF STATE OF S	Marrier Marr	Note	

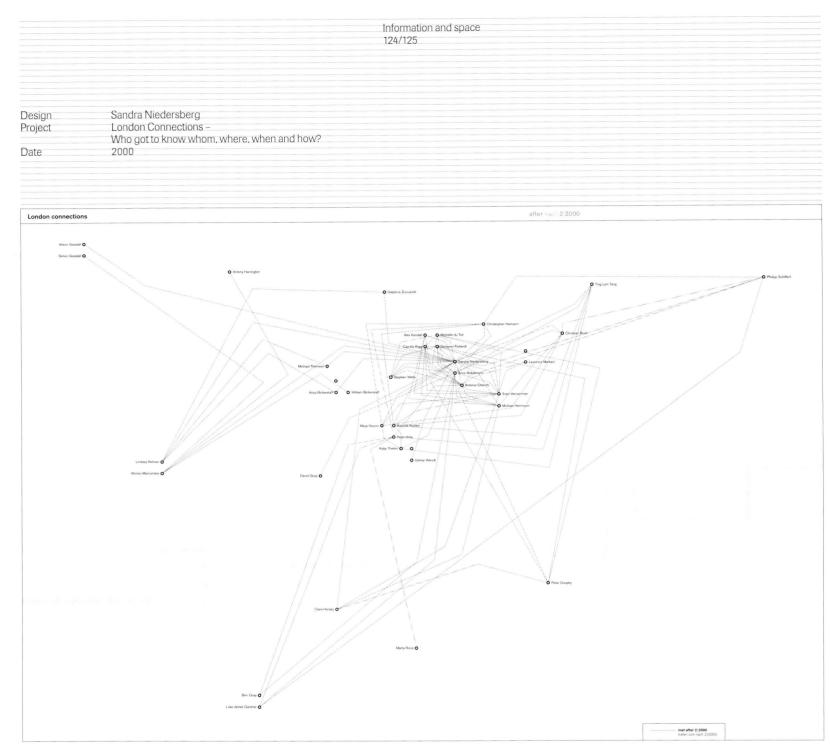

The 'six degrees of separation' theory claims that any two people are connected to each other through a maximum of six friends or associates – assuming that everyone knows a hundred people and those hundred people each know another hundred. In this way six connections are enough for the six billion people living on the earth.

Using this information as an inspiration, Sandra Niedersberg mapped and analysed the way she made friends and acquaintances over a five-month period after moving from Germany to London. The research was extended to include interviews with each contact which formed a book. With the information amassed she also created a series of A2 maps printed onto

translucent paper allowing the different levels to be over-laid to show further associations.

Each map uses the geography of London as its framework, reduced to a symbolic representation of the River Thames. Each person is represented by a dot and their name, the position of which corresponds to where they live. All the co-ordinate dots appear on every map, but a person's name only appears if they have a connection on that particular map. Each map shows different statistics for different situations, such as living, home, work, institutions, school, meeting points and so on, with colour coding used to reveal further levels of information.

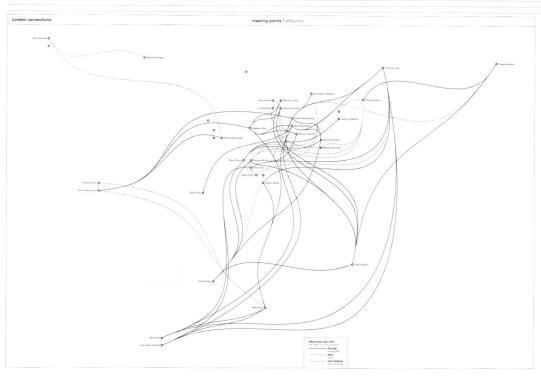

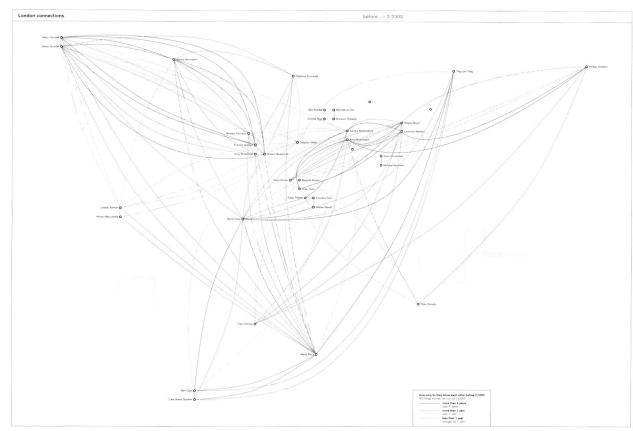

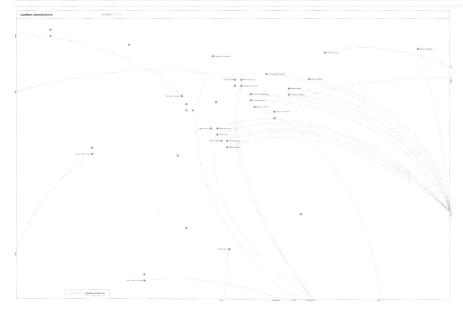

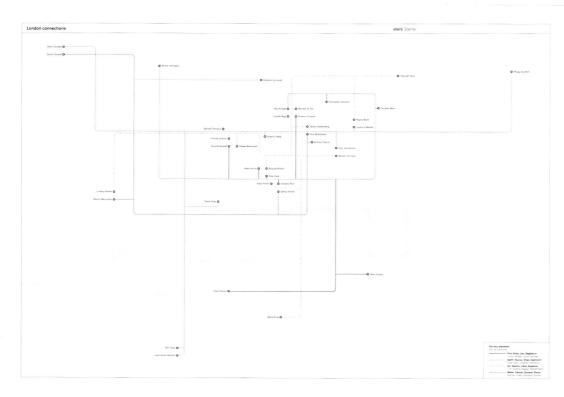

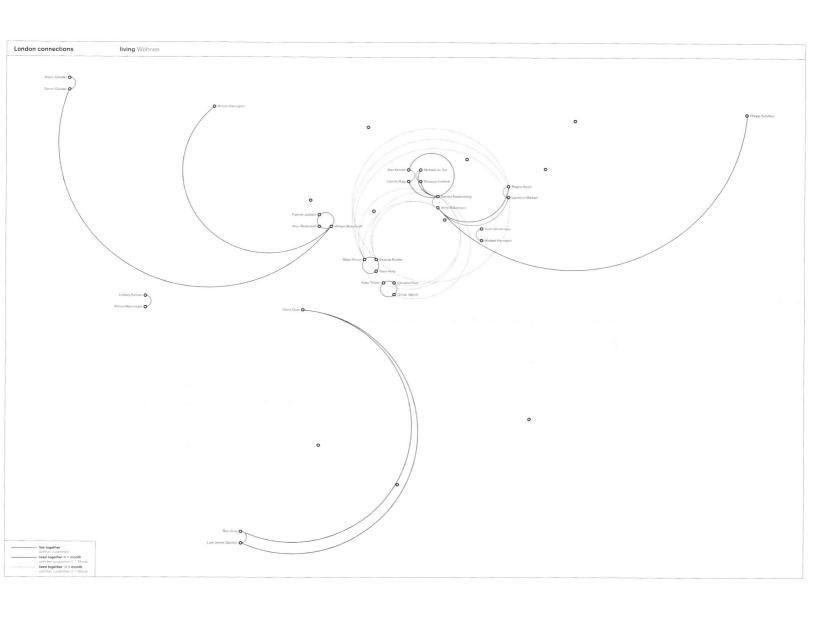

Lust 1³ Map 1999

I3: FROM SCIENCE FICTION

CONTACTS

Shopes - 52 2 TETUDE
FAIL 122 2 TETUDE
FAIL 122 2 TETUDE
FAIL 122 2 TETUDE
FAIL 123 2 TETUD
FAIL 123 2 TETUDE
FAIL 123 2 TETUDE
FAIL 123 2 TETUDE
FAIL 123 2

I³ is a design programme of the European Union involved in research into intelligent information interfaces. As a contribution to the design publication IF/THEN, design company Lust designed a map which showed the relationships between the projects of the 71 institutions involved with I³. It was important to show which project was associated with which other project, whether geographically or conceptually. To map the spatial relationships between the institutions, a cube representing

the world was used which was then deconstructed to reveal the existing and virtual connections of the corresponding projects. The map, although certainly informative in nature, also reveals the 'virtual' or 'experimental' aspect of each project. As well as hinting at the name of the programme, the choice of the cube was also a conceptual necessity since it afforded multiple geometries in which to visualise the connections. This map was designed by Lust for the Werkplaats Typografie, Arnhem, Holland.

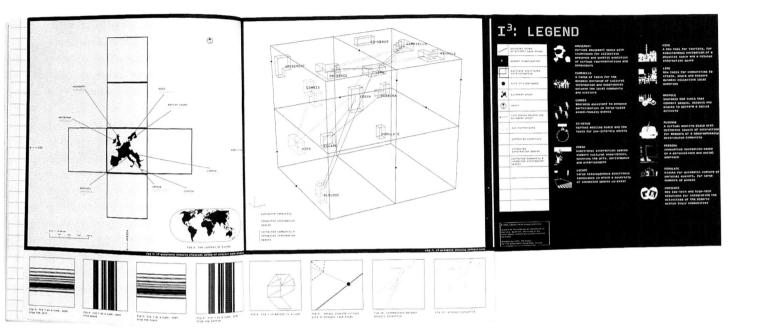

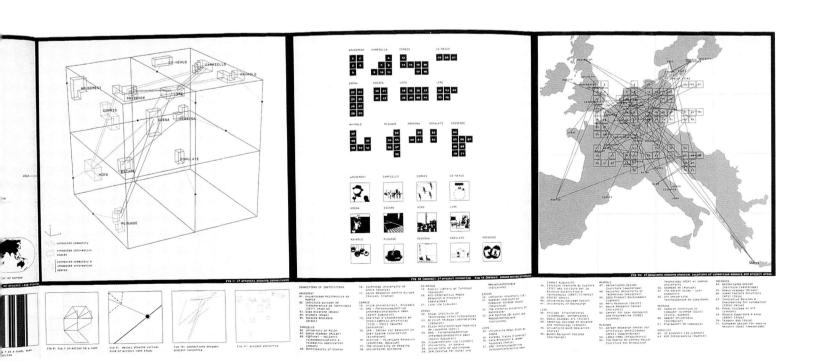

UNA (London) designers 'Lost and Found' exhibit

Nick Bell, art director of Eye magazine and principal of UNA (London) designers was invited by the British Council to create a piece of work for an exhibition entitled 'Lost and Found', held in Belgium in 1999. He designed a map in the form of a tablecloth which uses typography to show the wettest and driest parts of England and Wales, and simultaneously explores the influence of invaders and immigrants on the language. Screenprinted onto paper damask banqueting roll is a list of nearly all the rivers that drain off Britain to the north, south, east and west. When the work was exhibited, pots of crayons were placed on the tablecloths (covering tables in the gallery refrectory) inviting vistors to comment on what they had seen. The list of French, Celtic, Norse, Roman, Flemish and Dutch river

names all found in England and Wales, are testament to a rich and varied history. The map, the designer suggests, makes the point that "despite being an island race, with an occasionally isolationist stance, the history of the country seems always to have been multi-cultural."

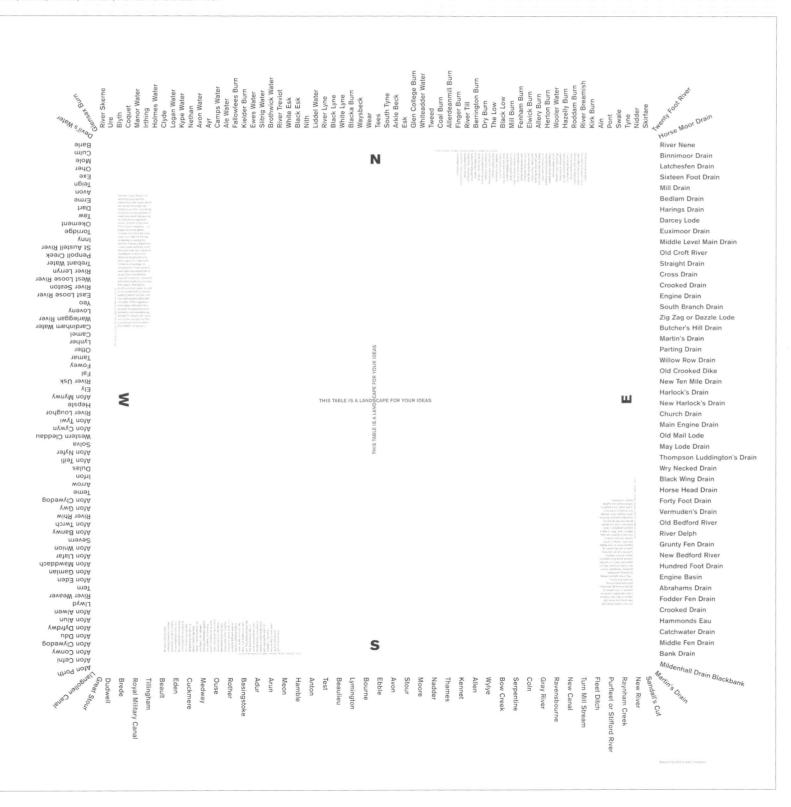

Lust

HotelOscarEchoKiloVictorAlphaNovemberHotelOscarLimaLimaAlphaNovemberDelta 2001

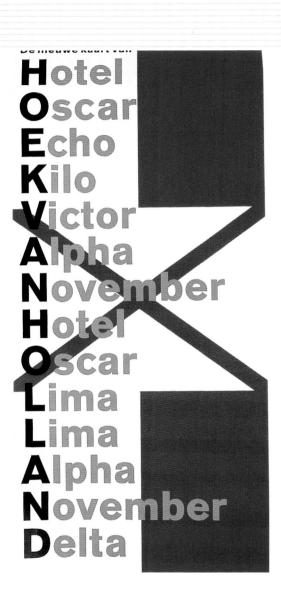

To highlight Hoek van Holland (Hook of Holland) as the 'beach & water recreation area' of Rotterdam during 2001, the year the city was European cultural capital, a map was published which revealed the many facets of Hoek van Holland: historical, economic, industrial, residential, maritime, recreational, and so on. A two-metre-long sheet was needed to cover the broad range of information presented in the map. To keep the map convenient and easy to use despite its size, a useful folding system was devised that eliminated the trouble of having to continually fold and re-fold the map to see the necessary information. As a result, the map can actually be used as four maps, each giving a greater level of detail than the one that

follows it: Hoek van Holland, the North Sea, Europe and the world. Each folded variant shows information pertaining to that specific area, as well as showing the relation to the bigger area around it. A special projection of the world was also designed that placed Hoek van Holland in the middle of the map. On the other side of the map, the tidal and lunar information of Hoek van Holland is given for a complete year. Full moon is represented by a solid blue, while the new moon is represented by a ten per cent shading of the same blue. The stages of the moon inbetween are shown by increasing the percentage of blue. Seen as a whole, the function system symbolises the ebb and flow of the tides.

The map also records the position of site-specific art installations created for Hoek van Holland, providing another point of contact between the user of the map and the area.

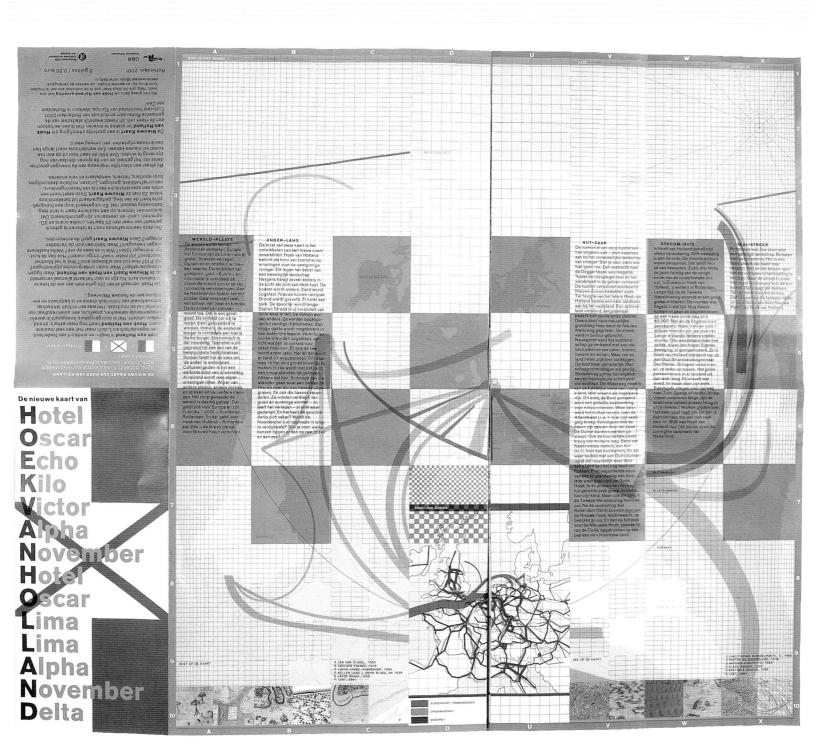

Information and space 134/135

Design Project Date

 $\label{loscar} Lust \\ HotelOscar Echo Kilo Victor Alpha November HotelOscar Lima Alpha November Delta$

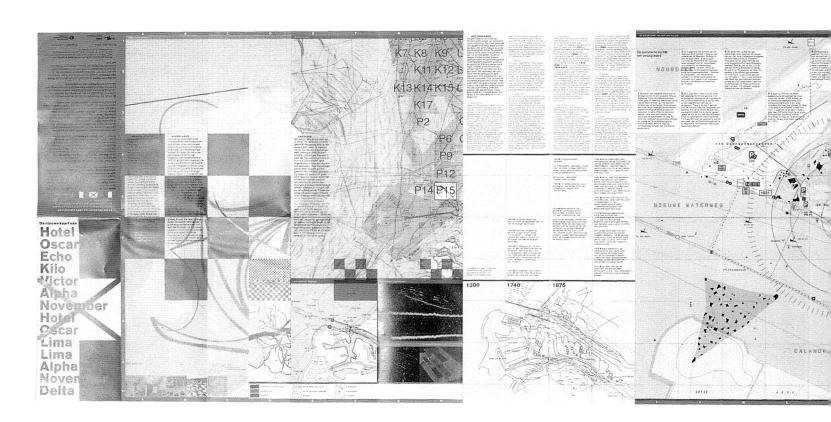

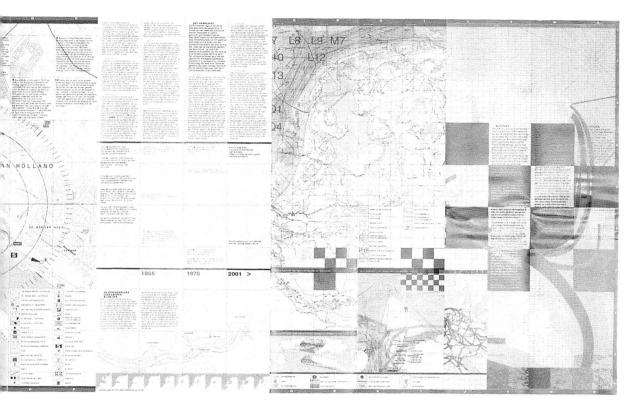

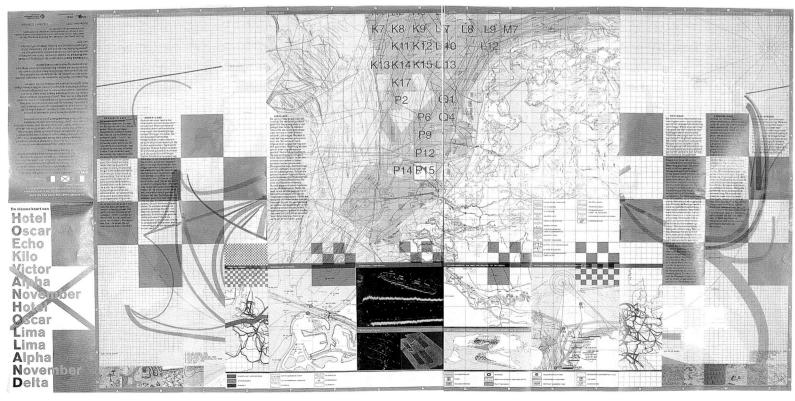

Damian Jaques The MetaMap

THE WETAMAP surveillance and privacy

DYMAXION DREAMS

Distribute in the systematic control of commercialization of commercialization controllation of commercialization of commercialization of commercialization control private flower control con

WWW This control of the control of t

REVERSING THE TRANSFORMATION

1.1.

144

MEAN LOW TEMPERATURE

9-X

This large format map of the world uses the Fuller Projection – Dymaxion. Originally devised by the mathematician, designer and engineer Buckminster Fuller, this system allows the map to be cut-out and folded to form a three-dimensional globe. The MetaMap was developed by Mute magazine and is concerned with global surveillance and privacy. Various colour coded information zones are set up around the edge of the map. These include: Research, State, Hacking, Security, Tech DIY Education, Privacy and Free Speech Campaigning,

Publishers, Independent Media and Open Infrastructures. Each zone has a numbered list of locations with URLs for relevant web sites and brief descriptions of each site. The number and colour of each entry is also reproduced on the map to show the global position. The map also contains information about radar listening stations and satellites.

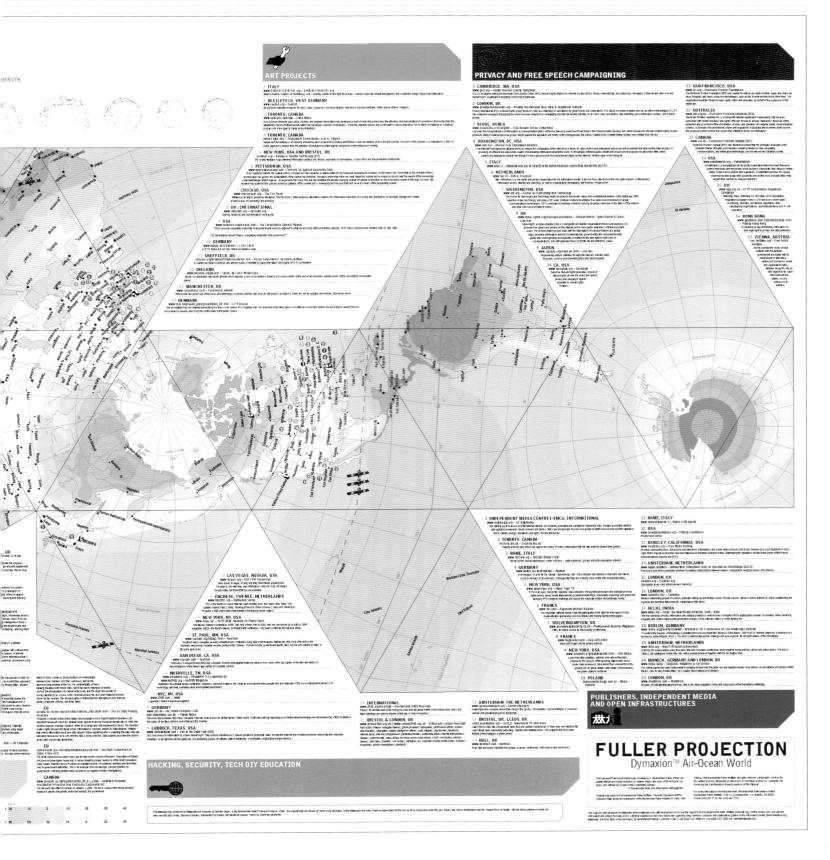

Lust kern DH map 2000

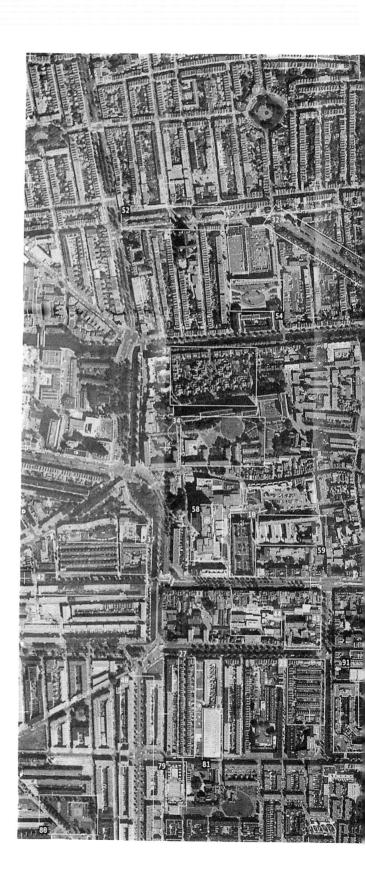

This map, designed to commemorate the 'Week of Architecture 2000', shows a number of 'year rings' that represent the periods of important growth and development of the city of The Hague. It features a giant satellite photograph of the downtown area. The map includes an extended index, showing the growth in structure' and 'mass' of every period, and covers in text and images the most interesting architectural projects and urban development. A colour scheme was designed which assisted in the mapping of these architectural projects in terms of location, the period of their development, and their relationship to the growth in structure and mass.

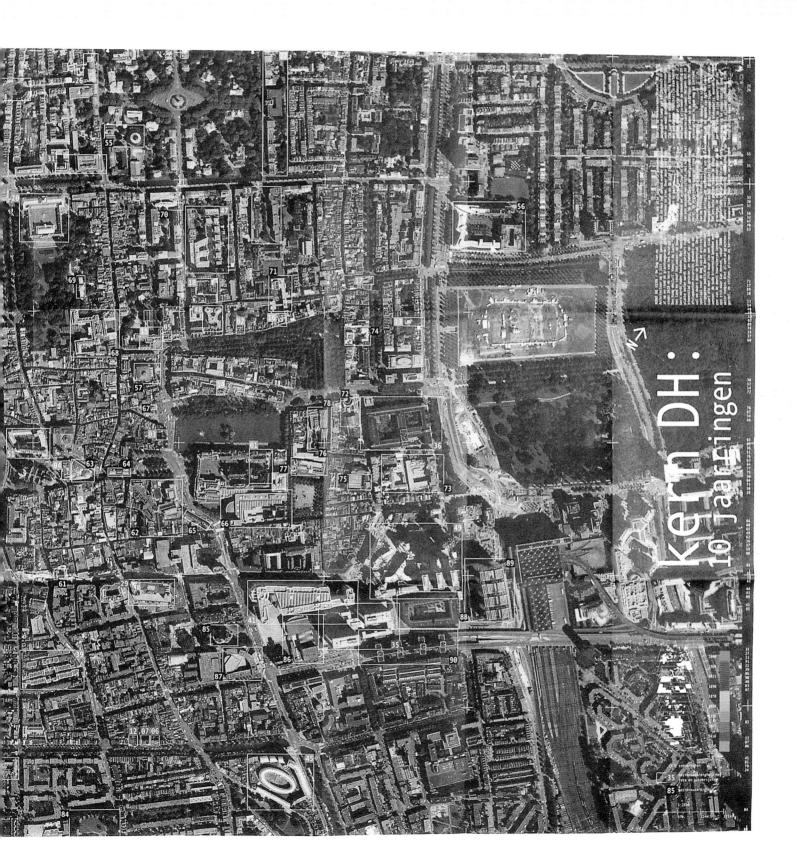

Lust kern DH map 2000

Studio Design Project Date Sinutype Maik Stapelberg and Daniel Fritz AM7/Die Deutsche Flugsicherung Frankfurst/Langen

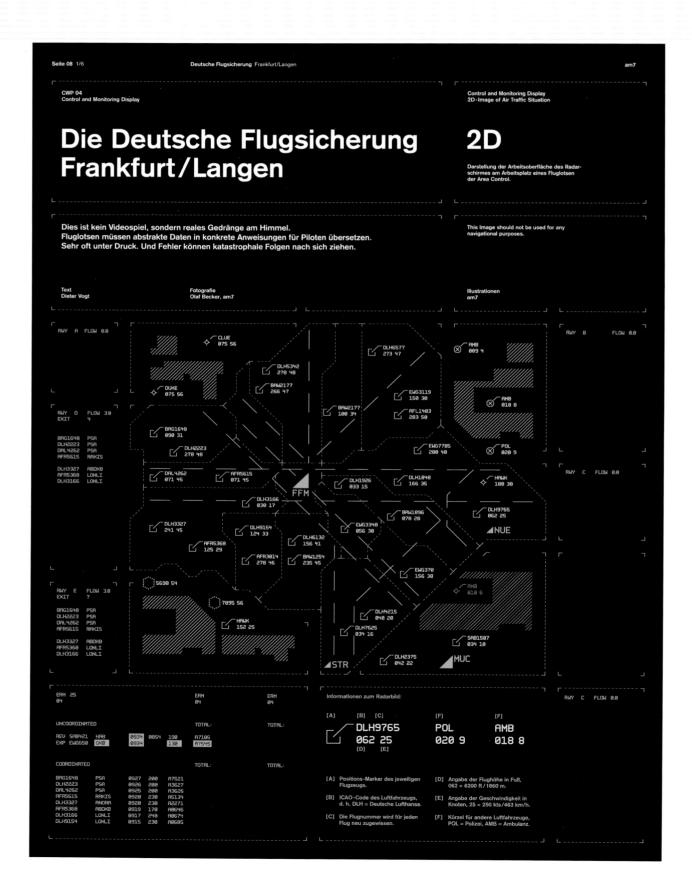

The 'Akademische Mitteilungen' (Academic Announcements) is a publication of the Academy of Arts and Design Stuttgart, Germany. Issue seven, edited by Daniel Fritz and Maik Stapelberg, two students from the academy, was based around the theme of communication.

This article is about the German air

traffic control network, based in Frankfurt/Langen, Germany. The diagram on the left shows the given information from the radar monitor of an air traffic controller which appears only as two-dimensional data. The diagram on the right shows a three-dimensional version of the same data. This view, of course, is left to the imagination of the air traffic controller. The three dimentional version is instantly more approachable, visually representing as it does the altitudes of the various aircraft.

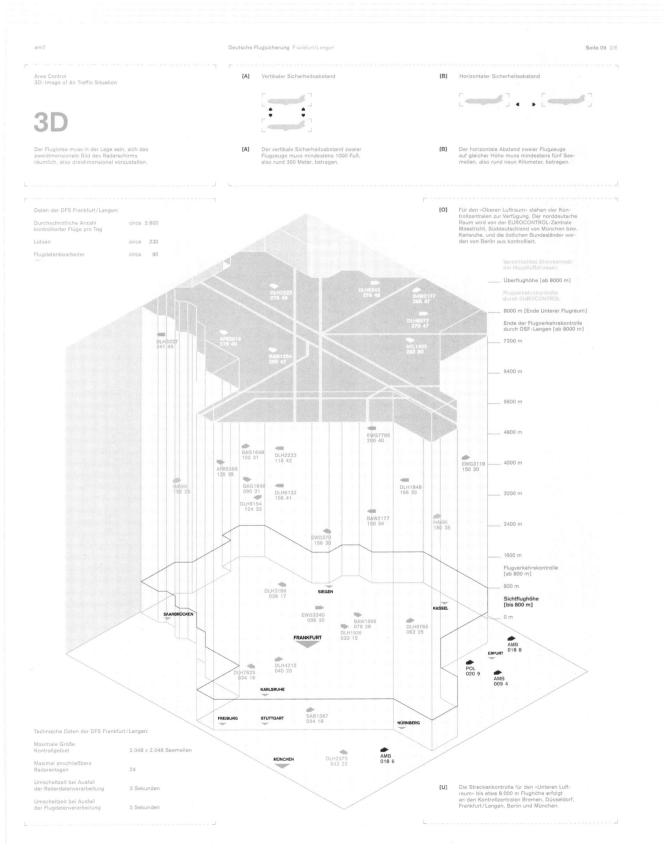

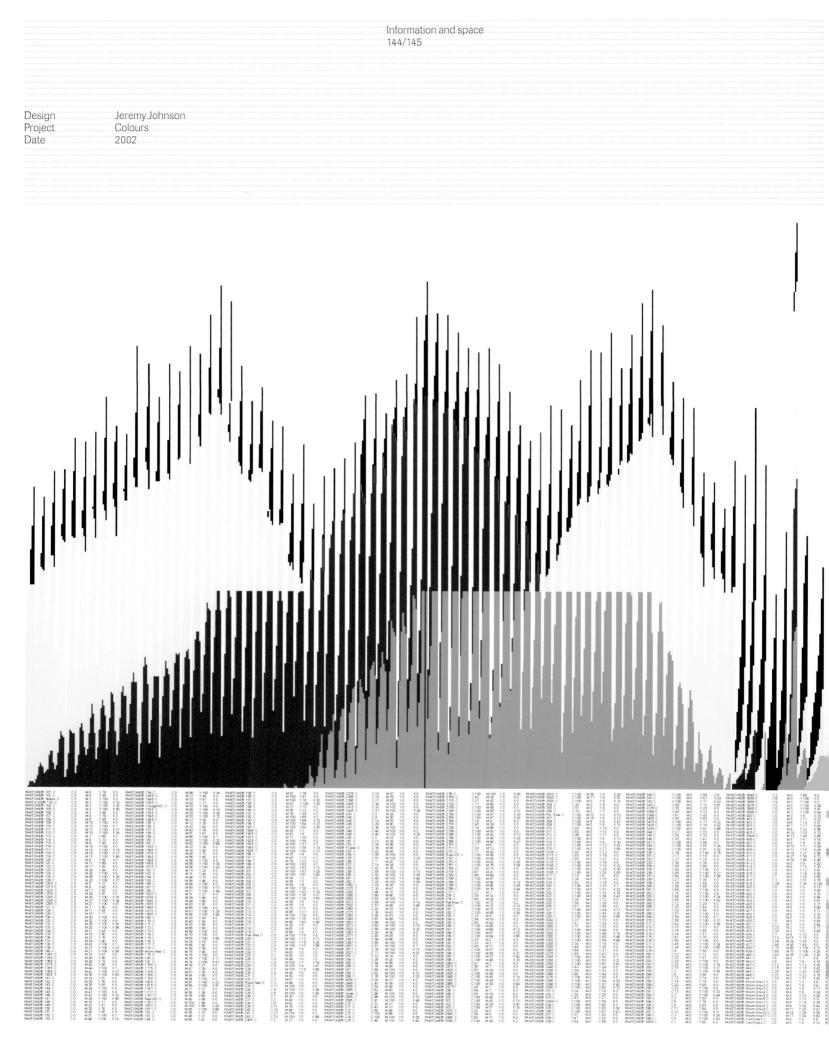

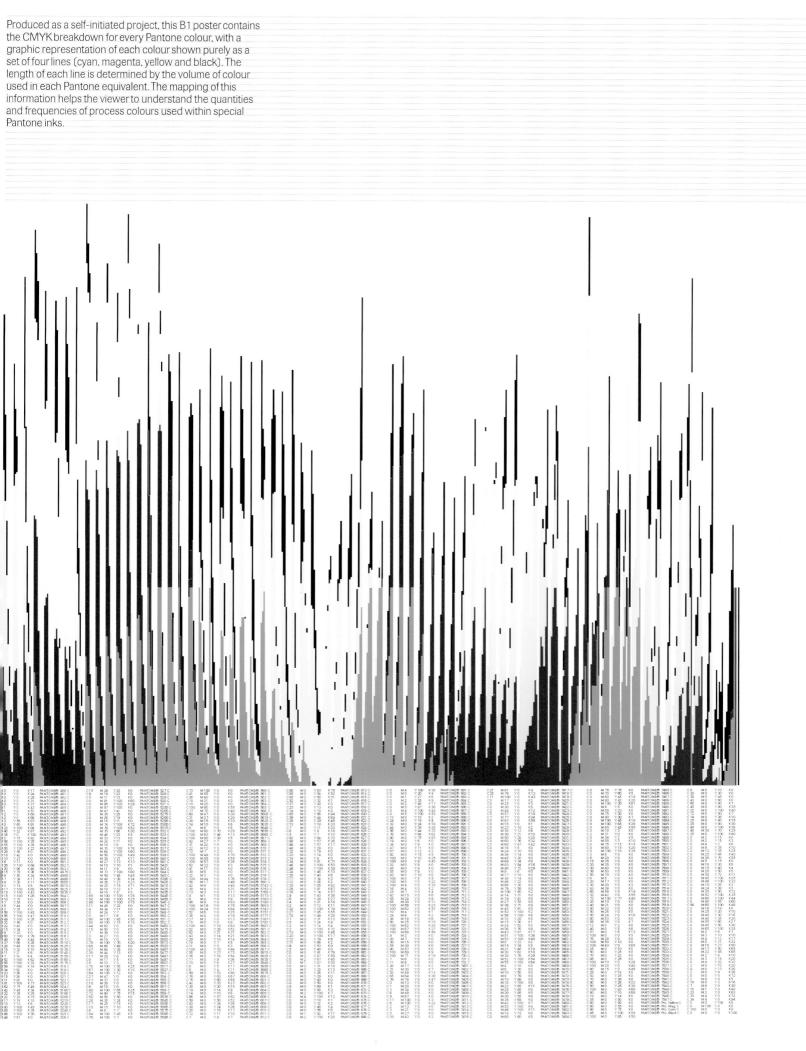

Design

Hochschule für Gestaltung Schwäbisch Gmünd Student project 'Arbeitssuche im netz' 2001

Project Date

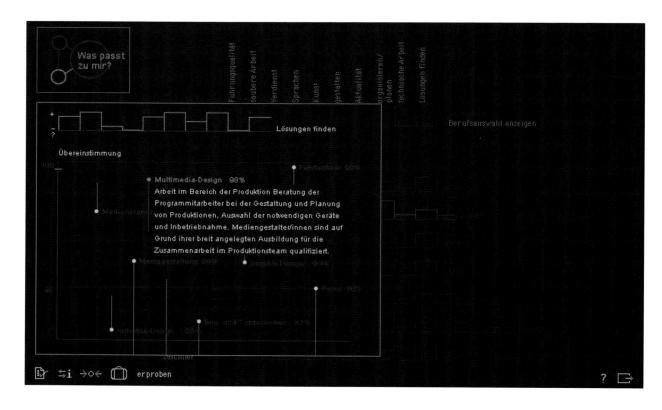

Produced as a project by students at the Hochschule für Gestaltung Schwäbisch Gmünd in Germany, 'Arbeitssuche im netz' is a system to aid job-hunting on-line. The site is aimed at people whose knowledge and skills do not fit in with the traditional criteria set out on many such sites. The site visually illustrates skills-matching and uses a complex indexing system to direct the prospective candidate to the correct area.

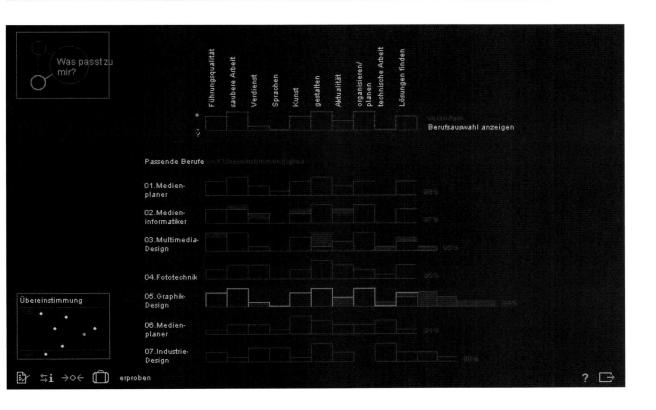

Information and space 148/149

Design

Hochschule für Gestaltung Schwäbisch Gmünd

Project Date Student project 'f.i.n.d.x.' 2001

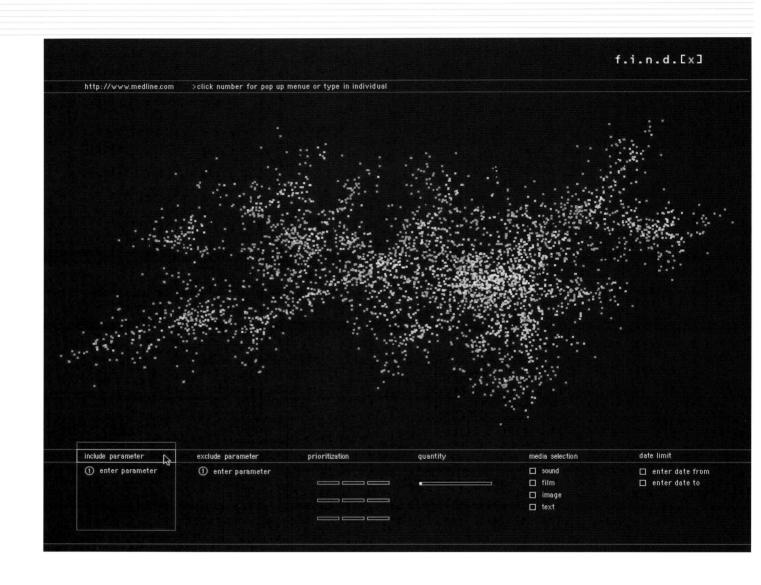

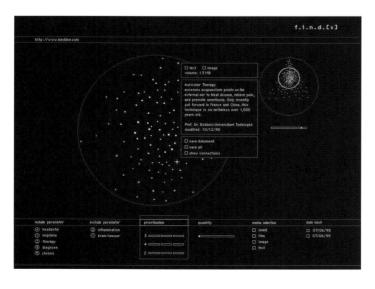

Produced as a project by students at the Hochschule für Gestaltung Schwäbisch Gmünd in Germany, 'f.i.n.d.x.' is a visually-aided investigation instrument for the medical industry. The web site uses as its starting point the chaos of fragmented information that is the Internet, illustrated using hundreds of small green floating squares which form an organic galaxy of information. The user can select areas and zoom in to focus on specific areas of research and information.

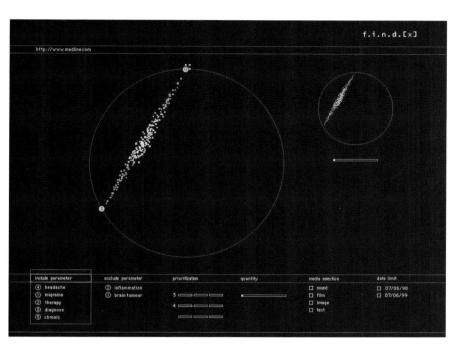

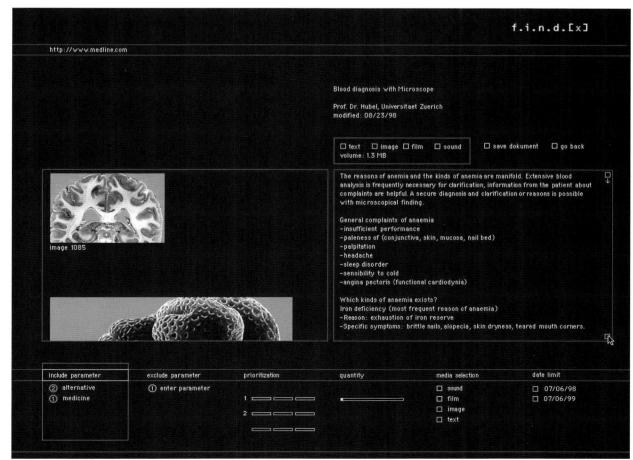

Information and space 150/151

Design Project Date The Attik Ford 24/7 2001

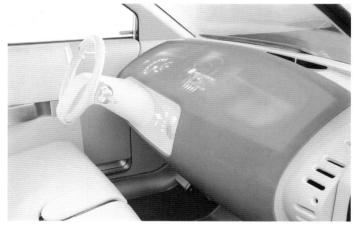

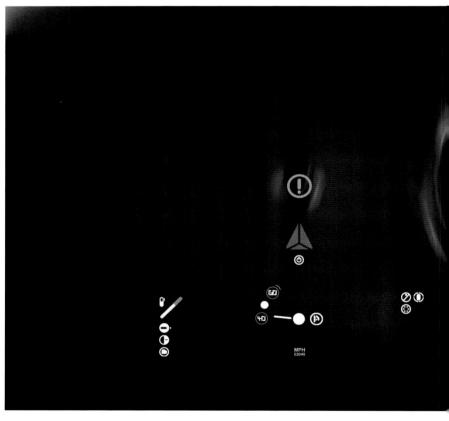

The Ford 24/7 car was one of the highest profile concept cars of recent years. The car was designed by the internationally renowned designer Marc Newson, who conceived the idea of a multi-purpose vehicle that could change its form for different uses. The Attik was commissioned to create an information system that would also revolutionise the traditional car dashboard. The designers' solution was to strip back and remove every knob, button and switch and replace them with a clean curved panel that occupies the full width of the dashboard

area. This touch-sensitive panel contains everything necessary for the car's on-board computer system. The information is viewed as a more filmic experience than a conventional touch screen interface, with morphing colours and information which changes according to the operator's requirements, in much the same as the car itself can be customised.

04_Time and space

Mapping change 152/153

I saw a man he wasn't there

Essay by William Owen 154/155

There is a class of maps that plot the things that are not there, that cannot be touched or won't be captured in a single instance. These are maps of information, ideas and organisations; of logical systems of thought, science, business or design; and of change - the mapping of events or actions unfolding over time.

The attraction of mapping intangibles (as opposed to using words or tables to represent them) is that the map can make the relationships of things to one another real and create an intuitive understanding of their dimensions and properties - whether these are concrete, abstract or metaphorical. The graphic language of maps lends itself to representation of the whole of a thing and its parts in a single view, within which we can oscillate rapidly between different levels of detail. Maps allow patterns to emerge and become real, by showing what lies between the visible incidents, artefacts or moments we can otherwise see

(Information maps are not diagrams. Diagrams are graphic explanations: a map is a graphic representation, although it might explain by inference.)

The importance of mapping intangibles has increased in proportion to the speed of technological and social change. The dematerialisation of products and services and an onrush of excess of choice, facts and demands for our attention results in a disordered and unfamiliar world. In many areas of life the speed of change has created a problem of understanding at the most basic level of what things are, what their value is, who they are for and how to use them. What is lacking is any kind of consensual systemic image of novel objects, organisations or networks. Customers are having difficulty understanding services or product offerings; businesses are changing so rapidly they cannot retain a complete picture of themselves, their operations or of their customers; citizens lack the consistent philosophies or world views that form a foundation for understanding, or the information needed to come to a decision. All of us have difficulty understanding the rate and extent of change itself.

As an aside, it is interesting to note that the last period in which map-making became a popular medium for reorganising thought was in the 16th and 17th centuries. This was the highpoint of the Renaissance and the birth of the modern world, when scientists, alchemists and Rosicruceans attempted to resolve in maps and arcane tables the contradictions between the old world of faith and a new world of rational thought. Their cabalistic maps sought to explain an alternative relationship between man and the universe. Our information maps are more prosaic but are just as much an attempt to extract order from the noise of everyday life.

GMYNERYN C NEW YORK TIMES

FMANJOO@WI JAMES MERW

PERFORMER + THIRSTY WOR + GRABBING TU + BUZZ ALDRII + THE NUMBER

Twenty-four Hours 182/183

control. A girl of whom met by ANONYMOUS

HI SOUTHERN'S

+SBREBRAND

+ JESUS REAL

In commerce, it is difficult to move forward with confidence unless you know where you are today. The mapping of businesses as a precursor to strategic change has become a valuable activity in itself, practised by design companies, IT suppliers and management consultants. The map becomes 'a moment in the process of decision making', a means of possession and control over the enterprise, and a tool for persuasion - part of a business case.

The need to map business has arisen from the rapidly changing boundaries of commerce and the speed of thinking and action required to shift a business back into a competitive position. The rate of change has been driven by a combination of technical development that has automated (or augmented) human activities, and the breakdown of traditional boundaries of business organisations, with looser arrangements of networks of partnerships and short term contractual arrangements replacing strong vertical integration and permanent employee/employer relationships. This looks like a comparatively messy situation, so we map it to find the pattern

Digital systems promise better business by placing a layer of technology over, or instead of, traditional business practices. Technology has spawned a blizzard of two- and three-letter acronyms - SCM (supply chain management), CM (channel management), KM (knowledge management), DSS (digital self service) CED (customer experience design) and CRM (customer relationship management) – each of which requires an understanding of the relationships, processes and dimensions that are affected. A sensible response is to map the existing and desired situation, and then to identify the gaps.

Businesses are not landscapes, but they do have their own geographies. These are comprised of a host of customer, supplier, regulator, partner and internal relationships; of processes with inputs and outputs, nodal points and directions of flow as well as a beginning and end; of numerous domains of competence of different sizes and characteristics, and diverse dimensions by which the nature and state of the business are monitored.

There is a class of maps that plot things that are not there – logical systems of thought, science, business or design; and change – the mapping of events or actions unfolding overtime.

Nina Naegal and A. Kanna Time/Emotions 194/195

Damien Jaques and Quim Gil Ceci n'est pas un magazine 192/193

UNA (Amsterdam) designers 2001 Diary 160/161

The signs and metasigns devised to map physical geography apply themselves well enough to logical systems. Network diagrams illustrate flow and dependencies. matrices show boundaries and absolute size, distribution maps show positions of entities relative to one other - such as competitive position referenced against selected axes or dimensions, and nested signs can represent hierarchies. Maps are particularly useful in revealing how complex activities such as customer interactions work. Businesses touch their customers in many different ways: different parts of a business may be involved in a particular relationship or transaction which may be mediated over multiple channels - shop, phone, SMS, letter, advertisement, etc. It may be critical to a business to understand what is known about a customer at each touchpoint, what value is being exchanged, who the customer is and how they can be characterised usefully and accurately, what is the cost to serve the customer and what is the customer's value over the lifetime of their relationship with the business. The problem is one to which mapping can be applied in order to understand complex patterns of communication and exchange - and to identify contradictory, unwelcome, inefficient or overpriced transactions of whatever kind,

The importance of taxonomy in mapping logical systems, such as this, or when mapping knowledge, cannot be overstated. It is essential to arrive at useful and coherent classifications of things before they can be ordered into their proper place. Inconsistent taxonomy produces a useless map. This is the point, then, at which cartography merges with librarianship and design strategy, and where we arrive at alternatives to standard tabular classifications of books and look instead at pictorial representations of families of information to enable the extraction, viewing and contextual

understanding of any kind of symbolic record.

The Internet has created a new class of problem in mapping information. Digitally stored information resolves into a much finer grain than analogue information, reducing down from the book, magazine or journal to the chapter, the article, the image, even the phrase or word. Likewise it no longer has any physical host to provide any kind of 'natural' ordering. This has been highly beneficial, in so far as we can extract information much more quickly in a more convenient form, and we can make connections more quickly wherever a link has been inserted. What we lack, however, is a representation of the entire body of information or a means to rummage around it - with two important exceptions: the catalogue (e.g. Yahoo) and the search engine (e.g. Google). These are of course purely linguistic tools, strictly finite in their nature, smothering serendipity, and sometimes limited to the point of stupidity in understanding what it is we are really looking for.

The alternative to linguistic search is a graphical interface that may allow for less exact but ultimately more successful investigations. A highly successful example is Smartmoney's 'Map of the Market' (a chloropleth map of the market capitalisation of Fortune 500 companies that changes dynamically with the stock price). This is a graphical representation that gives a genuinely useful overview of states and trends combined with detailed information, interrogated by a graphic interface.

The Map of the Market succeeds because it layers information in two dimensions and uses a consistent taxonomy to divide the layers and a design strategy that reveals the dynamic quality of the activity it represents. Everything necessary to obtain an overview is visible simultaneously and in the correct proportion and state.

This essay, however, ends with an acknowledgement of failure. Most designers who have attempted to represent Internet-based information have produced maps that show nothing but network flows or nested texts. These maps have failed to replicate, in even the most rudimentary way, the sensory representation (and the massive boost to the memory and the imagination) one receives on entering a library and seeing, smelling and feeling the books on the shelf. One of the reasons for this failure has been an obsession with 3D perspective within the computer-oriented section of the design community. The idea that a perspectival simulation of the physical world will help us understand digital information is a fallacy, because perspective limits viewpoint and imposes distance where none exists. For proof, visit Cyberatlas.com, where there are numerous representations of the Internet in three dimensions that tell us nothing at all about what is there.

Time and space 156/157

Design UNA (Amsterdam) designers / UNA (London) designers

Project Diary Date 1998

Photography Anthony Oliver

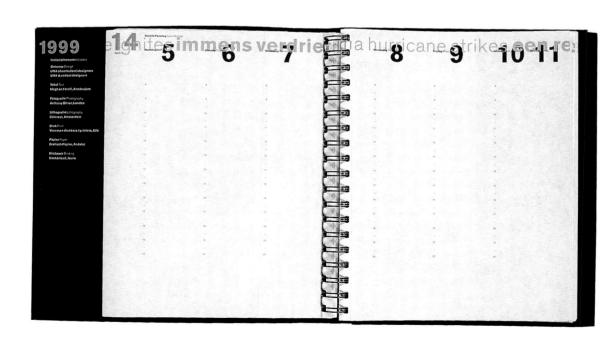

To date the Dutch design consultancy UNA has produced twelve diaries, one for each year of the company's existence. Possibly as a reaction to the impending millennium hype, UNA produced a double year edition for 1999 and 2000, as a way of connecting the two centuries. An elaborate folding system was employed enabling the correct year to be visible. The diary has two covers, the first cover titled 'two thousand =1' and the second cover entitled 'nineteen ninety nine +1'. For 1999 the pages work quite conventionally, however at the turn of the century, the pages of the diary have to be turned back on themselves to reveal the new dates, and a fresh selection of photographs.

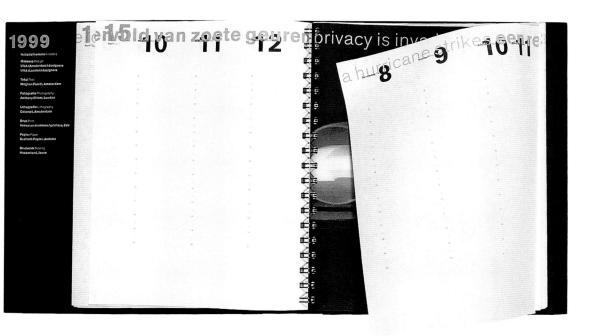

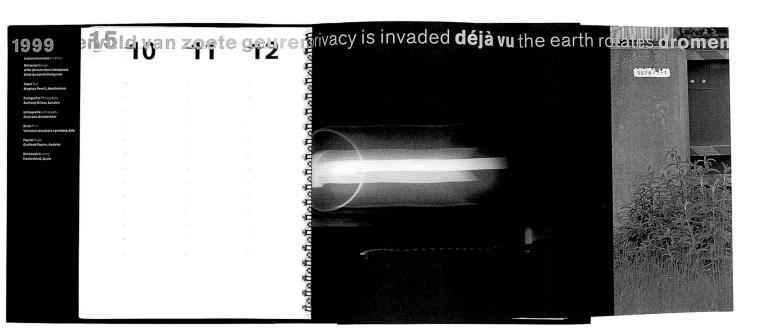

UNA (Amsterdam) designers

Diary 2000

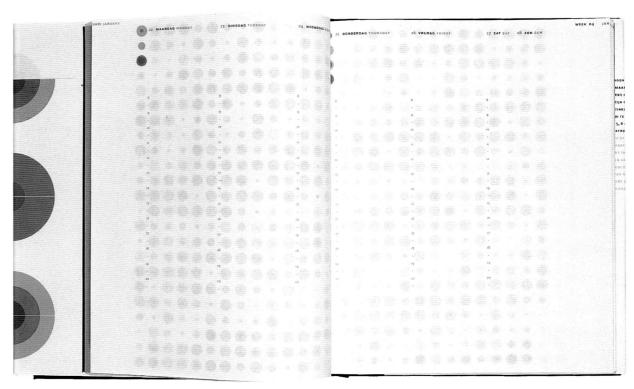

Many recipients of UNA's 2001 diary found it almost too beautiful to use. The quality and attention to detail present in this book is outstanding, as is the complexity of the idea and system behind the design. As stated on the back of the dust jacket: The 365 days of the year are divided into 12 months. each month naturally has a first, a second, a third, a fourth and sometimes a fifth Monday, Tuesday, Wednesday, Thursday, Friday, Saturday and Sunday.

In this diary these particular days are coded by a unique symbol, which means that there is a total of 35 different symbols. The symbols are constructed

by overprinting up to three varying sized concentric circles, in a combination of one of three different colours. On the page where January 1, 2 and 3 appear, the complete pattern of circles representing the 365 days of the year 2001 can be seen. The pattern is in fact mirror printed on the reverse side of the Japanese-folded sheet. On the following page, January 4, 5, 6 and 7, the symbols have moved three positions forward. This twice weekly rhythm continues throughout the diary. Consequently the empty space grows from the bottom right of the page and the year 2001 gradually disappears.'

Time and space 160/161

Design

UNA (Amsterdam) designers

Project Date

2001

THE PROPERTY OF STREET OF STREET STRE

Dutch design consultancy UNA's 2002 diary sets out on a mission to find a significant event globally for each day of the year. The diary, as with previous UNA diaries represents a significant typographic achievement and, through its printing, exudes quality. As in previous examples, the designers have used folded sheets – French-folded in this case – to allow subtle images to appear. The dates, together with information about special events, occasions and festivals, are printed on the face of the sheet, while icons and images pertinent to the particular event are printed inside the French-fold. The pages are perforated along the French-fold edge, allowing the user to easily tear open the sleeve to better access the additional information.

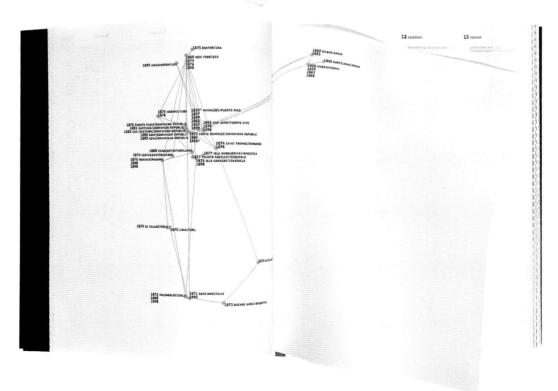

A.G. Fronzoni 365 diary 2000

any year as the only information it contains is the day of the year running from 1 (1st of January) to 365 (31st of December). Every page works the digits into a different form and as the pages are printed onto thin paper the preceding and following page numbers are just visible. which makes the diary even richer. The book is accompanied by a small 12-page concertina-folded leaflet with a month on each page, in which again, the 365 days of the year are listed in one continuous line, with the day and date information running adjacent to it.

This pocket-sized diary by the Italian designer A.G. Fronzoni only measures 95 x 80mm, but with over 600 pages is 38mm thick. Unusually, the diary can be used in Design Project

Date

Tonne Calendar52 2002

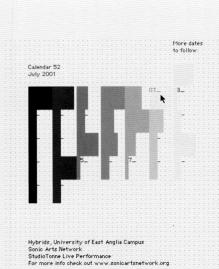

Calendar52 is an on-line visual exploration where the designers have challenged the conventions of visualising calendar dates with the use of experimental typographic systems. Each edition uniquely illustrates the corresponding calendar month, by referencing specific events you can jot down in your personal diary. Initially the project ran from June 2001 to May 2002; thereafter the 12 monthly editions will be archived and published in book format as a limited edition.

Although each monthly interface works differently from the last, the principle remains that by interacting with the site via the mouse, specific diary information is revealed as a date is hit. Interaction plays a large part in the workings of the site as Calendar52 is seen as a collective interactive environment where anyone can up-load diary information onto the site, thereby making the months dense with a variety of information about specific events and personal data.

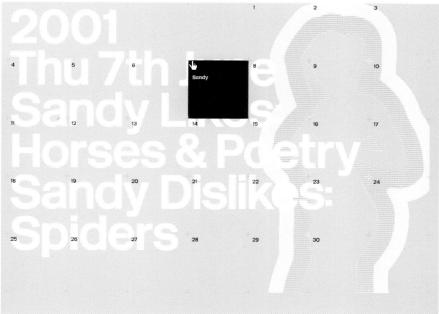

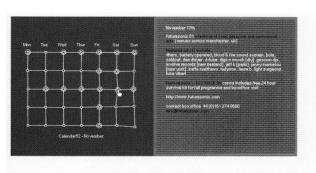

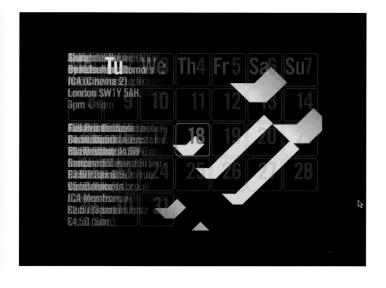

Irwin Glusker
Phases of the Moon 2000

PHASES OF THE MOON 2000

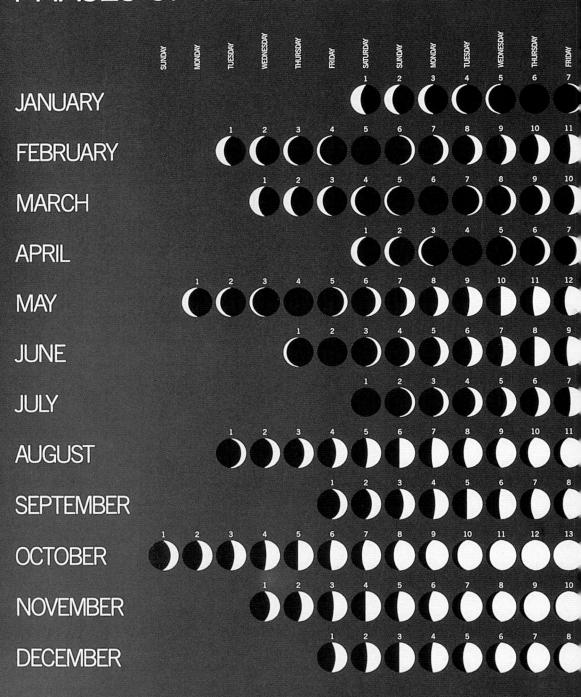

Although not the first or only example of a lunar-related calendar, this example from the Museum of Modern Artin. New York is simple, beautiful, effective, and clearly works as a conventional calendar with each progressive crescent of the moon shown for each day of the month. The calendar is finely printed with each moon crafted with a full circle in a spot UV varnish and the crescent printed white out.

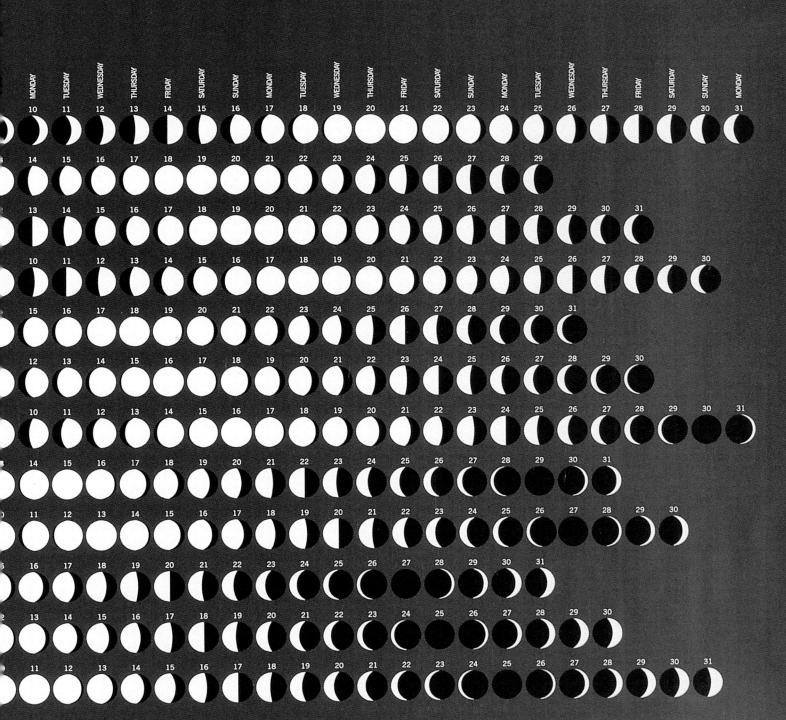

Time and space 168/169

Design Project Date Büro für Gestaltung Calendars 1998–2001 1998–2001

Produced as an ongoing self-initiated project to research the structure that lies behind the 365 days, 52 weeks and 12 months of the year, the aim is to find a different solution each year. The designers were less interested in the final visual appearance of the poster, and were mainly concerned with the process. Each poster measures 840 x 600mm and is reproduced in full colour. The calendars are always typographic, working purely with the given numerical data of the calendar.

Time and space 170/171

Design Project Date Secondary Modern 'Rokeby Venus' 2001

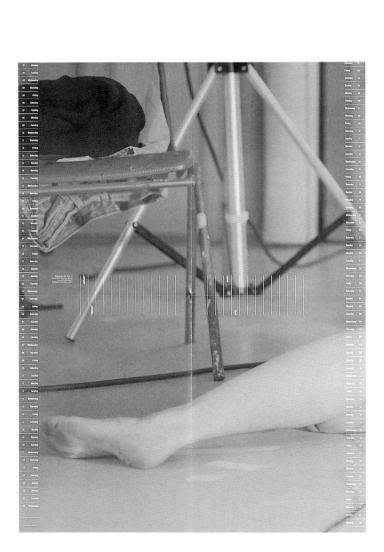

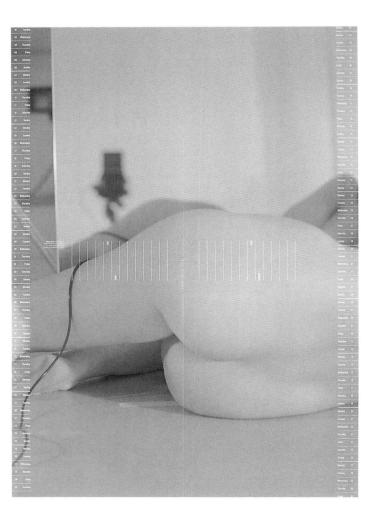

Produced as a set of three A2 posters folded down to A4 and encolsed in a clear plastic sleeve, the designers of this piece are exploring a theme introduced by themselves in 1998, and continued each year since (the calendar shown is for 2001). The typography changes from year to year, as does the content. The 1998 calendar utilised colour photographs of skyscapers shot through the window of an aeroplane. Their 1999 version reduced the work to pure typography, set in a similar manner to the calendar shown. The 2000 calendar used a large, detailed line drawing of an urban landscape.

The 2001 calendar works as a triptych in the classic sense. Entitled 'Rokeby Venus', the nude study is a self-portrait by Jemima Stehli set-up as a transcription of the famous painting by Velazquez, c1647. The only difference is that the cupid in the original has been replaced with photographic studio equipment. The calendar data works as follows: every two months run down a single column on each long edge of the posters. A series of 13 vertical rules runs horizontally across half of each poster; within these rules is positioned the relevant month.

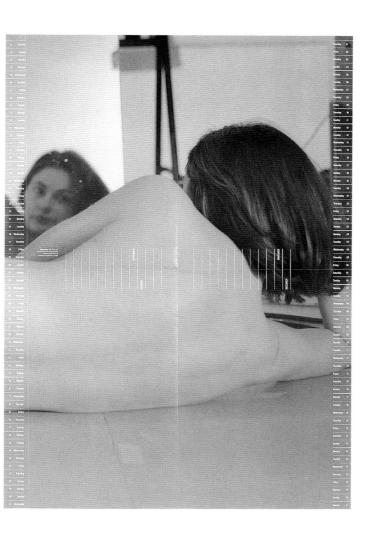

NB:Studio Knoll calendar – Twenty-First Century Classics 2001

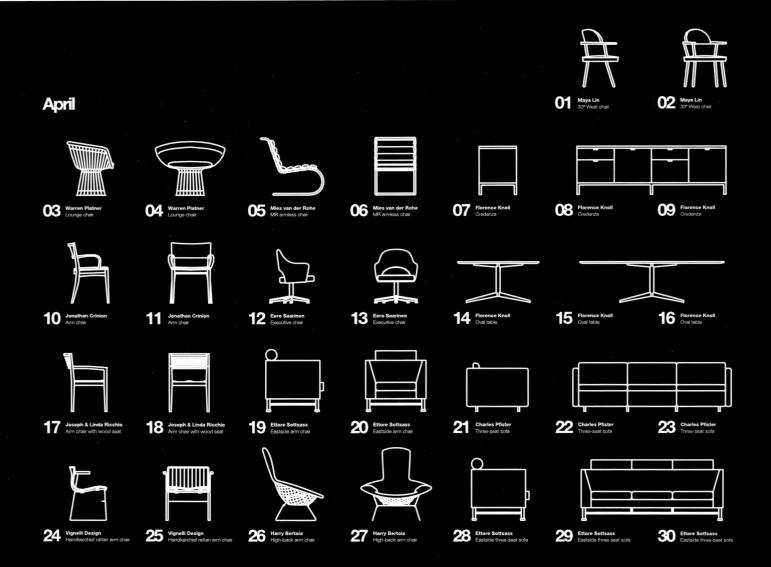

When the UK-based graphic design consultancy NB: Studio was commissioned by the furniture company Knoll International to produce a promotional calendar, the designers' response was this elegant poster. The months are set out in a conventional manner as are the dates within each month. The names of days, however, are replaced with the names of furniture designers and the names of famous pieces of Knoll furniture. Above this information is a keyline drawing of each classic piece of furniture. For weekends, a single sofa extends over the two-day period.

Knoll

ЩΠП

Twenty-First

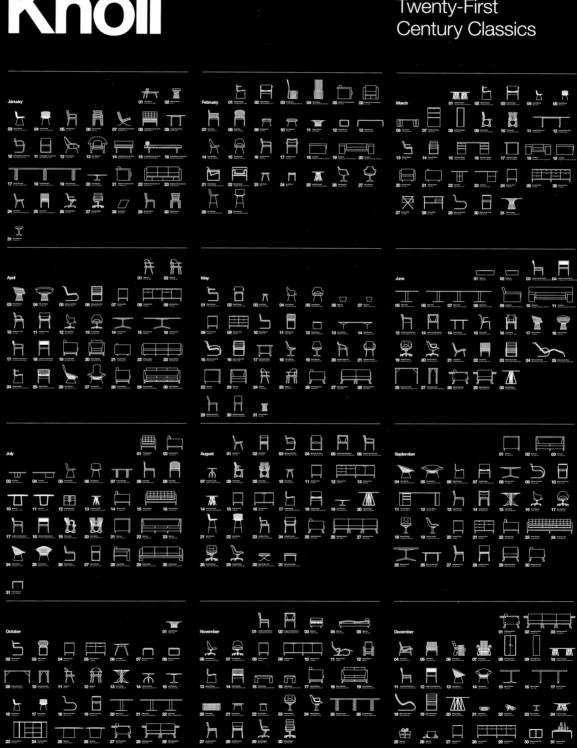

Proctor and Stevenson Calendar 2000

The Bristol, UK-based design company Proctor and Stevenson produced this A3 calendar for 2001. Each month, which was made up of two A3 pages, was given to a different designer within the company, which created a variety of responses within a single design piece.

April (shown here) was designed by Ben Tappenden. The first page maps out the design company's offices by showing the view out of every window in the building. Each image is credited with the name of the designer who sits by the window it represents. These photographs are positioned in rows according to the positions of the windows within the building – the top

row is the third floor, the bottom row is the ground floor. A thin colour bar runs along one edge of each image to denote the orientation of the window – east is represented by a yellow strip on the right edge, south by an orange strip on the bottom edge, west by a green strip on the left edge.

The second page of April contains the dates for the month with an aerial satellite photograph of the area the company's building is located within, together with a series of detailed images showing fragments of the surrounding environment.

Struktur Design 1998 Kalendar 1997 Design Project Date Struktur Design Seven Days 1999 1998

1998	01	Jonusty Theraiding	Federically Stanfal	March	April Wednesday	54ay Friday	Sine Monday	July Wednesday	August Saturday	September Toesday	Comber Thursday	Noncolities Standay	December Tuesday
	02	Jarridcy Friday	February Mgnday	March Manday	April Thursday	May Saturday	lune Tuesday	July Thursday	August Sunday	Semester Wednesday	Getober Friday	November Monday	December Wednesday
	03	January Saturday	February Tuenday	March Tuesday	April Friday	May Sunday	Arie. Wednesday	nd; Friday	August Monday	September Thursday	October Seturatry	Newscripe Tuerlay	Decomber Thursday
	04	Jantory Sunday	February Wednesday	March Wednesday	April Saturday	Musuley	Thursday	Saturday	Angust Toesday	September Friday	Occober Suitedity	November Wednesday	December Friday
	05	Jenosty Monday	Filtrary Thursday	March Thursday	April	May Tonsday	Reto Friday	July Secondary	August Wednesday	September	October Monday	November Thursday	Quotilities Saturdo
	06	Jonathy Tuesday	February Friday	March Friday	April Monday	May Wednesday	june Katurday	tuly Monday	August Thursday	Seprember	Ostober Tuesday	Newsolder Friday	(Micenhal)
	07	James day	February Saturday	Mach Exterior	April Tunsday	Nov Thursday	Aire Suedug	toly Tuesday	August Felday	Sipposter Monday	Verdee Wednesday	November Saturday	Discerties Monday
	08	Asterny Thursday	February Sometry	Mesh seed y	April Wednesday	May Friday	Arre Monday	kely Wednesday	Argust Saturday	September Tuesday	October Thursday	November	Gurenhe Tuesday
	09	January Friday	Monday	March Monday	April Thursday	May Successary	Julie Tuesday	Joly Thursday	Asyst	September Wethooday	October Friday	Monday	Decardos Wednesday
	10	Juncery Seturday	February Tuesday	Mirch Tuesday	Acri friday	May Sunday	hine Wednesday	fully Friday	August Monday	September Thursday	Outober Setterday	November Tunsday	December Thursday
	11	Jahonny Econology	February Wednesday	Mirch Wednesday	Koli Saturday	May	foot Thursday	33y Saturday	August	Saptember Friday	Sunday	November Wednesday	Decombes Friday
	12	Monday	February Thursday	Macen Thursday	April Surelay	May Tuesday	Ame Friday	July Secondary	August Wednesday	Septimilar Security	Descent Monday	November Thursday	Decorage Security
	13	January Tuesday	Friday	March Friday	April	Mis Wednesday	XXVE Materilay	Manday	Acquist Thursday	September	Desobs: Tuesday	November Friday	Dittenbet
	14	Amosy Wednesday	Femaly	Mack Enlarder	Acut Treesday	Ato Thursday	Jose	isily Tronsday	August Friday	Sustembs Monday	October Wednesday	Naisperies Salares	December Monday
	15	January Thuraday	Fetrusty Sunday	Maco Sounday	April Wednesday	May Friday	Acc Monday	Suby Wednesday	August Salarday	September Torosdoy	Getaber Thursday	November Surrelay	December Tuesday
	16	isourcy Friday	fromwy Monday	Monday	April Thursday	May Suburday	kine Tuesday	luly Thursday	Augus Sunday	Seprember Wednesday	October Friday	November Monday	December Wednesday
The state of the s	17	January Salurday	February Tuesday	Masch Tuesday	Aµ2 Friday	May Sumfay	hine Wednesday	Joy Friday	August Monday	Supremises Thursday	Supply Supply	Noomber Tuesday	December Thursday
CIO F. unidado	18	Jacquey Sunday	Fetons y Wednesday	March Wednesday	April Saturday	May Manday	Thursday	soly Suburday	August Tuesday	Suprember Friday	Drickle Santay	November Wednesslay	Occombine Friday
S (E)	19	Monday	F-degree Thursday	Stands Thursday	Acri Surviny	May Riesday	Jone Friday	Sunday	Acquisi Wednesday	September Seturday	Orbide Monday	Surgestics Thursday	Decimber Sistemary
7 810 800 F	20	Totaley Tuesday	Fatinary Friday	March Friday	April Monday	Wednesday	Line Satisfing	Aniy Monday	August Thursday	September Sured of	Distober Tuesday	Howmose Friday	Decomber Substay
(i) the C Date	21	January Wednosday	February Saturday	Morth Seturday	April Tuesday	Mary Thursday	Secretary	Lay Torsday	August Friday	September Monday	Wednesday	Missechtigs	Geotether Monday
London CCV	22	James y Thursday	February Sunday	Moreli Standag	April Wednesday	May Friday	Monday	wednesday	Acgent Saturday	Sepantias Tuesday	October Thursday	Mornidae Sunday	Destribution Suesday
Furens Sins	23	January Friday	February Monday	Morday	April Thursday	May Saturday	Tuesday	Thursday	Acquel Suntay	September Wednesday	October Friday	Monday	December Wednesday
Senter 24	24	Selectory	Feotury Tuesday	Mach Tuesday	Apol Friday	EAgy Suicity	None Wednesday	site Friday	August Monday	September Thursday	Cossoer Seluiday	Novembor Tupsday	Decenher Timesday
Struktur Des	25	Jamiera	February Wednesday	March Wednesday	April Security	May Monthly	havi Thursday	july Saturday	Acquist Tuesday	September Friday	October Street	November Wednesday	Decariber Friday
as and Bodow as	26	January Monday	Followick Thursday	Merch Thursday	April Sienday	May Tuesday	Friday	icity Surethay	Account Wednesday	September Saturday	Gctobs Monday	November Thursday	December Naturally
A. Snira, Ivak	27	January Tuesday	Fetousty Friday	Starch Eriday	April Monday	Mes Wednesday	Avic Security	Monday	August Thursday	Sestomber Swedzy	Cutoper Tuesday	November Friday	Dependag South
d they took and	28	Jimuzry Wednesday	femary	March Selectory	Apid Tuesday	May Thursday	lipe Serving	John Tuesday	Accuses Friday	September Monday	Octobel Wednesday	Nowcoler	Decames
one of the state o	29	January Thursday		March Sunday	April Wednesday	May Friday	June Monday	Joly Wednesday	Associa Saturday	Section bal Tuesday	Octobes Thursday	Teoresider Surviva	Denember Tuesday
ed group bear be	30	James Friday		Monday Monday	Acri Thursday	Way Saturday	June Toesday	holy Thursday	August Numbry	Septablier Wednesday	October Friday	November Monday	Gecenter Wednesday
Three sants	31	Aurilley		Merch Tuesday		May		Lily Friday	August Monthly		Outober		December Thursday

Working with a given set of information – the days and dates of the year – Struktur tried to re-organise the data in an unconventional manner. For the 1998 calendar, an A2 poster showing the entire year was chosen as the platform. Working with the principle that there are a maximum of 31 days in any given month, the hierarchy of the calender shifted from the prominence usually given to the months to the days of the month, from one through to 31. The individual days of the year are listed in columns, with weekends printed white out of the background colour.

The 1999 calendar took the form of a desk diary, and in a development from the previous year,

the information was re-structured grouping all the Mondays on one page, followed by all the Tuesdays, and so on, thus creating a daily calendar. At the back of the calendar is a page featuring public holidays, a vacation page, which contains all the days of the year, so the user can highlight personal holiday times, and finally a page called 'lunch', adding a time based element to the day.

The grid system present on each page is a graphic chart of each day of the year: the first column is January, the second column is February. On each page, the given day is represented with a white box, so on Monday, the chart shows white boxes for every Monday

throughout the year. The colour palette uses the basic process colous – cyan, magenta, yellow and black – with each day using a combination of the two colours, working like a printer's tint book, starting with the first of January in 3 per cent of each colour, going through to the 31st of December printed in 100 per cent of each colour.

The white keyline grid that separates each of the boxes becomes increasingly thick as one journeys through the week until by Sunday, the white lines become thicker than the boxes, visually referring to the end of the week.

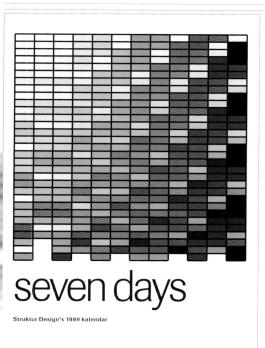

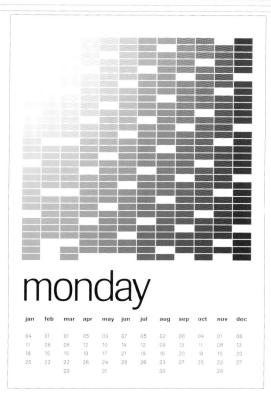

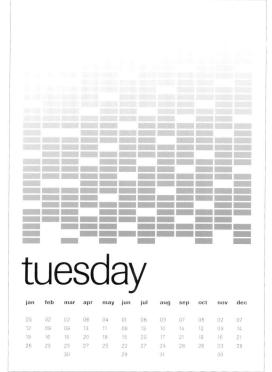

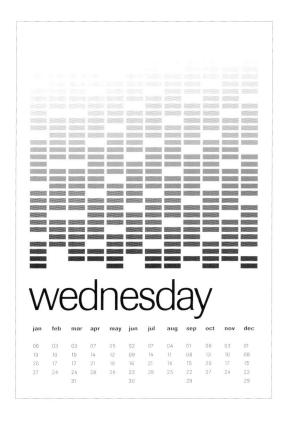

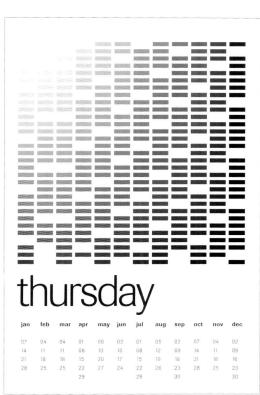

Struktur Design Perpetual Kalendar 1999 Design Project Date Struktur Design Twentyfour Hour Clock 2002

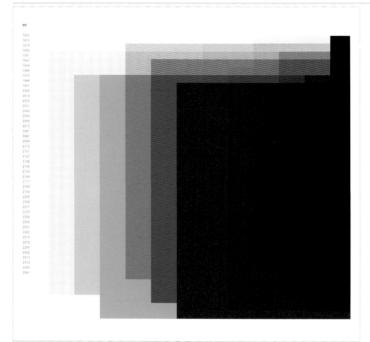

13	January	February	March	April	May	June	July	August	September	October	November	December
fonday									01			01
uesday				01			01		02			02
Vednesday	01			02			02		03	01		03
hursday	02			03	01		03		04	02		04
ndey	03			04	02		04	01	05	03		05
iaturday	04	01	01	05	03		05	02	06	04	01	06
Sunday	05	02	02	06	04	01	96	03	07	05	02	07
Vonday	06	03	03	07	05	02	07	04	08	06	03	08
uesday	07	04	04	08	06	03	08	05	09	07	04	09
Vednesday	08	05	05	09	07	04	09	06	10	08	05	10
hursday	09	06	06	10	08	05	10	07	11	09	06	11
nday	10	07	07	11	09	06	11	08	12	10	07	12
iaturday	11	08	08	12	10	07	12	09	13	11	08	13
lunday	12	09	09	13	11	08	13	10	14	12	09	14
Aonday	13	10	10	14	12	09	14	11	15	13	10	15
uesday	14	11	11	15	13	10	15	12	16	14	11	16
Viidnesday	15	12	12	16	14	11	16	13	17	15	12	17
hursday	16	13	13	17	15	12	17	14	18	16	13	18
nday	17	14	14	18	16	13	18	15	19	17	14	19
iaturday	18	15	15	19	17	14	19	16	20	18	15	20
iunday	19	16	16	20	18	15	20	17	21	19	16	21
Monday	20	17	17	21	19	16	21	18	22	20	17	22
uesday	21	18	18	22	20	17	22	19	23	21	18	23
Vednesday	22	19	19	23	21	18	23	20	24	22	19	24
hursday	23	20	20	24	22	19	24	21	25	23	20	25
nday	24	21	21	25	23	20	25	22	26	24	21	26
laturday	25	22	22	26	24	21	26	23	27	25	22	27
unday	26	23	23	27	25	22	27	24	28	26	23	28
Aonday	27	24	24	28	26	23	28	25	29	27	24	29
uesday	28	25	25	29	27	24	29	26	30	28	25	30
Vednesday	29	26	26	30	28	25	30	27		29	26	31
hursday	30	27	27		29	26	31	28		30	27	
riday	31	28	28		30	27		29		31	28	
aturday			29		31	28		30			29	
unday			30			29		31			30	
Aonday			31			30						

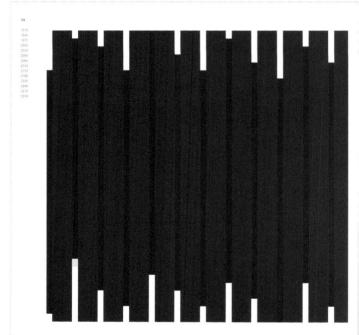

3	January	February	March	April	May	June	July	August	September	October	November	Decem
londay					01							
estay		01			02			01				
led resday		02	01		03			02			01	
hursday		03	02		04	01		03			62	
nday		04	03		05	02		04	01		03	01
aturday	01	05	04	01	06	03	01	05	02		04	02
landay	02	06	05	02	07	04	02	06	03	01	05	03
Aonday	03	07	96	03	08	05	03	07	04	02	06	04
Liesday	04	08	07	04	09	06	04	08	05	03	07	05
Vednesday	05	09	08	05	10	07	05	09	06	04	08	06
hursday	06	10	09	06	11	08	06	10	07	05	09	07
nday	07	11	10	07	12	09	07	- 11	08	06	10	08
alunday	08	12	11	08	13	10	08	12	09	07	11	09
unday	09	13	12	09	14	- 11	09	13	10	08	12	10
tenday	10	14	13	10	15	12	10	14	11	09	13	11
JESCHY	11	15	14	11	16	13	31	15	12	10	14	12
echesday	12	16	15	12	17	14	12	16	13	11	15	13
hursday	13	17	16	13	18	15	13	17	14	12	16	14
rday	14	18	17	14	19	16	14	18	15	13	17	15
aturcley	15	19	18	15	20	17	15	19	16	14	18	16
unday	16	20	19	16	21	18	16	20	17	15	19	17
londay	17	21	20	17	22	19	17	21	18	16	20	18
uesday	18	22	21	18	23	20	18	22	19	17	21	19
ednesday	19	23	22	19	24	21	19	23	20	18	22	20
tursday	20	24	23	20	25	22	20	24	21	19	23	21
day	21	25	24	21	26	23	21	25	22	20	24	22
sturday	22	26	25	22	27	24	22	26	23	21	25	23
inday	23	27	26	23	28	25	23	27	24	22	26	24
onday	24	28	27	24	29	26	24	28	25	23	27	25
jesday	25	29	28	25	30	27	25	29	26	24	28	26
lednesday	26		29	26	31	28	26	30	27	25	29	27
ursday	27		30	27		29	27	31	28	26	30	28
dity	28		31	28		30	28	-	29	27		29
sturday	29			29			29		30	28		30
inday	30			30			30			29		31
londay	31						31			30		31
estay										31		

Produced at the end of the 20th century, the Perpetual Kalendar effectively completed Struktur's series of calendars, as this calendar can be used for every year from 1900 to 2343. The single publication contains 14 permutations of the calendar, which allows for every variation of the day/date sequence – 1st of January can fall on a Monday, Tuesday, Wednesday etc. (seven versions), and the day/date sequence alters every leap year, requiring a further seven variations.

Each spread from the calendar shows a full year, working as a clear typographic page and an illustrative page, based on the inherent grid system and flow of dates. A list of the relevant years appears down the side of each spread for ease of use.

Twentyfour Hour Clock was produced as a result of an open brief set by the London-based specialist printer Artomatic. The A2 silkscreen printed poster was designed as part of an ongoing research project looking at time systems, and works as a direct extension of the Struktur Design calendars and diaries (see pages 176/177/178). The poster sets out every second, minute and hour of a 24-hour period, with each time measuring unit reproduced in progressively larger point sizes.

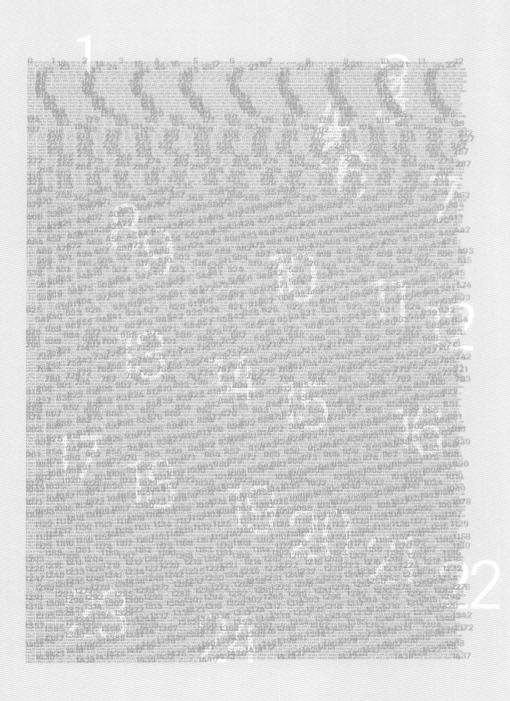

Time and space 180/181

Design Project Date

The Attik 'NoiseFour' screen saver 2001

NoiseFour.

Year. 2002

Late2001.

NoiseFour. is coming. Order your advance copy.

NoiseFour.

Sent out as an e-mail attachment to interested parties as a teaser for graphic design company The Attik's latest self-promotional book, 'NoiseFour', this screensaver once loaded onto a computer works as a three-dimensional clock showing seconds, minutes, hours, months, year and day of the week. The user can 'spin' the co-ordinates around by interacting with the clock using the mouse, causing the different time units to come to the fore. The appearance of the clock can also be manipulated further by dragging the time units forward which increases the

size of the type on screen. This allows the user to have great control over which units of time they wish to see most prominently displayed.

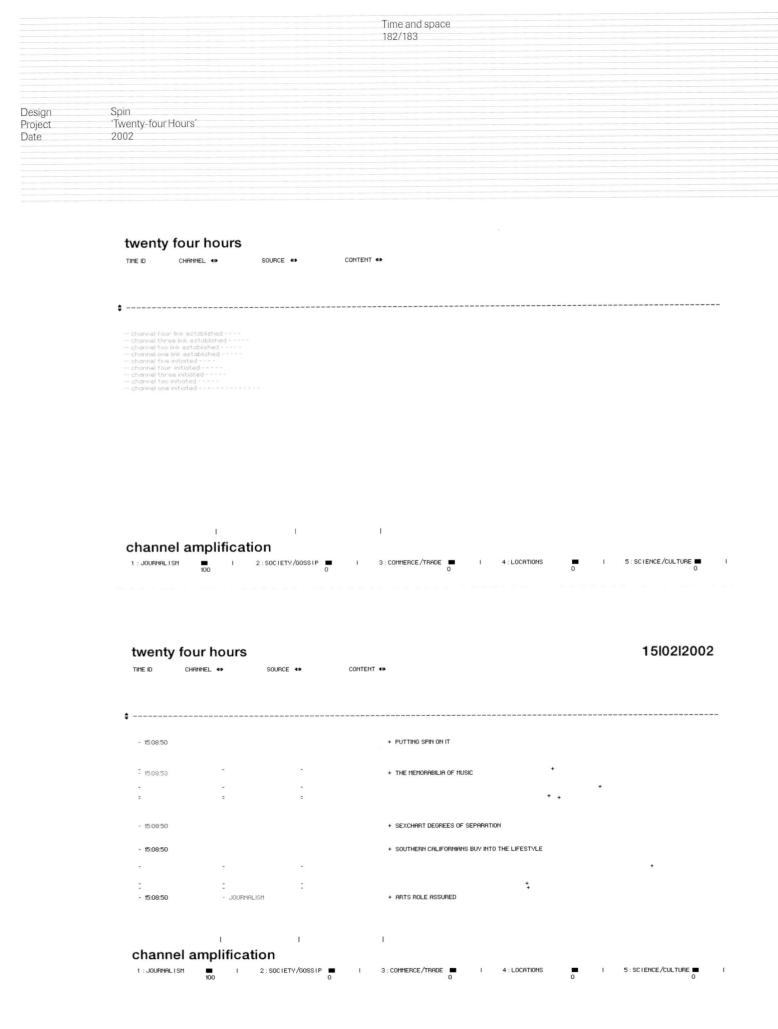

'Twenty-four hours' is a self-initiated on-line project by Spin, a London based multi-disciplinary design company. The interface scans news information from various international sources and up-loads the data onto the web site. The data, which first appears as a timecode, title and source, can be 'amplified' to show the full news story. Different filters can be used to channel the source material to personalise the information. The project has been built as a small homage to the millions of bits that make up the avalanche of information available on the web 24 hours a day.

twenty four hours

15|02|2002

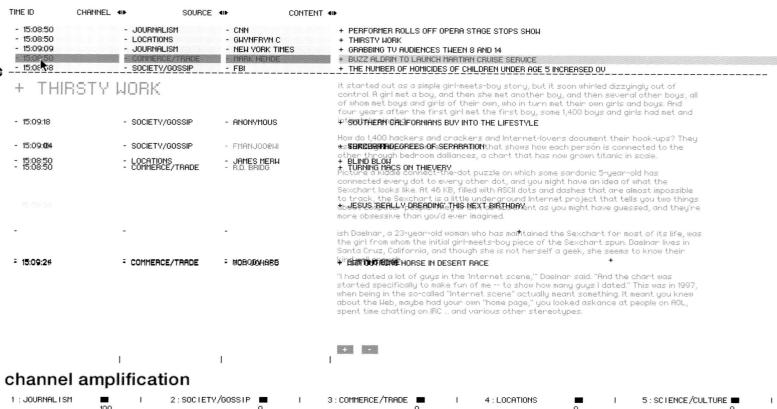

twenty four hours

1510212002

TIME ID CH	HANNEL ◆ID SOURCE	← CONTENT ←													
- 15:09:43 - 15:09:34 - 15:09:28 - 15:10:07	- COMMERCE/TRADE - SCIENCE/CULTURE CONTECORNS - LOCATIONS - LOCATIONS	- ANONYMOUS - ROMALD BUC - BEER BUOVA - MELISSARSPINCO.UK	MMSBILITY ACHIEVE MILLIONS OF BUTTERFLIES KILLED BY FREAK STORM SEE CUST STOVE-BILLION SUBSIDIARY PATRIAGE TO BBS+, ON WHICH DEV. BEER BOUNS HEADAM DIVINENTS												
944951DIA	CUTS TRYG-BAL RRY R阿柳柳感勢町)EV LOCATIONS		A grazier har found fautralia's largest dinosaur fossi while austering his sheep near lithron, in Duensland's Tossis triangle". • OPLY CHECKINGS UILL DO PRODUCTION OF THE STATE OF THE ST												
- 15:09:56 -	- JOURNALISM	- NEW YORK TIMES	So far, the museum's Steve Salisbury and his colleagues have found parts of the HEN ASHK COULD BE HAT FIT FOR HIGHS. but they say there are more fossils to be												
÷		*	Salisbury says: "There are indications that Elliot is sileler to previous finds, but we've dready noticed a few differences". Size is the most obvious. Even a fragment of the fasur is a heavy load. Photo: Steve Salisbury, thanks to hustralian Segraphic. * Hustralian Segraphic.												
-	-	-	Nathout the tail and nack bones, Salisbury cannot say exactly how big the beast was, but there are enough clues to say it stood about four metries high and was 16 to 21 metries in length.												
± ± 15:10:18	: SCIENCE/CULTURE	: MASON	Salisbury adds that the fossis vertebrae appear similar to existing sourcood finds in Riustralia and sortained. "But portions of the feeuer have a slightly different shape," he +-vullsRELLA OUNSPRACE dealing with an endesic group of sourcoods, nather than shat's found eisenhere in the world."												
- 15:10:02			+ KILLER COMPUTER												
	í	f .													
channel a	amplification														
1 : JOURNAL I SM	1 2:SOCIET	Y/GOSSIP ■ 1 3 36	3:COMMERCE/TRADE 4:LOCATIONS 5:SCIENCE/CULTURE ■ 25												

Time and space 184/185

Foundation 33 Numerical Time Based Sound Composition Daniel Eatock Timothy Evans 2001

Design Project Composer Musician Date

Numerical Time Based Sound Composition Composer: Daniel Eatock Musician: Timothy Evans Foundation 33 33 Temple Street London E2 6QQ This is a personal project by Foundation 33, exploring the point at which an audio experiment/composition becomes visual, or the point at which a visual composition becomes audible. The project moves into the realms of the concrete, where the visual is inseparable from the audio, one is not complete without the other. The piece is sent as an A3 sheet of paper with the tonal bands printed on it, together with the audio CD mounted on a sheet of pulp board.

The explanatory text reads as follows: 'A digital time display counts to one hour using four units: seconds, tens of seconds, minutes, tens of minutes. A numerical sound composition has been constructed using the ten sequential digits: 0, 1, 2, 3, 4, 5, 6, 7, 8, 9. Each digit has been assigned a tone. The tones are mathematically selected from a range of 20Hz to 20,000Hz – the two extremes audible to the human ear. The tones are logarithmically divided between the ten digits providing tonal increments that produce a musical scale. Every second a different combination of four tones is defined by the time counter.'

Numerical Time Based Sound Composition

Composer: Daniel Eatock / Musician: Timothy Evans

A digital time display counts to one hour using four units: seconds; tens of seconds; minutes; tens of minutes.

A numerical sound composition has been constructed using the ten sequential digits: 0,1,2,3,4,5,6,7,8,9.

Each digit has been assigned a tone. The tones are mathematically selected from the range of 20Hz to 20,000Hz; the two extremes audible to the human ear.

The tones are logarithmically divided between the ten digits providing tonal increments that produce a musical scale.

Every second a different combination of four tones is defined by the time counter.

Above is a diagram that represents the

Copyright Eatock/Evans 2001

Foundation 33 33 Temple Street London E2 6QQ

020 7739 9903

Time and space 186/187

Design Project Date Cartlidge Levene Canal Building brochure 1999

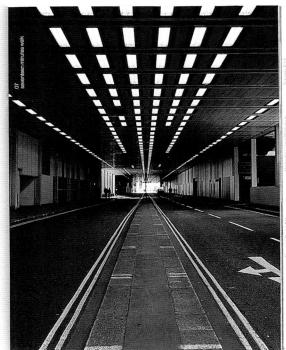

Decrea Real III

Decrea

A clever brochure designed to promote a development of apartments in Islington, London, includes photographs of the raw, unmodernised interior shell of the building, as the brochure was produced prior to the start of the redevelopment. A large section of the lavish brochure is dedicated to a map of the surrounding area, but unusually, the map is purely photographic, and no diagrams of streets and roads are included. The map is based on the walking times to various local amenities, but these routes are illustrated with more abstract images of tree bark, water and concrete. This mapping method is useful to people not familiar with the area, as it shows with a flick of the pages the texture of area the development is set within.

Towards the back of the brochure are two further maps, one a conventional line drawing of the area, and the other an aerial photograph showing a larger area of London. This image is overlaid with a grid system on a scale which equates to a three-minute walk for each square on the grid. A series of numbers is also printed on the image which relates to the page number of the photographic mapping system, allowing the two views to be cross-referenced.

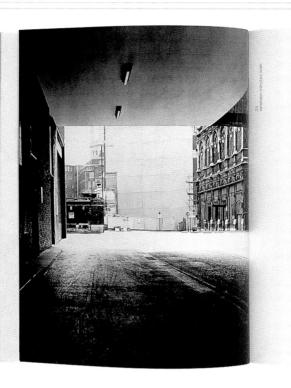

Particular Manuel Manue

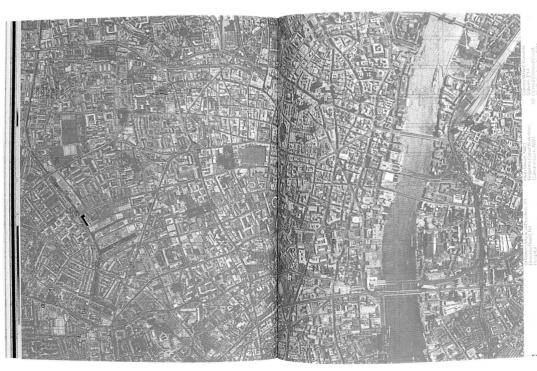

Hemoteutrietonial, Farnoton Control Activities, 2016.

1-6. Sheptenbear Walk, N.I.

1-6. Sheptenbear Wa

Time and space 188/189 Sagmeister Inc. 'Made You Look' timeline 2001 Design Project Date

'Made You Look' is a collection of the work of New York-based graphic designer Stefan Sagmeister. At the beginning of the book is a timeline, which extends over the course of eight pages. The timeline is just that, a line that weaves its way back and forth across and up and down the page in a clean and pure fashion. At the top of the first page a small circle is annotated with the words 'Big Bang'. Nothing further happens until the sixth page, where another annotated circle is flagged 'Earth sees light of day'. The final two pages see a quickening of pace, towards the bottom of the pages 'Green blue algae appear, Jellyfish

evolve, Plants appear, Amphibians come alive, Marine reptiles appear, Dinosaurs start to flourish, Birds emerge, and so on, until just before the end of the line, 'Neanderthals appear' and finally 'The entire history of graphic design'.

A footnote reads as follows: The little circle representing the entire history of graphic design is of course shown much too large here: In real life and scale it is about 1/100 000 of an inch, which is a very, very small circle. Now, my whole working life: Too bitsy to think about. That Aerosmith job that went on forever? Oh boy.'

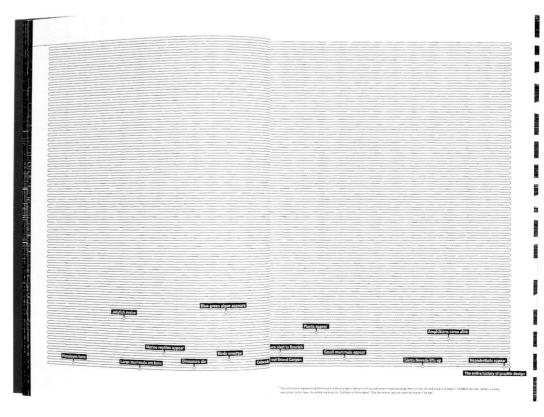

Time and space 190/191

Design Mark Diaper Artist Tony Oursler

Project 'The Influence Machine'

Date 2002

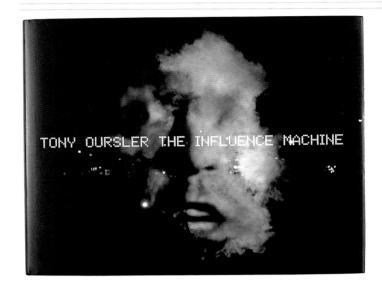

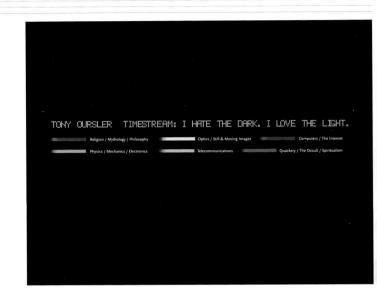

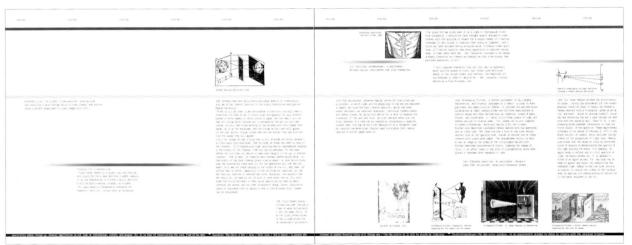

Timestream: I hate the dark. Hove the light.' is a timeline developed by the artist Tony Oursler and designed by Mark Diaper for the Artangel/Public Art Fund book. The Influence Machine.' The timeline, which extends over 26 pages of the book, is intended to chart the history of religion/mythology/philosophy, optics/still and moving images, computers/the Internet, physics/mechanics/electronics, telecommunications, quackery/the occult/spiritualism. A specific colour is attributed to each of these broad categories and is plotted horizontally over the pages

starting in the 5th–2nd centuries BC with the Egyptian god Seth and ending with the Endoscope pill camera in 2000 AD

The colour bars for each strand of information fade in and out and swerve up and down to make space for the various entries. Interestingly the red bar used to represent religion/mythology/philosophy fades out around 1705 AD as the orange of physics/mechanics/electronics becomes prominent.

Design Illustration Project

Date

Damien Jaques

Quim Gil

Mute - Ceci n'est pas un magazine

(We've crossed oceans of time to find you...)

Comments? Ideas? Flames? Metamute's new forum [http://www.metamute.com/forum] awaits you. Or contact us at the editorial address.

Mute's evolution in perspective

Mute's evolution in perspective

Over the last six months, Mute magazine has been in a suspended state of publication. During this time, we've been contemplating the implications of our magazine's content—the digital 'revolution' and its discontents—for its form and self-sustainability.

When Mute published its pilot issue, in 1994, the Net was anything but ubiquitous. Mute's original 'Financial Times' newspaper format was a deliberate attempt to debunk the information revolution's much vaunted inclusivity—hence our decision to make a printed object and our motto 'Proud to be Flesh'. Six and a half years later, we face a very different picture: the many-to-many publishing environment is now far more than a theory spouted by inspired techno-lotus eaters and our publishing gesture is dwarfed by the reality of today's Net.

So, our gawky teen phase of self-contemplation has resulted in a few structural and 'philosophical' adjustments. You might have seen the first signs of this in our fledgling e-letter Mutella and our recently relaunched Metamute website. Well, the long shadow of cyberspace has now fallen across our paper-bound and 'top-down' notion of content generation too. Like us, you'll have come across words such as 'prosumers' and 'user-generated content'. Such New Economy buzz-speak for the consuming producer (or producing consumer) often functions as an alibi for no editorial at all or, worse, a vampiric relationship to a community. Nonetheless, in sticking so monogamously to a traditional editorial model we have ignored the non-vampiric alternative.

If you think this is all a very long-winded way of saying we want to be in better dialogue with our readers, you're both right and wrong. Right because we do, wrong because that's only the start of it. Part of our objective is to continue producing Mute as a printed magazine; the other part is to develop discussion forums, tools/files/software exchanges spaces, research areas and special publishing projects. This way, Mute can hopefully become a more accura

A printed magazine with an online archive and Metamute v.1.0 (aka 'meta' soon to be archived on Metamute)

A printed magazine, the Mutella e-letter, Metamute v. 1.1, archive, events

Mute, a British magazine, wanted to show a state of play timeline with the intention of setting out future goals, directions and ambitions with as yet undeveloped technologies. The result is a very unusual and organic timeline, which resembles a map rather more than a line. The information is clustered into six modules; 1:The dawn of time 1994–1995, 2: When dinosaurs stalked the earth,1996–2000, 3:The present, 2001, 4:The near future. 5:The slightly more remote future, 6: Objective...oh God, why am I here?

A series of icons is used to illustrate the stages of development and expansion, while a satellite module represents the relationships between readers, editors, promoters, users and network participants.

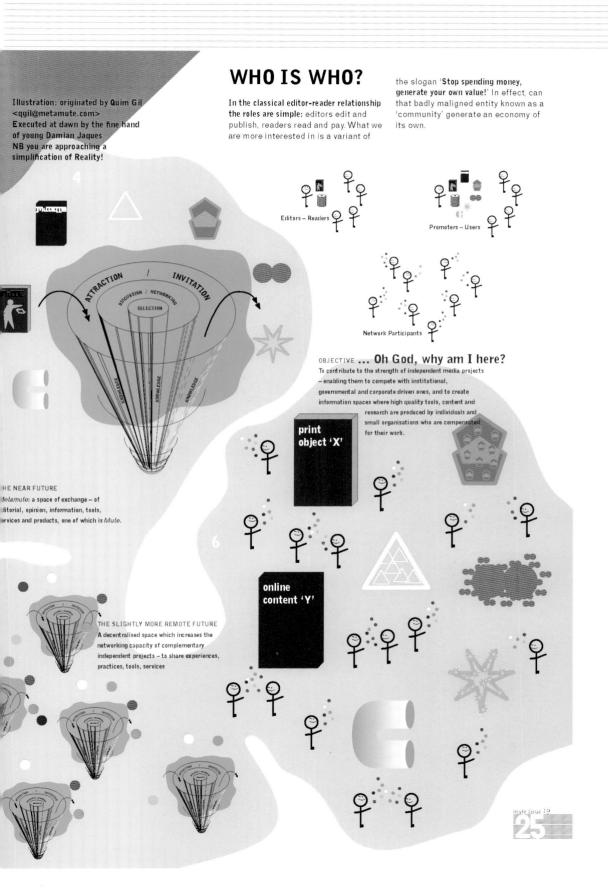

Time and space 194/195

Design Project Date

Nina Naegal and A. Kanna

Time/Emotions

2000

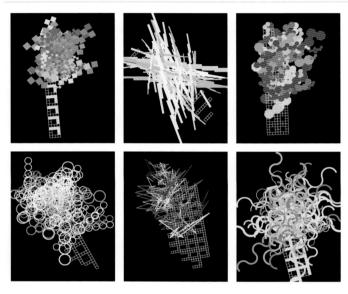

24 HOURS - TIME EMOTIONS preparation of a road the time. It's visualised by two combined patterns. The first pattern symbolises the actual time and there fore it's created by a rule which uses the figures of that time as a guide. The second pattern which shows the emotions is made out of many different shapes which were put down by a rule, determining the shape, size, colour, rotation of the shape and placement of the shapes on the grid. As the grid to put down the second pattern we used the first pattern as the emotions hinge on that moment of time. The final pattern visualises the new system 'Time/Emotions'.

24 HOURS (24 books in slip case)

The system'Time/Emotions' runs through 24 hours. Every hour has been analysed according to our emotions and has then been put through the two rules to visualise the system of reading the time. shown above > spreads of magazine accompanying exhibition

'Time/Emotions' was developed by Nina Naegal and A. Kanna as a new method for reading time. The image is generated by the overlaying of two different patterns; the first is a grid system formed by a time sequence, this gives a uniform base grid. The emotional pattern is then placed over the time grid. The emotional patterns are made out of many different shapes which are placed by a rule, determining the contours, size, colour and rotation of the shape as well as the position of the shapes on the time grid.

Shown here are pages from a 24-part book which shows the various stages of emotion. Also shown is an A1 poster related to the project.

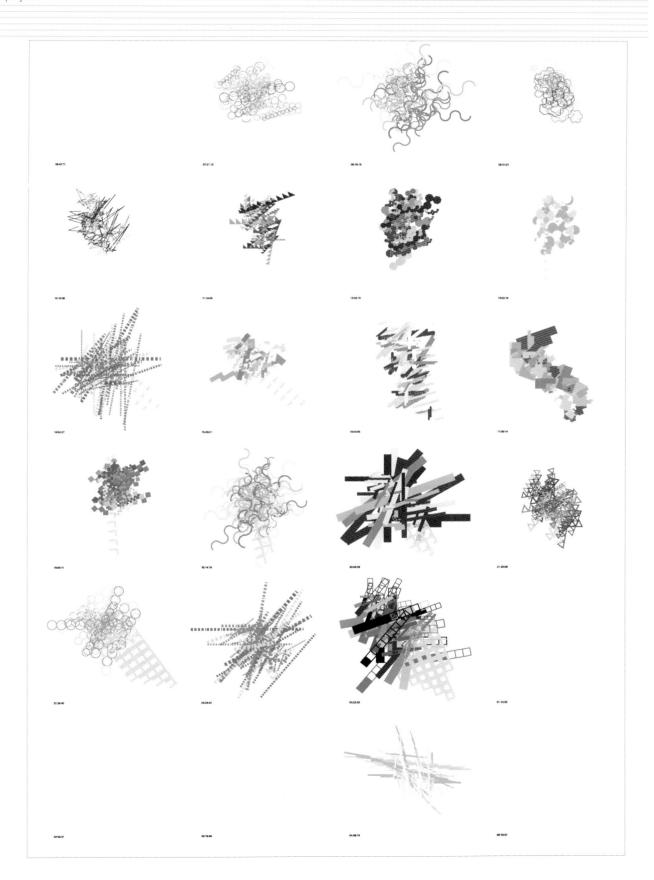

Artist Project Date Jem Finer Long Player 2000

Commissioned by Artangel, Longplayer was developed by Jem Finer and managed by Candida Blaker with a think-tank comprising artist and musician Brian Eno, British Council Director of Music John Kieffer, landscape architect Georgina Livingston, Artangel co-director Michael Morris, digital sound artist Joel Ryan, architect and writer Paul Shepheard and writer and composer David Toop. Longplayer was conceived as a 1000-year musical composition, which began playing on 1st of January 2000 and will play continuously and without repetition until 31st of December 2999.

Longplayer can be heard at listening posts in the United Kingdom, with plans to establish other listening posts at diverse sites around the world. The first site was established in a disused lighthouse at Trinity Buoy Wharf in London Docklands. Longplayer is also planned to stream in real time on the Internet.

The music is generated by a computer playing six loops taken from a pre-recorded 20-minute, 20-second composition, each of which is of a different pitch and advances at a different speed. The constant shifting of these layers creates ever-changing textures and harmonies. The instrumentation in the source music is primarily Tibetan singing bowls of various sizes.

Technology is embraced as a means to share an experience not only of music but also of a dream of time. There is no wish to send an ideological monument out into the future landscape, only the ambition to engender connections through time and space. Though it starts its life as a computer program, Longplayer works in such a way that its production is not restricted to just one form of technology. The resilience of Longplayer will be evidenced by its ability to adapt rather than to endure in its original form.

Design Project Date Imagination The Talk Zone 1999

Composed of two structures that literally and metaphorically talked to one another, The Talk Zone was the pavilion in the UK's Millennium Dome housing an exhibition that dealt with issues of communication. This timeline was produced as part of the overall design treatment for the Talk Zone, starting from either end of the structure and meeting at the entrance to the pavilion, between the two buildings. The large-scale timeline, which

kept visitors entertained while they queued for entry, held both significant objects and information on the biological, social and technical histories of communication over the last 5000 years. Supplementing the visual information, soundbites spoken by the voices of the talk structures, punctuated the queue line at regular intervals, delivering facts about the way we communicate.

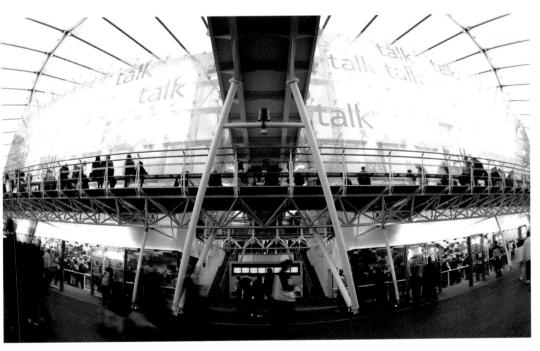

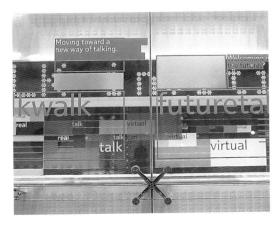

Design Project Date Studio Myerscough Forest of Infinity 1999

To celebrate the 25th anniversary of the specialist furniture supplier Coexistence, graphic design consultancy Studio Myerscough designed both a commemorative book and an exhibition held at the RIBA architecture gallery in London called 'Forest of Infinity'.

dimensional timeline showing classic pieces of furniture design which have been produced over the last 25 years. Each item was positioned under a white lozenge-shaped lampshade with the year printed on which was suspended from the ceiling, on the back of each lamp shade 2000 was printed back to front. There were mirrors at either end of

the space so that the time line continued indefinitely. The '2000' on the back of the shades then reflected the correct way round, as all the products shown were still in production. The captions explaining each exhibit were printed next to the item on the floor.

Design Project Date

MetaUnion Deutschbritischamerikanische Freundschaft 1995

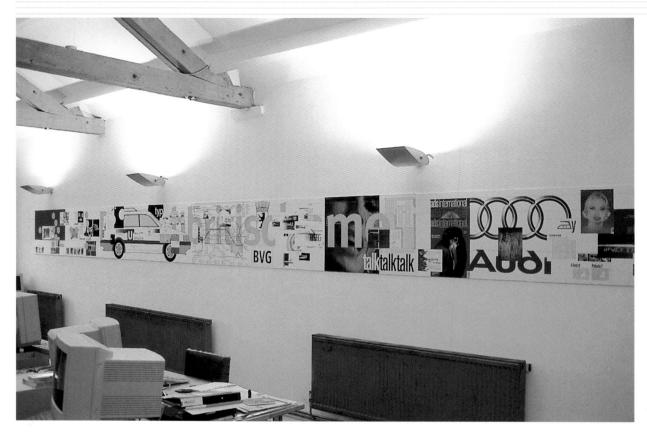

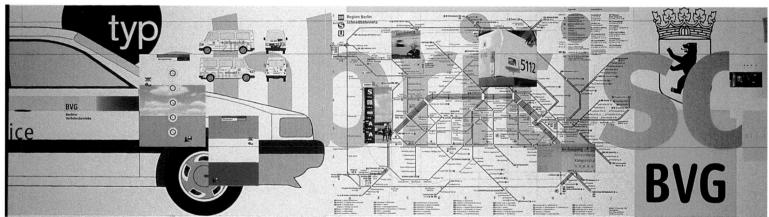

To celebrate the formation of MetaUnion in 1994, the London-based graphic design studio created a timeline/mural showing elements of work from Union Design, MetaWest and MetaBerlin – the three companies which in various ways had input into the new company (by becoming MetaUnion, the former Union Design was joining the international Meta group of design companies). The panels were one metre high and ran the full length of the studio, focussing on key works by the three companies in a loose chronological order.

The title of the piece, 'Deutschbritischamerikanische Freundschaft' (German, British, American friendship) runs down the full length of the mural set to an x-height of 600mm.

Time and space 204/205

Design Project Date Studio Myerscough Web Wizards 2002

6	60 70								80												90									00						
1963	196-	4	1968	1969	1971	1972	1973	1974	1975		1977	1978	1979		1981	1982		1984	1985	1986	1987	1988	1989		1991	1992	1993	1994	1995	1996	1997		1999	2000	2001 20	002
Network	22.		Million (III) gave some popular, some some popular, some some popular, som some popular, some some			ef (tex)	100.00		MES SUPER PARTY OF THE PARTY OF	META Processor		With Disa Security		Name of Orașele I Internation Computer Santopia Cirin	Sweep (NE) Speep (NE) speep self-buller prope (And graphers	tropic of Special marks of temperature of the	Topic of Comments	tes ni in tes formation to Consulto apro- tessa (ET CO mas	rape of	to Company (March of March of	to the best of the control of the co	der ert est.	Communication Standard	MC Frequent OF to space with the paper of the paper of page Fig. 10s - 10s the paper of page Fig. 10s - 10s the page of page of p	Apple Received Duning		Age best	Spile Monthly Frame	services on turneys age agency continues	Fast Fast	•	Foreign and Street,	T have been	Age Sector in ad		Sedept
Bollean Services promoting parties observed only on higher are side	the transport				NOT A	Trong			WORLD'T GARAGE	State of the state		N-MO 	TOTAL But approximate		WATER	North Add of the Add o	argusps montes (Norde State State	Topic Security Security Of the Control of the Con- trol of the Control of the Control of the Con- trol of the Control of the Con- trol of the Control of the Control of the Con- trol of the Control of the Control of the Con- trol of the Control of the Control of the Con- trol of the Control of the Control of the Con- trol of the Control of the	Million I		Million II	lara	Marine 17	March Silver Military Self or Product Asses Promiting 1		familiar fra dominal i	Tipe Man William self-feet the Indoor Tripener	notified by many	Michigan N Services (See Michigan (See Michigan M	Sales op Processes	No. (IC)	of many o	-	the Tile	of trace of Fee	- liter
broads parties					TO ACRES VOIC (ATT	the red to be		Nac Saffer Safe	ortain garry with cleaning whose	Har Francis I source for appearing toward widow garte with part's day com-	Miles But of our party artists origin party	The Speciments See Armedia Survivasion Product	An islands An Lord Lotte Salabilities Salabir	And Saffers for change on the Saffers garner frames for man	See the contract of	Tomas Year Same Year	man Makesa Diame of Tree	Total Street, and	from his tips		Court freetyne Wilson * toe	too are lage too tops more boor	Togal Today No.	toge 1905 backers, brooks i	town also Discour	Maria New Service	Signal William	Sept Service JOS	Night Republi	Har har have to the	of Sup-ton Pin (ea)	No larte open		Sage Corres Small Sage 4 Williams	Service Rogal Room	throate person
Name Oracles						try here non princ				Policie of last 6 position for games fraction Charmer? the contribute programms	-	Print House		to stone		10.00			town	laps Marris Scotter	No. 15	AC Cope	marine Samon	true fame fam	hije krazin svet	lage Hagaine	100	Spe Passon	Impa fasturi						E-silver	
Bight At The Colpus and Dange At European	(a) - ke	office (A) speed					Million or the second of the second or the s										der	Service Services	Table to Rept to	-							Next flore for resulter regard busines bear nor fung and Medicinals		Mouths Reven up - Meader water took sea Hart (1) Age	Arterior of Ref's, Application of the contraction o			Hate haden made conduction	-		Style or and Design Street

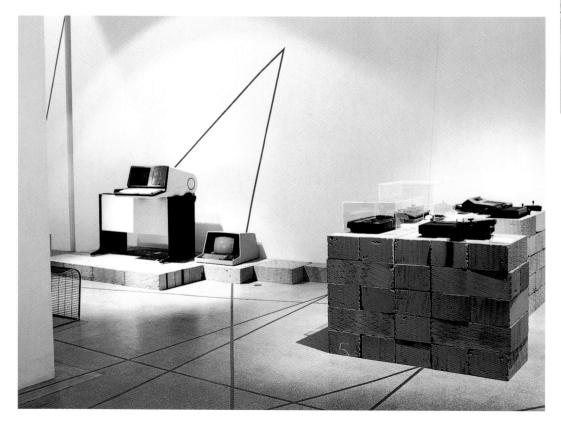

'Webwizards' was an exhibition held at the Design Museum in London, presenting some of the most innovative contemporary on-line art and design work. The exhibition, designed by Studio Myerscough, included a large scale timeline charting the history of computers and the Internet from the 1960s to the present day, which was printed along an entire wall.

Exhibits were connected with each other via lines printed across floors and walls, which made the entire event interrelated, with objects treated like coordinates within a virtual computer world.

Acknowledgments

206/207

I would like to extend my deep thanks to all those who have helped in creating this book, whether by kindly submitting work or for help and advice.

A special thank you should be extended to William Owen for his insight; Sanne, Tristan, Minnie and Monty for their constant support and understanding; Chris Foges, Laura Owen and all at RotoVision for their faith and patience.

rf-t

Roger Fawcett-Tang is creative director of Struktur Design which has developed a reputation for clean understated typography, attention to detail and logical organisation of information and imagery. It has won various design awards, and has been featured in numerous design books and international magazines. Roger compiled and edited Experimental Formats (RotoVision 2001). He is a contributing editor to Graphics International.

William Owen is a writer and a consultant in digital services and brand development for international corporations and institutions. He is the author of Magazine Design (Laurence King/Rizzoli 1990), Unsteady States (in Digital Prints, ed. Adam Lowe, Permaprint 1997) and of numerous articles and essays on design, culture and business for the European and American design press. He is a consulting editor to the international review of graphic design Eye and a visiting tutor at the Royal College of Art.